Praise for *How to D*

"Coming upon [*How to Disappear*] was like finding the Advil bottle in the medicine cabinet after stumbling about with a headache for a long time. . . . For [Busch], invisibility is not simply a negative, the inverse of visibility. Going unseen, undetected, overlooked: These are experiences with their own inherent 'meaning and power'; what we need is a 'field guide' for recognizing them. And this is what Busch offers, roaming from essay to essay in a loose, associative style, following invisibility where it takes her."

—Gal Beckerman, *The New York Times Book Review*

"Akiko Busch's *How to Disappear: Notes on Invisibility in a Time of Transparency* serves as a gentle reminder . . . [to] stop confusing what is most obvious or distracting for what is genuinely important. . . . Ms. Busch, who has rightly been compared to Annie Dillard and Edward Abbey, has dedicated nearly 30 years to sounding this message, one that our age seems intent on ignoring. . . . On the surface, *How to Disappear* is a palliative for the alienation that modern overexposure begets. Ms. Busch would like to save us from ourselves, from the lonely fate that afflicts Narcissus, his eyes forever locked on the only person he has ever truly loved—himself. But in its deeper moments, the book touches on an abiding, but easily forgotten, truth: Disappearing, the act of losing our selves, is a precondition of selflessness. Ms. Busch's deeper concern is to save not Narcissus but rather the wider world his selfishness affects." —John Kaag, *The Wall Street Journal*

"In this provocative series of essays, Busch examines how social media and the surveillance economy have redefined the way we live. . . . Throughout, she asks important questions about the consequences of hypervisibility." —*BBC Culture*

"In *How to Disappear*, Busch contemplates how government surveillance, smart technology, and our own desire to be seen have all contributed to a perhaps irrevocable loss of personal privacy.

She does this circuitously, eschewing the alarmist and Luddite tropes that encumber many studies of our technology-dependent culture. Instead, Busch meanders across a broad cultural landscape to locate the source of our beliefs, fears, and desires about invisibility. . . . [She] explores camouflage, anonymity and unsigned works of art, and police surveillance of minorities. By drawing from natural science, children's literature, folklore, art history, and more, Busch takes the timely issue of privacy and makes it timeless." —*The Paris Review*

"What a mesmerizing, unexpected, and *hopeful* book this is. A wondrous magic hat of revelations on the power of the unseen—to disappear into, lose oneself in, and emerge transformed, with new hope for the possibility of a surer, quieter, more humane way of being." —Jennifer Ackerman, author of *The Genius of Birds*

"What a stunning, intelligent book! And timely in these times of endless exposure. Akiko Busch leaves no pebble unturned in her contemplation of invisibility in all of its myriad guises, many of which will surprise you, and in the course of things her contemplation becomes a search for one's place in nothing less than the flow of life itself." —Mary Ruefle, author of *My Private Property* and *Madness, Rack, and Honey*

"Kafka dreamt of being a waiter. He wanted to be present but invisible. Akiko Busch has illuminated this essential part of being. Examining with a clear lyricism, what it means to protect yourself from too much visibility. Her work offers a much needed sense of balance in a time of turmoil. A reminder that we can shift and change and that there is such a thing as privacy." —Maira Kalman, author and illustrator of *Beloved Dog* and *The Principles of Uncertainty*

"What a perfect moment for this beautiful and affecting book. Aki Busch writes with grace, humor, and breathtaking precision about the unsung virtues of blending in rather than standing out,

of finding our most essential selves by losing our need to be perpetually seen. Weaving together science, myth, and storytelling, anecdotes from Iceland to Grand Cayman Island, the Bay of Fundy to a virtual reality studio in Brooklyn, she reminds us that it is often in those all-consuming moments of losing ourselves— in love, in work, in the natural world—that we see and feel most acutely, that how to *be* depends on knowing both how to be fully present and how to disappear. This is a book that will be passed from friend to friend like a secret handshake—a must read."

—Andrea Barnet, author of *Visionary Women*

"An impressive look at myriad, diverse examples of invisibility."

—*Library Journal*

"These are by no means 'notes' but rather fully formed and often powerful explorations of the many realms and levels of invisibility to which one might aspire or withdraw. . . . With a tone that is more evocative than provocative, Busch meaningfully celebrates value where it goes unseen by others." —*Kirkus Reviews*

"Busch's exploration of her subject is free-associative, wide-ranging, and poetic in its own right. . . . Busch offers a path to quiet dignity that is rich and enlightening." —*Publishers Weekly*

"As the world grows ever more connected, it's imperative that voices preaching caution without hyperbole come to the fore. How refreshing, then, to read Akiko Busch's *How to Disappear*, which perfectly threads the needle. . . . [The book] isn't interested in providing a roadmap for getting off the grid, but in exploring the various ways humans do disappear, whether it's from view or simply into themselves. . . . Philosophical and thoughtful, *How to Disappear* beautifully illuminates the ways we choose to hide." —*Shelf Awareness*

PENGUIN BOOKS

HOW TO DISAPPEAR

Akiko Busch is the author of several essay collections, including *Geography of Home*, *Nine Ways to Cross a River*, and *The Incidental Steward*. She was a contributing editor at *Metropolis* magazine for twenty years, and her work has appeared in numerous national magazines, newspapers, and exhibition catalogs. She is on the faculty of the School of Visual Arts in New York City and lives in the Hudson Valley.

HOW TO DISAPPEAR

NOTES ON INVISIBILITY
IN A TIME OF TRANSPARENCY

AKIKO BUSCH

PENGUIN BOOKS

PENGUIN BOOKS

An imprint of Penguin Random House LLC

penguinrandomhouse.com

First published in the United States of America by Penguin Press,
an imprint of Penguin Random House LLC, 2019
Published in Penguin Books 2020

ISBN 9781101980422 (paperback)

THE LIBRARY OF CONGRESS HAS CATALOGED THE HARDCOVER EDITION AS FOLLOWS:
Names: Busch, Akiko, author.
Title: How to disappear : notes on invisibility in a time of transparency / Akiko Busch.
Description: New York : Penguin Press, 2019. | Includes bibliographical references.
Identifiers: LCCN 2018029070 (print) | LCCN 2018036687 (ebook) |
ISBN 9781101980439 (ebook) | ISBN 9781101980415 (hardcover)
Subjects: LCSH: Invisibility—Social aspects.
Classification: LCC QC406 (ebook) | LCC QC406.B87 2019 (print) | DDC 304.2—dc23
LC record available at https://lccn.loc.gov/2018029070

Printed in the United States of America

Designed by Gretchen Achilles

For Colin, Julia, Conor

Clouds gather visibility, and then disperse into invisibility.
All appearances are of the nature of clouds.

—JOHN BERGER

CONTENTS

HOW TO
DISAPPEAR

INTRODUCTION

The more invisible something is,
the more certain it's been around.

—JOSEPH BRODSKY

I pull myself up to the makeshift platform in the lower branches of the white oak. It has been wrenched awry after years of neglect, and the rungs leading to the damp, rotting platform have been pulled out of place. The whole geometry of the thing has gone askew, conforming more to the chaos of the woods now than to whatever plan a hunter had years ago when he leveled the boards and nailed them into position. Still, this small, mossy podium is not an uncomfortable place to take in this forest of oak, maple, beech, hickory, ash and to see what I can of the forest, and what I cannot.

It's unusually warm for early March. In New York's Hudson Valley, winter often finds a way to linger late into this month, but in 2016, the peepers from the wetlands nearby have already started their rhapsodic chirping. On this particular afternoon, the forest floor is damp, with the only bits of color the green moss and silvery lichen, a scattering of wild chive sprouting up in the bed of dry leaves, and the last few red winterberries. The

tree canopy remains wide-open, afternoon light flooding the hillside. On my way up to the ridge, I surprise a ring-necked pheasant and two eastern bluebirds, whose low warble picks up at the sound of my steps. I hear raspy, distant cawing from a handful of raucous crows but doubt they are reacting to my presence. Crows are capable of recognizing human faces, but I am not familiar to them. It has been months since I've visited this ridge.

An eastern gray squirrel momentarily stops scuttling along an upper branch of a maple tree a few yards away. With eyes on either side of its head which have a highly focused wide-angle vision, it can see me without moving. But the squirrel has only moderate color vision, and a yellow pigment in its lenses naturally reduces glare. Smell and light are as vital to how it perceives the exterior world. Its perception of me has as much to do with my scent and shadow as with my actual form. Its nest, one of the messy arrangements of leaves, twigs, and bark assembled in the upper reaches of this forest, will be fully camouflaged once the leaves have come in.

After thirty minutes or so, a slight rustle alerts me to a doe, the color of dust and bark, twenty feet away. She stops midstep and stares toward me, tilting her head. My own invisibility is a matter of silence and immobility. She nibbles on a tuft of grass emerging through the leaf litter and then steps quietly through the woods, past the platform, and down the ridge into the hollow, where she happens upon a pheasant. It screeches and flaps its wings, and the doe bounds up the opposite hill. Deer are unable to make the color distinctions that we make. They have discerning nighttime vision and can see light in the blue, violet,

and ultraviolet range, the last of which is not visible to us. But they are unable to detect reds and oranges. Sound and movement, rather than shape and color, are what alert them to human presence. I don't know what she sees, but I assume it is a handful of indistinct shapes in a range of violet hues.

Birds not only perceive gradations of color we miss, but extra color cones in their retinas allow them to perceive other hues that we are unable even to imagine. Snakes are equipped with pit organs on either side of their heads to detect the warmth of what is around them; capable of infrared sight, they navigate the world by reading the heat signatures of the prey that may be nearby. By discerning ultraviolet light, bees see patterns of flowers invisible to us and use them to locate nectar. They process color as much as five times faster than humans, seeing the way colors change with angle and perceiving iridescence where we do not. The black-eyed Susans outside my kitchen door have discs of hues on their petals I cannot see, and when I take in the radiance in a field of sunflowers in July, it is bright with patterns that remain out of my view. The range of visible light apparent to us is only a small part of the electromagnetic spectrum. The entire world is shining with things we cannot see.

A place actually called *a blind* seems like a good spot to begin thinking about being unseen and the conditions under which we become visible. To the doe, it is not my vaguely concealed form or my brown sweater, but my stillness that keeps me out of view. For the crows, it is my unfamiliarity, and for the gray squirrel, my shadow. My own vision is limited to an arc of 120 degrees, most of that peripheral, and I know this invisibility conference includes insects, amphibians, rodents, and birds that

entirely escape my notice. What is the difference between being invisible and just landing in a blind spot?

In the woods no more than an hour, I am struck anew by invisibility, and its improvisational choreography, as a necessary condition of life. I am reminded of the grace of reticence, the power of discretion, and the possibility of being utterly private and autonomous yet deeply aware of and receptive to the world. If I am enchanted by staying out of sight, it is because such behavior seems so rare in our own species. In recent years, we have been more preoccupied than ever by the question of how to stay in view.

Yet we humans have our own diverse ways of being seen or unseen. We have our own metrics of invisibility, and our vision is a matter that goes beyond the electromagnetic spectrum. We make ourselves known or not, and familiarity, color blindness, and peripheral vision are the least of it. We have devised a vast catalog of inventive strategies—physical, psychological, technological—for how we maneuver our way in and out of one another's sight lines. They can be captivating, enchanting, deceptive, manipulative, hopeful, despairing, gracious, isolating, logical, illogical, strange, and altogether mysterious. This age of increasing transparency is time to consider them anew.

Visibility has become the common currency of our time, and the twin circumstances of social media and the surveillance economy have redefined the way we live. In his landmark 1979 book, *The Culture of Narcissism*, Christopher Lasch noted that "success in our society has to be ratified by publicity." Forty years later, our cult of transparency shows his prescience, as do the enabling new technologies. It has become routine to assume

that the rewards of life are public and that our lives can be measured by how we are seen rather than what we do.

The exposure begins at home, a place once considered private. In the nursery, internet-connected baby monitors equipped with high-resolution lenses, built-in microphones, and motion sensors may serve security, but they also reconfigure the relationships between parent, infant, and caregiver. The Internet of Toys—Barbies outfitted with Wi-Fi, Bluetooth-equipped kitties, teddy bears that allow for voice messaging—promotes interactivity but can be easily hacked for the child's own data, including address, birth date, photos. A smart refrigerator in the kitchen can gather shopping habits, information we may willingly surrender, but numerous brands of smart TVs track viewer data that advertisers can access for targeted marketing. Robotic vacuum cleaners have the ability to map our rooms, and Alexa, Amazon's personal home assistant, can produce evidence in court of what we say and do. Send an email, use Google, research something, anything, online—a dress, a book, a roasting pan, a lawnmower—and these items digitally trail us in endless popups and sidebars.

Leave the house, and our cell phones deliver location data to service providers. Pass through a tollbooth, use a credit card, rent a car, or take a plane, and Big Data can gather even more personal information. But even if we don't do any of these things, dash cams, body cams, and backyard cams, along with closed-circuit security cameras at banks, malls, gas stations, transportation hubs, convenience stores, and street corners, observe our activities with little regulation. As drones continue to shrink in size while their cameras become more sophisticated,

they are used for everything from reporting news and traffic to the remote patrolling of private and commercial properties alike. Madison Square Garden uses facial recognition software to identify fans, and equipped with new radar technology, some billboards can now track the cell phones of nearby drivers, allowing partnerships of telecommunications companies and advertisers to ever more closely monitor consumer behavior patterns. In 2016, in an effort to fight crime, the city of Baltimore used footage from aerial surveillance cameras to monitor city streets within a thirty-mile radius; no one below knew they were being photographed. A more personal device, Snapchat Spectacles, allows the wearer to tap the frames to film a ten-second video of whatever happens to be on view, and that could be anyone or anything.

The ever-growing catalog of consumer electronics offers convenience and efficiency, all the while eroding conventional ideas about privacy. With a touchscreen display, the medallion of the FrontRow camera necklace can record, livestream, and create time-lapse videos. Facebook Live and Periscope advance our orgies of disclosure by allowing us to stream daily life in real time to the world. As the Internet of Things continues to expand, accommodating home appliances, jewelry, and all manner of electronic assistants, such digital scrutiny will only increase. Voluntary and involuntary participation are uncomfortably close: we willingly wear Fitbits that document our location, but Amazon has received patents to test wristbands capable of monitoring workers' movements, whereabouts, efficiency. Our desires, whims, habits, and curiosities become our collaborators, witnesses, and informants. And when it became

publicly known in 2018 that Facebook had allowed Cambridge Analytica to harvest data from eighty-seven million users in an effort to profile voters for the 2016 presidential election, there was no longer any question that the idyll of connectivity offered up by social media is a knife's edge away from the surveillance state.

A new vocabulary has emerged for this visibility. The word *optics* now has to do less with the science of light and more with how visual impressions of events and issues may be more important than the events and issues themselves. In altering the flow of information, the technological revolution has also radically revised the way we present ourselves to the exterior world, and the novel phrase *curating identity* refers to the self-promotion, personal branding, and ability to create and cultivate assorted profiles—consumer, social, political, professional—on social media that are viewed as valued, indeed essential, commodities. *Data ecosystem* describes the complex networks of information, which both create and track patterns of consumer behavior. *Neuropolitics* refers to the practice of reading facial expressions to help political campaigns better analyze the reactions of voters to specific candidates, while *microcelebrity* refers to limited and temporary fame acquired through such venues as Instagram and YouTube.

And the phrase *personal data mining*, which was meaningless only a few decades ago, now describes an industry unto itself in this "post-privacy" world. The FCC has traditionally protected consumer privacy, preventing phone companies from selling call records, for example, and, in earlier days, prohibiting video stores from releasing information about which movies were

rented by whom. Such oversight is in decline. In 2017, regulations to prevent internet service providers from selling consumer data were rolled back, allowing them to profit from our internet browsing and purchasing histories.

If we don't acquiesce, we can tape over the lenses of smartphones and web cams. Facebook founder Mark Zuckerberg and ex-FBI director James Comey have both admitted to using this quaint security measure, and I do as well. Every morning when I turn on my laptop, I see this little DIY repair, a messy scrap of masking tape that looks like some dumb insignia for the awkward partnership between the digital and material worlds, ridiculously conspicuous in its effort to confer inconspicuousness.

Visibility has gone from being passive to active. In Jennifer Egan's 2001 novel, *Look at Me*, Charlotte, a model struggling to reconstruct her identity after her face has been grossly disfigured by a car accident, explains her choice of profession by saying, "Being observed felt like an action, the central action— the only one worth taking. Anything else I might attempt seemed passive, futile by comparison." I agree. Teaching recently, I assumed an afternoon visit to my classroom by a camera crew documenting campus life would be inhibiting to students. I was sure the two young men with video cameras would make the students feel self-conscious and that classroom discussion would become stilted and awkward. To the contrary, the students were suddenly participating more actively, sitting up a bit straighter, choosing their words more carefully, and citing sources with greater precision. The intensity of their engagement improved under the eye of the camera, and the classroom conversation found new energy. It wasn't so much

about performing for the camera as coming alive before it, engaging and perhaps even conversing with it. Of course, I later thought, these kids were filmed as they emerged from the birth canal, took their first steps, uttered their first words, and stepped onto that first school bus. Of course they find the camera not only a congenial presence but also an affirming one.

But it is distracting. When identity is derived from projecting an image in the public realm, something is lost, some core of identity diluted, some sense of authority or interiority sacrificed. It is time to question the false equivalency between not being seen and hiding. And time to reevaluate the merits of the inconspicuous life, to search out some antidote to continuous exposure, and to reconsider the value of going unseen, undetected, or overlooked in this new world. Might invisibility be regarded not simply as refuge, but as a condition with its own meaning and power? Going unseen may be becoming a sign of decency and self-assurance. The impulse to escape notice is not about complacent isolation or senseless conformity, but about maintaining identity, propriety, autonomy, and voice. It is not about retreating from the digital world but about finding some genuine alternative to a life of perpetual display. It is not about mindless effacement but mindful awareness. Neither disgraceful nor discrediting, such obscurity can be vital to our very sense of being, a way of fitting in with the immediate social, cultural, or environmental landscape. Human endeavor can be something interior, private, and self-contained. We can gain, rather than suffer, from deep reserve.

Invisibility can mean pride and opportunity, offering privilege by allowing some people to smoke weed in public places

or to break speed limits with fear of little more than an ordinary traffic ticket rather than handcuffs and jail time. In a number of ordinary transactions, being ignored can be useful. But unplugging, digital detox, and disconnecting are luxuries available only to certain professional, academic, or corporate elite. A young teacher I know who is trying to move up from visiting lecturer to tenured professor told me in disparaging tones about a group of CEOs heading off on a junket to Morocco with no social media "to enlighten us all on the joys of unplugging. Thanks. Meanwhile if their employees did that, they would be fired. If I stop promoting myself, I don't get work from semester to semester. My entire worth as a teacher is not based on quiet moments in the classroom, but rather on publication or how sexy I am in a press release."

Invisibility for people on the social margins is different. It has become a byword for exclusion, alienation, and subjection for populations sidelined as a result of poverty, ethnicity, and low social status. It allows entire communities to be ignored. "Might as well be invisible," reads a hand-lettered cardboard sign propped up by the knees of a homeless man sitting on a New York City sidewalk. Because of this association with social estrangement and neglect, invisibility has gotten a bad rap. Hiding and being hidden are routinely viewed in relation to disrespect, bias, prejudice, shame, and failure. This is true in some communities. But the presumed invisibility experienced by affluent retired men, women of a certain age, and millennials who don't have as many Twitter followers as they would like is hardly a burden. Invisibility can mean one thing, and then the opposite. It enables and denies. It has become a loaded idea. Is it possible

to go beyond these meanings to find a larger human value in the unseen?

Vanity is the least of it. Exposure is an inevitable by-product of the connectivity so many people today find vital. Websites, digital forums, social networking sites, and message boards give us not only a tremendous validation but also a bond and necessary sense of engagement with the larger world. Oblivious to geographic or political boundaries, online communities nurture loyalties and professional allegiances. These networks enable diverse populations to connect, exchanging ideas, experience, and knowledge. In some cases, the very invisibility of these gatherings is exactly what assures their success. A management adviser I know tells me that individuals in virtual teaming can contribute ideas in ways unfiltered by gender, age, race, and status. "The disembodied communicator can have a greater chance in such circumstances to get heard," he says. "And shy people and those who might otherwise stay in the background often report greater comfort in contributing."

But this comes with constant exposure. A friend's website recently went down. She is the respected author of several books, has written countless articles, connects with her readers on a blog, has been interviewed on national television, and has read from her work and lectured widely across the country. Her ideas have been discussed in mainstream media and otherwise absorbed into public discourse. Her website is what keeps her connected to her readers, 150 or so of whom check in daily, and after a media appearance, closer to 1,500. "It is a vehicle to sell my books," she says. "It is a dynamic and interactive conduit, how I reach the world, and how the world reaches me. It is my

gateway to the world. It is powerful and gigantic. And when it disappeared, it was as if my whole identity had disappeared. No one could find me. I became invisible." Viewing the internet as a gossamer filament to a greater community of readers, she described the crash as a body blow. Then she paused. "Two percent of me felt really OK."

That 2 percent is what interests me. Because this may be the moment to reclaim invisibility's authority, rescue its greater meaning, and reconsider it as a positive condition of human experience. The human species is finding renewed interest in passing unnoticed. As it turns out, a public presence may not be as vital as we think. Maybe it began in 2012, when Snapchat allowed images to be posted online only temporarily. In fashion, some designers now renounce brand names. One emerging fashion entrepreneur was recently described as "never speaking to the news media," and an internet search for him was unable to turn up press photos. He dresses in a form of camouflage: jeans, work boots, an untucked plaid shirt. Legions of new parents are now reluctant to post photographs of their children online. A friend of mine, who recently became a grandmother, takes dozens of digital photographs of her infant granddaughter sleeping, but is reprimanded by her thirtysomething son: "Come on, Mom, just *look* at her!" A new generation of teenagers is wary of publicizing dating experience on social media. And perhaps because constant self-regard is recognized now for its intrusiveness, the selfie stick is banned at venues as varied as the Roman Colosseum, the Palace of Versailles, Mecca, Lollapalooza, the Sydney Opera House, and Disney's Magic Kingdom.

New ideas about discretion are suddenly being ubiquitously marketed and commodified. On an afternoon in Manhattan, in the space of a few blocks, I passed a hair salon called Anonymous and a restaurant called Incognito. Slightly more surreal, Nivea has promoted the notion that invisibility might be applied as a cosmetic enhancement by naming a deodorant that doesn't stain clothes of any color: Invisible for Black and White. Blind is the name of a new chat app that allows employees in tech companies to anonymously discuss salaries, office hierarchies, and corporate policies. And *The Art of Invisibility*, a recently published book offering advice on concealing personal data, includes chapters on encryption algorithms, passphrases, and biometric locks, and on how to create a separate identity, "one that is completely unrelated to you."

A recent virtual reality TV series, *Invisible*, features a prominent New York family whose wealth, stature, and influence on the global economy seem to come from a genetic knack for going unseen. "Every family has a secret," the show's tagline declares. And in an ad for Nationwide insurance that aired during the 2015 Super Bowl, the actress Mindy Kaling riffed on the invisibility of women of color. Strolling through a car wash, doing yoga in the nude in Central Park, and meandering down a supermarket aisle eating a tub of ice cream, Kaling is exhilarated and liberated by going unnoticed.

In the fall of 2015, a black polyester bodysuit was among the more popular Halloween costumes. Conforming exactly to the body of the wearer, rendering that person all but impossible to see at night, the invisibility suit is the costume not of *someone* but *no one*. Instead of being an obscure specter draped in a white

sheet, a child could simply disappear. Not a ghost, but a nobody. I don't know exactly how the child slipping across my porch in her invisibility suit came to choose her costume, but I'd guess it has something to do with her videotaped birth, the monitored nursery, the minutely recorded first steps and words. A friend of mine recently told me how her granddaughter, at the age of two, knew how to pose for the iPhone lens, at what angle to put her leg forward, and how to tilt her tiny face just so.

So what kid, or adult for that matter, wouldn't be drawn to the full-body mask? Who wouldn't want to slip out of sight from time to time? In a world of ever-diminishing privacy, inconspicuousness has a certain cachet, a mystique, a glamour even. Which may be why invisibility shows up in luxury branding. Priced at more than $310,000, the Rolls-Royce Ghost is marketed for its silence, power, restraint, simplicity, and ability to "cosset you from the outside world." The copy on its website taps into that intersection of authority and invisibility, intoning: "The essence of style. The next chapter. I am Ghost." The *idea* of being unseen, of silently traveling as a spectral presence, has become a rarity, commodity, or symbol of prestige—something to be desired.

Invisibility as a source of power is not new. H. G. Wells and Ralph Ellison both wrote novels in which the invisible man reflected disquieting social forces. In Wells's 1897 sci-fi narrative, *The Invisible Man*, Griffin, a student of physics and self-described "experimental investigator" whose research has gone awry, injects himself with a potion that has bleached a cat white and driven it mad. Still, to become invisible, Griffin explains, "would be to transcend magic. And I beheld, unclouded by

doubt, a magnificent vision of all that invisibility might mean to a man,—the mystery, the power, the freedom. Drawbacks I saw none." With such high hopes, Griffin makes himself invisible for personal curiosity and convenience, and shortly thereafter finds himself morally corrupt; he robs his own father. He finds, then, that he is unable to reverse the process. The movie adaptation includes a series of indelible images: the bandage wrapped around his head being slowly unwound to reveal empty space, a white shirt floating around the room, a bicycle riding itself away, a cigarette dangling in midair. Only upon death does Griffin again become visible, suggesting that scientific progress can deprive us of our own identity and humanity.

In 1952, Ellison's unnamed protagonist in *Invisible Man* reflects on the impossibility of the black man to find a place for himself in American society; his invisibility is an amorphous vessel for the assumptions, beliefs, and expectations of white Americans around him. "When they approach me," he says at the outset, "they see only my surroundings, themselves, or figments of their imagination—indeed, everything and anything except me." Though unseen, the protagonist nonetheless must take on false identities, assume temporary aliases, and wear absurd disguises.

But another member in the confederacy of invisibles is Harvey, a six-foot-three anthropomorphic rabbit, the eponymous star of a 1944 play by Mary Chase. She was motivated to write her play by seeing a neighbor, whose only son had died in the war, going to work, day after day, with brute resignation. Drawn from Celtic mythology, the invisible rabbit is a philosopher, imaginary friend, adviser, and ambassador from the

spirit world whose message about valuing kindness over intel-
ligence resonated with a war-weary nation. Its formidable, al-
beit comedic, presence prompts consideration of mental illness,
alcoholism, societal norms, and the power of the human imag-
ination.

One summer when I was in college, I worked in a theater
that produced this play, and I saw it every night for two weeks.
Some forty years later, I realized I was unsure whether the over-
size rabbit had ever actually appeared onstage. I could recall the
huge creature perfectly with his great powder-white paws and
towering ears as he lounged in an armchair by the fireplace
with his legs crossed. I could even hear his soft voice. But, no, I
found out, throughout the play, he had remained unseen and
unheard, present only in the conversation and behavior of the
actors. This mistake speaks not just to the inventions of human
memory but also to the permeable line between the seen and
unseen, and the ways ideas and images take shape in the human
imagination, going from empty space to a material presence.
Equating Harvey with Wells's Griffin or Ellison's unnamed pro-
tagonist is not to diminish the very real and grim social ills the
latter's stories explore. Rather, the benevolent rabbit offers an-
other example of the elusive truth, intelligence, and acumen
the unseen can bring to our lives. Invisible presences can have a
stature and status of their own.

The world we inhabit today seems to be increasingly in-
discernible. I find it hopeful that there are as many ways to con-
ceal as to reveal. Just as the digital age offers us nearly infinite
new forms of transparency, so too does it advance obscurity—
cloaking devices, augmented reality programming, and photo-

reflective textiles that use infrared light to distort what is visible to the human eye.

But even beyond such technologies, the chasm between seeing and knowing is ever widening in the twenty-first century. We recognize that the universe includes abstract and imperceptible dark matter and dark energy, which is expanding it. Dark matter is thought to take up about 27 percent of the known universe, dark energy 68 percent, leaving the visible world with a mere 5 percent. In *The Accidental Universe*, physicist Alan Lightman catalogs the invisible realms: the expanding universe, the spin of the earth, microwaves and radio waves, the dilation of time, and the wavy nature of subatomic particles. But he goes on to suggest that "this knowledge, not to mention the technology that has emerged from it, has created a working familiarity with the invisible." In other words, we know it when we don't see it.

But this familiarity is derived from other enterprises as well. Because of course, *of course*, we all traffic in the unseen, all the time, every day. The extravaganzas of surveillance and social media may lead us to believe otherwise, but what we believe in and the ideas to which we commit ourselves are unseen, as are all our emotional ties and spiritual convictions. Perhaps, too, our interest in invisibility stems from how we hide from ourselves—how our desires, fears, hopes, and motives are concealed so deeply beneath our conscious lives and actions. Just as we have come to understand that the light visible to us is only one small section of the electromagnetic spectrum, we know that immense segments of human knowledge and experience remain unseen. The world around us is an encyclopedia of the

discreet. As David Mitchell writes in *Cloud Atlas*, "Power, time, gravity, love. The forces that really kick ass are all invisible." The ubiquity of the word *invisible* is growing.

In his 2014 book, *Invisibles: Celebrating the Unsung Heroes of the Workplace*, David Zweig itemizes the ways in which people can do good and acquire profound personal satisfaction without the slightest need for personal promotion. Professional success can be a matter of "doing excellent work, [rather than] on seeking attention for themselves," a quaint notion today, but one that probably went without saying a generation or two ago. Zweig found that the three common traits of people in such professions—such as a fact-checker, fragrance designer, structural engineer, and prop master on a TV series—were ambivalence toward recognition, meticulousness, and a savoring of responsibility.

I see those traits in the people I know who choose anonymity: a friend who constructs special effects in film and prefers not to have his name listed in the credits, a woodworker who chooses not to sign his precisely crafted pieces, and a graphic designer who chose her profession exactly for its discretion. "I didn't know what graphic designers looked like," she told me. "No one cared what I looked like. I wanted to be anonymous. It was about the work." As Zweig writes, "It's the Invisibles' pure satisfaction from the work itself, their lack of need for recognition, that is a powerfully grounded trait we all can aspire to. The Invisibles are not an exclusive group; they are simply at the far end of a spectrum we all live within. We are all Invisible to varying degrees, in different ways, and in different contexts."

In architecture and design, invisibility can likewise be an

ordinary virtue. The German industrial designer Dieter Rams suggested that great design does not call attention to itself. Instead, it permits the user to hold the pen, sit in the chair, and walk with ease into the building, oblivious to the idea of design at all. The coffeepot, razor, and keyboard intuitively explain their own use through form. A generation later, Canadian designer Bruce Mau reiterated that good design is invisible—until it fails. In the age of information, design invisibility has evergreater value and meaning. A new generation of architects is coming to understand that great architecture is a matter not simply of form and construction, but of environment, climate, energy, and ecology, and that light, air, energy, and heat are as essential as conventional, material building supplies.

In fall 2016, the unseen even earned its own bit of celebrity when the Museum of Modern Art in New York City hosted an audio exhibition, *Dust Gathering*, that asked viewers to consider not the storied masterpieces of its collection, but the detritus that collects on ledges, windowsills, doorways, blinds, frames, and the art itself. Allergists as well as art handlers and other museum staff not ordinarily heard from were consulted about how dust, brought to the museum by visitors from around the world, in fact arrives from the earth and the greater cosmos. The museum's air filtration system was examined, as was the most difficult-to-clean art. Lest we take an amused or ironic view of such curatorial efforts, we are reminded of the theological component of this inconspicuous material from which we come and to which we will be returned.

But poetry may be the medium best suited to invisibility. It was Wallace Stevens, after all, who pointed out that a poet is

"the priest of the invisible." In her poem "The Art of Disappearing," Naomi Shihab Nye suggests traveling with a sense of lightness. When recognized in the grocery store, she advocates that one "nod briefly and become a cabbage." And she advises: "Walk around feeling like a leaf. / Know you could tumble at any second. / *Then* decide what to do with your time." The invisible leaf is not a transgression. It is not robbing anyone, nor is it trying to get away with anything. It simply exists unnoticed.

Nye's forest has many trees, many leaves. I can tell you what invisibility is not. It is not loneliness, solitude, secrecy, or silence. The nature of the subject makes it difficult to be comprehensive, but my hope is to compile a field guide to invisibility, one to reacquaint us with the possibilities of the unseen world, to reimagine and reengineer our place in it with greater engagement and creative participation. And to find those ways in which remaining out of view can be a resourceful exercise. Inconspicuousness begins as self-protection but soon extends to self-reliance and a deeper appreciation of who we are and where we belong in things.

Invisibility is a protean idea. It can be a diminution of scale or significance. It can be pejorative, referring to subterfuge, dishonesty, psychic emptiness, a vanishing act, an extinction. It can come with an arbitrary and cruel loss, as when the emerging identity and skills of a young child seem to vanish with autism or when the distinctive character of an elderly person seems to disappear with the onset of Alzheimer's. But if you suffer from social anxiety disorder, you may want nothing more than to vanish. It can be a metaphor, a visual trick, a psychological state, a matter of physics, or a question of neuroscience. It can be

corporeal or ethereal. It can be chosen or conferred. It can be power or powerlessness. It can be desired or despised. It can be ambiguous and full of intrigue, or straightforward and even banal. Invisibility is often believed to be about transgression— the ability to do wrong, to get away with something, to cheat, lie, or steal. But it can be the opposite as well.

One can disappear in solitude or in collective effervescence, a phrase that describes the phenomenon when members of a community collaborate intuitively in thought and action. Invisibility can be ephemeral or enduring. It may require following the advice of Pliny the Elder in the first century AD to find a stone of green jasper with flecks of red along with a flowering heliotrope, and then to sing a series of songs. In the index of invisibility compiled by folklore scholar Stith Thompson, its accessories may include a flower, a candle, a stone, a mask, a seed, a bird nest, an herb, a shirt, a sword, a mirror, an animal's heart. Invisibility can be the very real walking stick insect positioning itself as a twig on the wisteria vine on my porch and as weirdly mysterious as Gully Gawk, an unseen Icelandic troll who steals foam from buckets of cow milk.

What follows is neither a lesson in physics nor a primer on new technologies. There are other routes to invisibility, more subtle measures that can help us escape the constant distractions of social media and surveillance. You can tweet less, read the poems of Mark Strand, or learn to scuba dive.

My own field trip through the geography of invisibility began in the natural world, where the human imperative to be seen is shown to be less practical than we think. It is the place where inconspicuousness is power rather than weakness and

where, as the American naturalist John Burroughs wrote in his essay "The Art of Seeing Things," "the birds, the animals, all the wild creatures, for the most part try to elude your observation. The art of the bird is to hide her nest; the art of the game you are in quest of is to make itself invisible." But I continued to a café table in New York City; a physics lab in Rochester, New York; a virtual reality studio in Brooklyn. My tour went from Grand Central at rush hour to a coral reef off Grand Cayman island to a fissure of rock in a harbor town in Iceland.

I learned that it was possible for our empathy to grow when the self disappears. Beneath the sea, invisibility is a matter of immersion and a reassessment of physical weight and presence. But on dry land in Iceland, it is an act of the imagination; there, the belief in an unseen population that is part of the country's history and geography has relevance to our own partnerships with digital personas.

There are likely many, many more sites—I just didn't *see* them. But all of them suggested that people can go unseen in all the different realms of human experience. All of them offer ways to reposition ourselves, to rethink our place, to step back from the theater of exposure, to find the powerful interiority that can be gained when we remain out of view.

At times it seemed possible that my expedition into invisibility had two parts. The invisible world contains all those things, people, and actions that are not apparent to us. But our own capacities for going unseen may be a different matter altogether. I increasingly began to see that the borders between these realms of experience are inexact, converging easily and often. The unseen world is all around us. It also *is* us.

When Christopher Lasch expressed nostalgia for obscurity forty years ago, he echoed the philosopher and statesman Edmund Burke, who, in his 1757 essay, "A Philosophical Enquiry into the Origin of Our Ideas of the Sublime and Beautiful," advocated for what he called "judicious obscurity." It is the unknown and the unseen, Burke suggested, that appeal to the imagination, and he concluded that poetry, "with all its obscurity, has a more general as well as a more powerful dominion over the passions than the other art. And I think there are reasons in nature why the obscure idea, when properly conveyed, should be more affecting than the clear." Or in the more enigmatic phrasing of Aldous Huxley, "I'm afraid of losing my obscurity. Genuineness only thrives in the dark. Like celery."

This view, I suspect, is more relevant and necessary than ever, not because we should be more modest, reserved, discreet, or quiet—though all of these would probably do us good—but because the earth is warming. There will be nine billion of us soon. We will have no choice but to reassess our place in things. And part of that may have to do with how we reevaluate our identity, how we imagine some reduction in scale, and how we consider a different way of being in this world. We are, each one of us, less important than we think.

When the ceramic artist Eva Zeisel was asked how to make something beautiful, she famously replied, "You just have to get out of the way."

THE INVISIBLE FRIEND

*Invisibility comes in different degrees
to different people.*

—MARINA WARNER

When my son Lucian was two years old, he threw his grandmother's gold earrings out the window. He had been told to take a nap and reluctant to do so, he took action. Appropriate reprimands were made, but as many parents might have been, I was curious. Was this some little experiment in gravity? Were they treasures that he hoped to retrieve later and keep for himself? Or did he fling them out the window because he hated them? Did I have a thief on my hands? The gesture was decisive, but what was his plan? He remembers none of this, of course. If a plan had been in place, it has long since vanished.

I have since come to learn that such gestures are not unusual for small children. He was discovering the marvelous truth that he was *himself* able to be the agent of disappearance. *Object permanence* is the name child psychologists give to the revelation, which infants have at five or six months, that objects and people can continue to exist even though they may not be seen. It is a milestone of childhood development and assures the baby that

the mother—or nipple, bottle, or rattle—will return even though she may be out of sight. It is when babies begin to grasp the thrilling fact that when something is absent, it is not necessarily gone. It is where notions of privacy begin to germinate, and it is why the game of peekaboo causes such colossal delight in the tiniest people: I can't see you, but I know you are still there. I can't see you, but you can see me. A paradox that often causes hilarity, object permanence may be how our relationship with the unseen world begins.

But this is just the start of the way children experience invisibility through play.

Throughout childhood, appearance and disappearance, coming and going, acts of concealing and revealing are the shared objectives in countless games. When my own children were toddlers, there was nothing more exhilarating to them than burying themselves under a quilt, a blanket, or a coat, concealing themselves entirely, then jostling slightly, giggling, or squealing, giving hints they were there. They would be quiet and wait. Moments later, more laughter or slight movement. In such a way, they found they could influence and control the process of discovery. And that a sense of power and authority could come with being unseen.

As they grew older, more structured games of hide-and-seek offered them the opportunity to safely explore the power of being lost and the ensuing thrill of discovery; they were perfect little specimens from the cabinet of psychoanalyst D. W. Winnicott, who once observed, "It is a joy to be hidden but disaster not to be found." But if peekaboo is about

cognitive development, hide-and-seek is about emotional growth. The first is a thought process, says David Anderegg, a psychotherapist who works extensively with kids. It is a manner of problem solving, while the second has to do with emotional awareness and understanding how to manage one's own feelings. "In hide-and-seek, the fun is in finding the sense of power when one is hidden and the conviction that you live in the mind of the other," he says. "You are being desired. And you are being searched for. And then being found is confirmation." He points out the anguish a child can feel when the game is called off without her knowledge, when she is still hiding, waiting behind the tree or under the stairs, only to finally realize no one is searching for her. It is probably not much of a stretch to think that exercises in the seen and the unseen can serve as an early tutorial on autonomy.

Small wonder, then, that children's literature is full of accessories that grant invisibility—capes, caps, rings, shields, potions. Childhood narratives speak constantly to the power that children imagine comes with going unseen as they learn to become citizens of the larger world. The power of invisibility is illuminating, protective, advantageous, and serves as a route to knowledge. The invisibility cloak in the Grimm brothers' tale "The Twelve Dancing Princesses" allows a traveling soldier to accompany the girls to a silver lake and golden forest, where he is able to solve the mystery of where they dance and with whom. Harry Potter's seven-centuries-old Invisibility Cloak, immune to charms and hexes, allows him to survive all manner of challenges unscathed. In the *Calvin and Hobbes* comic strip, Calvin

really believes—as does his mother—that he can disappear when he is asked to be helpful. He takes an elixir and tests his invisibility by stealing cookies.

Hans Christian Andersen's 1845 story "The Bell" is a more epic account that involves the search for the source of a distant and mysterious ringing that villagers hear for a few moments at sundown. They explore the forest for the sound's origins, but some become discouraged and deterred, while others attribute the chiming to imagined causes, possibly an owl in a hollow tree. A prince and a poor boy come upon the source of the celestial ringing after traveling through thickets of blackberry brambles, meadows of wood lilies and sky-blue tulips, woods of oak and beech trees, giant boulders, and forests of moss and finally reaching the sea. Their discovery of the invisible bell in a liminal space between night and day, pealing in the cathedral of nature between forest, ocean, and sky, suggests that the innocence, innate trust, and open curiosity of children make them able travelers to the spirit world.

Children experience invisibility spatially as well. *The Secret Garden* by Frances Hodgson Burnett is the classic English children's story about a frail, unwanted child who discovers friendship—and how to love and be loved—in a secret walled rose garden situated on the chilly moors of Yorkshire. Just as Lewis Carroll's Alice tumbles down the rabbit hole, and Kay Thompson's Eloise navigates the Plaza Hotel through a series of passageways and corridors known only to her, the empire of childhood is often explored through its hidden avenues: the rooms, the garden, the tree, the tree house, the thicket, the closet, the nook in the attic, the space beneath the stairs, the raft

on the river, or inside a piece of furniture, such as C. S. Lewis's giant wardrobe that is the doorway to the forests of Narnia with all their fantastic and mythical creatures. These are unknown, unseen places into which one can disappear—for solitude, escape, or dreaming, or as a passage to some elusive knowledge of the human and spirit worlds. They are places that allow the child's imagination to flourish. "Where, after all, do human universal rights begin?" asked Eleanor Roosevelt in an address to the United Nations in 1958. "In small places, close to home—so close and so small that they cannot be seen on any maps of the world."

On the need for children to hide and to seek, New York psychologist Alison Carper writes that "we all need to hide sometimes. We need to go into the private space of our mind and take measure of our thoughts. We need to enter this space so we can reflect." Once we do that, she says, we long for discovery, to be found by someone who wants to find us. If we remain unknown to the people important to us, hiding goes from being a game to a way of life. She suggests, too, that our capacity for intimate relationships can depend on having this deep core of private awareness; and that acknowledging our unknown and unseen selves, and offering these up only when and if we choose, is essential to our ability to engage in close relationships. Valuing interior experience is vital to developing a sense of self, and how we reveal ourselves to the outside world has everything to do with how we stay out of view when we need to.

Learning to manage disappearance is intrinsic to childhood play, as Freud observed in his eighteen-month-old grandson's

improvisational fort/da game. The child would throw a wooden spool attached to a piece of string over the side of his curtained bed and then retrieve the spool by reeling it in with the string. "Fort," the boy would say, German for "gone away," when the object was no longer in sight. Once the object was back in his sight and possession, the child would exclaim, "Da," meaning "There it is!" The boy would repeat this action and the words again and again, the toy coming and going, in and out of sight.

For Freud, the game signified the child's effort to manage his mother's absences, but it seems to me that children are fascinated by the way nearly *everything* comes and goes. They are inevitably intrigued by learning how things can appear and disappear in the material world. Discovering that the chemistry of lemon juice, baking soda, and other ordinary kitchen ingredients makes for invisible ink is an introduction to the ephemerality of words. And what would Freud have said about the hologram maker on my own kids' shelf? Marketed as an "instant illusion maker," the device consists of a chamber with two parabolic mirrors facing each other. When one puts something inside the bowl—a ring, a coin, a little plastic baby, a frog figurine—it reappears on the surface in 3-D, seeming to be solid until one's hand passes through it. Nothing more than a cheesy toy, it still serves as a daily lesson that things can be there and not at the same time.

Grasping the idea that words, places, and objects can all exist in an unseen world is one of the major discoveries of childhood, and I am certain such games are central to how consciousness develops. Visiting the walled garden, playing with the illusion maker, and writing with invisible ink—all of these

convey something about the beauty and magic of the passage between the seen and unseen realms. But it is with imaginary companions that children may make that transit most fully.

Once frowned upon by Freud and the Swiss psychologist Jean Piaget as instruments of dysfunction and social maladjustment, invisible friends are today recognized as more treasured consorts. Arriving in the shape of humans, animals, fish, clouds, trees, or some other fantasy form altogether, they can teach empathy, invention, compassion, and comfort. Alison Carper suggests that one function of the invisible friend is to serve "as an imaginary witness to our internal experience. Perhaps for some this marks a halfway point between knowing ourselves only through our mother's gaze and knowing ourselves by simply being able to reflect. We imagine our imaginary friends knowing us." Carper suggests that those needs evolve over time, and that the imaginary friend can become "a vital supporting actor in a dress rehearsal" for future intimate relationships. As eccentric escorts to our interior lives, such unseen partners can help test ideas of friendship. They can be confidantes for secrets, subjects of devotion, wells of knowledge, beings with whom one's imagination travels, a means of tempering solitude and loneliness, or some other solace to which we can hardly put a name.

The closest I came to having invisible friends was as a six-year-old Episcopal child attending a Catholic school. I wasn't confirmed, didn't go to Mass or take the Communion wafer, and was sometimes left alone in the classroom when the other students were engaged in formal catechism. Of no matter. I had acquired just enough knowledge of the saints to be fascinated.

They might be wearing gauzy blue veils and holding bouquets of lilies, but they were capable of organizing armies, marching through fires, facing down ferocious bishops, and having euphoric visions. Saint Margaret of Antioch slayed a dragon and withstood efforts to be incinerated and drowned, and Saint Christina handled fire and could levitate. Even those with greater reserve like Saint Gertrude, the patron saint of cats, who lived quietly in the forest, had deep appeal. I'm sure they offered lessons about courage, kindness, forgiveness, and faith, but it was the sensational bravado of their lives and their appreciation for colossal risk that captivated me most. But as a non-Catholic, I understood that such devotional attachments were not available to me and that these were forbidden friends. Which, of course, made them all the more irresistible. Their imprint remained, as did the attraction to illicit alliances. My high school friend who convinced me to skip school with her and a boyfriend who dealt drugs were not exactly saints of the Catholic Church, but the intrigue, the righteous thrill, the sense of danger they offered were just the same. I would have done anything for them too.

Tracy Gleason, a psychology professor at Wellesley College, suggests that invisible friends help children "to address social concerns and to understand others' perspectives. Imaginary companions are associated with the benefits of real relationships, such as emotional support, validation, and affection." They can offer solace, happiness, empathy, and compassion; likewise, they can help children manage "disappointment, sadness, and anger." And we invent such friends to listen, instruct, and protect in whatever ways seem to make sense at the time.

When she was five, my friend Katherine had a companion, Keiko, a five-year-old cowboy who wore blue jeans and a dark felt cowboy hat whipstitched around the brim. "I don't remember that he was ever in the house with me," she says, "but outside he was with me everywhere—on the swing, building forts in the bushes, climbing the scrub cherry trees. I thought he was the child version of dashing, freckles and all. And I had a huge crush on him. We never talked about it, but I think he knew. It was right before I became a real tomboy." Years later, she says, she was driving and passed a truck with the name Keeko. "It was spelled differently, but seeing his name as I was sitting in that car all those years later, it all came back to me with sudden intensity, the great closeness we had and his importance in my life."

Another childhood friend of mine had two imaginary friends who drove to her house in a pink Cadillac convertible to visit her at night. When they arrived, they all told jokes to one another. And then my friend fell asleep. To this day, she is unable to say what these guests in the pink car represented other than some vague intersection of humor and comfort, but she laughs when she thinks of them, and remembers them fondly. Another woman I know told me of Cookie and Jim, both stick figures, but Cookie had the face of a chocolate chip cookie. "They joined me when I played by myself indoors," she says. "We would have conversations. I would hold them by the hand, and they would follow my instructions. Finally, they just faded away."

Young children often use invisible accomplices to explore relationships with other people, learning that a sense of self is sometimes acquired through a sense of others and that

friendship can take multiple forms, hierarchical and not. When my friend Alena was young, she had an imaginary friend called Marisa, who was older and more sophisticated than she was. She also had an imaginary brother named Guard, who watched over her. "They were just ideas about people," Alena says now. "I wanted an invisible friend, but I never totally believed in them. Someone just introduced me to the idea. They were the most real at night before I went to sleep. I think it was a type of storytelling. I was experimenting with the possibilities of fantasy relationships."

As Gleason says, it can be someone who has the same power and competence as the child. It may be an ideal friend, someone who is the same as you, a mirror self. Or it could also be someone annoying, who is unavailable, who doesn't do what you want to do. What does it feel like to be rejected? How do you manage that? she asks. These are ways to practice other people's perspectives. It is a big cognitive leap that children make. Understanding that other people's thoughts and feelings are different from yours helps to clarify your own beliefs.

Our invisible friends are not necessarily supportive, kind, and generous. Like our friends in life, they can be unreliable, annoying, and disloyal. In his poem "Invisible," James Tate encounters a strange man on the steps of the post office. The man drives away in a yellow car. They meet by chance again at the dump, on the street corner, at a Christmas party. They exchange words, books, directions. They recognize each other and don't. They are awkward with one another. They conjecture on which man is invisible. "I didn't like him anyway," Tate concludes at the end of the poem.

Awkward or not, imaginary friendships can extend to celebrated, out-of-reach personas. When my sons were young, their friend Sam took Michael Jordan, the venerated Chicago Bulls basketball player, on a summer vacation trip. "Come on, Michael, let's go," he would say before they left the motel room. Or during dinner at the picnic table in the campground: "Did you have enough to eat, Michael?" Now, years later, Sam tells me that his memories of that trip "are a little fuzzy" but he does remember that he "used to play Jordan, one-on-one, using rocks and a garbage can, and he was always there." It turns out there is a name for this, *parasocial relationships*, those affiliations we develop with admired characters, media figures, and celebrities who are wholly unaware of us. They are people with whom we have an affinity, possibly even worship, and relationships with them may be a way for a child to navigate a route away from his family. You may not want to turn to a peer, Gleason says, because you know your peers don't always have it together. But you are trying to find a way away from your parents, so you have this idea of a person, a kind of safety net.

It is impossible today to consider the universe of invisible friends without considering our digital relationships. My friend Anne meditates and sometimes uses an app that connects her with a global congregation, some 1.8 million people in 210 countries. It is an experience of community, she says, that allows her to practice in congruence with sometimes up to 8,000 others. Although she is alone in silence, she tells me, she is also vibrating with connection, and the unseen assembly deepens the experience.

I do not meditate, but from time to time, I visit the website

and find I enjoy inhabiting the outermost margin of its gathering. The community link documents the number of people meditating at that moment. The continents appear in pale gray, with the placement of those in practice marked by pale brown dots. The composition of those dots changes constantly in real time. I know that contemporary digital graphics allow us to map almost anything, and this atlas of contemplation appears on my monitor as a mesmerizing geography. Perhaps it is possible to look at the entire digital world as a vast bazaar of unseen colleagues. I have heard of fitness apps for running, lifting weights, and cross-training with partners who may be on the other side of the country, and GPS tracking for real-time swim meets with people in pools in different countries. Maybe to measure your breath, your steps, and your strokes in unison with an unseen partner is to have an invisible friend today. I am tempted to think that when Olympian Michael Phelps raced a great white shark swimming alongside him in computer-generated imagery technology for the Discovery Channel in the summer of 2017, it was yet another example of how the digital world has enhanced these imaginary alliances.

But it is not as simple as all that. Scientifically constructed companions, whether real people on the other side of the world or entirely fabricated, may engage our imaginations, but they do not emerge from them. Apple's Siri, Amazon's Alexa, and Microsoft's Cortana are virtual assistants that can recognize our voices, make dates, organize our calendars, and play games, but they are not shaped by our own curiosities, anxieties, and desires. They are designed. Hatsune Miku is a sixteen-year-old Japanese pop idol with teal pigtails and hundreds of thousands

of fans who attend her concerts—despite the fact that she is a hologram. Xiaoice is the name of a Chinese chatbot, a text messaging program created by Microsoft with the voice of a seventeen-year-old girl. Millions of Chinese confide in her each day, detailing the events of their lives and their feelings about them. Her storage capacities enable her to remember each caller's emotional history, though due to privacy concerns, such histories are deleted over time. Clearly, the chatbot and the hologram arouse a genuine emotional response in their followers, but they have little else in common with Cookie, Keiko, Marisa, or with Michael Jordan tossing rocks into a garbage can at the campground. The fundamental difference between imaginary friends and technologically based partnerships is agency. The latter come from outside; the conversation is initiated by someone else.

Such agency is not the only difference. There is also the question of choice. The perpetual exposure of online partnerships facilitated by iPhone cameras, Instagram, and other social media outlets can be inhibiting, and Anderegg points out that there can be a quality of joylessness in contemporary teenage exchange. Contrary to the popular assumption that being unseen is negative, the constant need to shape identity for public consumption diminishes us. Socially awkward moments are invariably documented and posted on social media, and internet shaming is familiar to most teenagers. Whether it's a photo posted of the kid with his mouth full, with his clothing awry, or in some other compromised or embarrassing pose, being seen and being humiliated are often linked. "There is a joy in being uninhibited, but not if your picture is going to be posted

on a social media site," Anderegg says, concluding that "it is almost impossible to have a non-self-conscious experience. You can't let yourself off the leash. We all wish to be seen, but it is perilous."

The phenomenon of Facebook depression, one result of this ceaseless exposure, refers to the anxiety induced by social comparisons and the feeling of being less attractive or accomplished than other users. But it also alludes to the more general disquiet that comes with relinquishing—unreservedly and unconditionally—the personal information that is key to retaining a sense of identity. When private experience is indiscriminately offered for public consumption, ideas of interior self are easily devalued.

Even more reason, then, to acknowledge the full emotional depth and range of those friendships we invent, shape, and manage ourselves. And to recognize that friendship is an act of the imagination rather than of counting social media followers. Children use imaginary allies to work out social puzzles, and the make-believe conversations help them with cognitive leaps. Such alliances are not simply a way of knowing ourselves, but a way of discovering how we become attached to others. In a world of social networking, digital tracking, and ubiquitous surveillance, our invisible associates offer us both rich and ambiguous solitude. They serve as our witnesses, confidantes, and chaperones, and they can return to us in more profound ways throughout our lives. A friend of mine who works with elderly patients told me of a woman she had helped to care for at the end of her life. The woman spoke of family members and friends, already passed, who had gathered now in her room.

"But they are not really here, Mom," her daughter had said, and her mother replied, "They are just not here to see you."

As Gleason points out, there is not always a hard line between fantasy and reality. "They are not necessarily opposites," she says. "Whether something is real or not can be irrelevant." Even as adults, she says, we find ourselves playing out conversations with our partners. We can have simulated discussions with real people and imagine things they might say. We talk things over in our minds with people who are not in the room. We can be deeply affected by fiction we've read. Something that is not real can have a real impact and foster a real emotional reaction.

We all use these acquaintances to navigate important passages: the infant's mother leaves the room, a child becomes a teenager, a woman argues with her husband, a man confronts a difficult diagnosis. In all these volatile circumstances, the exchange with an unseen partner, the sometimes even intimate dialogue with someone *who is not there*, can be an inventive exercise, a way to comprehend and negotiate some unanticipated turn of events. All of us, Gleason says, can recognize the human imagination as a "forum for practicing our social skills or safely experiencing powerful emotions." Whether something is real or not is irrelevant. My mother-in-law grew up in Ireland and remembers as though it were yesterday the morning she was playing with her cousin near the hedgerow and a small, shining carriage pulled by little horses drew up alongside them. A coachman with golden curls jumped out. He smiled at the children, tipped his hat, and was gone. The children were frightened, and her cousin's hair was white after that morning.

My mother-in-law is in her midnineties now and lives in an assisted living facility in Raleigh, North Carolina. She no longer remembers the afternoon in which her small grandson tossed the gold earrings out the window. But sometimes she finds her own grandmother from Belfast sitting in the armchair across from her.

My husband likes to think it is his mother's Celtic heritage and its tradition of belief in the spirit world that has made her so receptive to these unseen alliances. That may be so. But I would like to believe that we can all have what one scholar of our invisible compatriots calls the "unique capacity to love, share our lives, and even bare our souls to imaginary others." Those *others* can be reinvented versions of people we know well, drawn from characters we encounter in books, or created solely to correspond to some whim, desire, or need. They may be particular to time or to place. They may offer us a single directive or consult with us regularly, and their inclusive parliament is wide-ranging enough to accommodate Saint Gertrude, Michael Jordan, a stick figure with a cookie head, and an old woman from Belfast.

TWO

ORLANDO'S RING

A voice, a perfume or something microscopic
may be present and yet invisible, not because of its
whereabouts but because of its nature.

—JOHN BERGER

It is almost impossible to emerge from childhood without some appreciation for invisibility, without some knowledge of its power. What is surprising, then, is how as adults we so easily associate it with wrongdoing, degeneracy, malice, even the work of the devil. Published in 1693, Cotton Mather's *The Wonders of the Invisible World* was a pious consideration of the Salem witch trials in which the Puritan minister catalogs those ways in which the possessed have been "infected and infested with demons." Mather describes the disturbances of Salem as a situation "snarled with unintelligible circumstances," of unseen presences and spirits. But for all the invisibility of Satan's efforts, Mather nonetheless reports with graphic precision on the work of one of the possessed women: the twisted necks of her victims, the sores and swelling in one neighbor, the paralysis of another, the bewitched herd of cattle.

More than three centuries later, we routinely accept the

association between invisibility and malevolence. The gold ring in J. R. R. Tolkien's *The Hobbit* and *The Lord of the Rings* begins as an accessory to an empowering invisibility, though its corrupting influences are revealed as the story progresses. The ring can extend the life of its wearer, both limiting the wearer's vision and allowing him to see a shadow world. As the inherent evil of the ring becomes apparent, the reader understands it as a darker force, which must be destroyed for Middle-earth to be saved.

The Gyges effect, a term for anonymous online bullying and aggression, is taken from Plato's myth of Gyges, the story of a shepherd who discovers a ring that confers invisibility. Once placed on his finger, the ring enables him to enter the kingdom, seduce the queen, kill the king, and ultimately secure the empire for himself, and it serves as an example of how going unseen allows—indeed, encourages—an otherwise ordinary and honorable person to commit transgressions and behave unjustly. It suggests that opportunistic invisibility emboldens amoral behavior, and indeed, the entire digital world is full of examples in which dishonesty and indiscretion are enabled by invisibility. The Ashley Madison Agency, hacked in 2015, is an online service for presumed committed partners to arrange affairs. "Photo vault" apps allow high school students, or anyone else for that matter, to hide sexually explicit photographs or illegal material on their phones. And designed to bypass the surveillance of cyberspace, the darknet is a macabre digital underworld that allows users to encrypt their identities in order to hire assassins or purchase drugs, weapons, or child pornography unavailable in conventional consumer venues.

The subtitle of Philip Ball's comprehensive encyclopedia,

Invisible: The Dangerous Allure of the Unseen, refers to the perils of going unseen. In the opening paragraphs he writes, "If you could be invisible, what would *you* do? The chances are that it will have something to do with power, wealth or sex. Perhaps all three, given the opportunity." Ball suggests that rather than feel guilty, we need simply to recognize that, human nature being what it is, our expeditions into invisibility naturally invite such episodes of degeneracy. Likewise, in a segment titled "Invisible Man vs. Hawkman" on Ira Glass's weekly radio show, *This American Life*, writer and humorist John Hodgman asks the age-old question: Would you rather be able to fly or be invisible? He finds that those who choose invisibility imagine sneaking into movie theaters and onto planes. Women steal cashmere sweaters, while men watch women taking showers. "Here's one thing that pretty much no one ever says—I would use my power to fight crime. No one seems to care about crime," says Hodgman, concluding that invisibility in the adult world is largely viewed as a means for wrongdoing.

But it is not just about transgression; paranoia also figures in contemporary ideas about invisibility. In 1977, an Austrian artist who goes by the name Valie Export made the film *Invisible Adversaries*, which is about a woman who believes that those around her have become inhabited by unseen space aliens. In her 2013 film, *How Not to Be Seen: A Fucking Didactic Educational .MOV File*, the Berlin-based artist and filmmaker Hito Steyerl offers five lessons in going unseen. Satirizing the tone of an instructional video, the voice-over assures us that love, war, and capital are all invisible. In Lesson One, "How to Make Something Invisible for a Camera," one can hide, be removed,

go offscreen, or disappear. In Lesson Two, "How to Be Invisible in Plain Sight," one can feign absence, hide in plain sight, or be shrunken or erased. Lesson Four offers a grab bag of invisible personas—a resident of a gated community or a military zone; anyone in an airport, factory, or museum; someone wearing an invisible cloak or surfing the dark web; a woman over fifty; a dead pixel; or someone who has been disappeared by a totalitarian regime. Used as the backdrop for much of the video are old dilapidated calibration targets, their geometric patterns drawn on the California desert floor as training targets for unmanned aircraft, which is to say, an early practice exercise for drones. The message is that in an age of perpetual surveillance, invisibility resonates with alienation, and though it may be of occasional service, it generally implies estrangement and disaffection.

But it is time to question this orthodoxy. Transgression, paranoia, and social disparagement are the most obvious and least interesting things about invisibility. *Jardin secret* is a French term that refers not to a horticultural plot but to a kind of psychic cloister, anything from a small personal ritual to a state of mind, some private thing, idea, or activity that people keep to and for themselves. It might be a particular view through a window; a haven or retreat; an early morning walk; a spot on the river near a bridge; a table in the café; a piece of music; or a private collection of feathers, stones, books, or fans. The idea of privacy is intrinsic to the jardin secret. Possession, ownership, and intimacy may all come into it, and it may be erotic, but not necessarily. Implicit in the jardin secret is that small personal histories need not always be shared; that human experience and

imagination are sometimes a matter of private intentions, actions, or rewards; and that social exchange and shared experience may also depend on having this deep well of privacy.

The imprecise parameters of the jardin secret reflect the inherent opacity in the very idea of invisibility. Perhaps our adult suspicion of the unseen condition has to do with this vagueness, untroubling to children but disquieting to adults who prefer to have things more clearly defined. But the idea of invisibility *is* nebulous. It can live clearly in the imagination or be entirely unknown. And if it allows for transgressions of all sorts, it can also be about pleasure, knowledge, the growth of the psyche, discovery, privacy, discretion, silence, autonomy, keeping one's own council, being quiet in a raucous world, and being still in a world that is moving too quickly. In Greek mythology, the cap of Perseus conferred invisibility as a mist or cloud, and Athena, goddess of wisdom, wore this helmet of ambiguity regularly.

The work of South African artist William Kentridge offers a nuanced view of invisibility's meanings. Kentridge is well-known for his convergence of fine art and animated films, and in his work, sheets of paper, shadows, and human figures materialize and dematerialize suddenly and of their own volition. In his short film *Invisible Mending*, the artist is seen using a brush and an eraser to correct a charcoal portrait of himself. The figure in the finished portrait then walks off the sheet of paper, and the artist reappears and pieces together the portrait once again with fragments of it that float to him from a source off-screen. Then, again, he begins to mend the image. Artist and subject become each other in perpetuity, doing and undoing one another in a continuous cycle of construction and

deconstruction. The film, part of a series titled 7 *Fragments for Georges Méliès*, was made in homage to the French magician, illusionist, and filmmaker; a master of special effects, Méliès often created ghostly characters infused with a comedic sensibility.

If Kentridge explores the evanescence of human identity here, elsewhere he addresses the tenuous qualities underlying social, political, and geographic identity, and his work often references the seams of gold that run beneath the city of Johannesburg that have determined its history. These unseen veins, the mines tunneling underground, the water pumped into those mines, the sudden sinkholes and the unstable character of the excavated earth are the city's invisible landscape and serve as metaphors for the country's political volatility.

In his final work, *The Reveries of the Solitary Walker*, Jean-Jacques Rousseau, the eighteenth-century French philosopher and essayist, offers an alternative use of the ring of Gyges. Written at the end of his life, these are contemplations that consider the human soul's capacities for good and evil. During his sixth walk, Rousseau reflects on how men can serve one another fairly and makes an all but rhapsodic argument for obscurity. He suggests that anonymity can confer moral power and that invisibility might be a partner in our efforts toward social justice: "If I had remained free, obscure, and isolated as I was made to be, I would have done only good; for I do not have the seed of any harmful passion in my heart. If I had been invisible and all powerful like God, I would have been beneficent and good like him." Rousseau speculates blissfully, if not entirely convincingly, on the occasional miracle he could not but help perform

"in moments of lightheartedness" and then contemplates the "thousand merciful and equitable" acts of justice he would enact had he worn the ring, certain that on his own hand it would be an accessory for human concord. Eventually, Rousseau comes to believe—albeit reluctantly—that any human being whose skills and abilities elevate him above ordinary people is corrupted. While he concludes that the ring should be thrown away, his suggestion stands that obscurity can serve kindness as easily as it does evil.

In his sixteenth-century Italian Renaissance poem, *Orlando Furioso*, Ludovico Ariosto views with less inhibition the creative powers of the magic ring, in this case one "stolen in India from a queen." Throughout the saga, Orlando is driven mad by his love for the princess Angelica, and the early lines of the epic work tell us of "the assistance of the magic ring, which often to its bearer has borne fruit" and its "medicine against enchantment and all evil spells." Indeed. Worn on the hand or carried in the mouth, the ring allows its bearer to remain unseen. It is given as a gift, a token, a bribe; it is stolen, it is lost, its whereabouts both known and unknown to different characters throughout the saga. The story is extravagant, wild, raucous, and surreally situated on earth and the moon alike, veering from the transcendent to the grotesque and back again. The ring offers a carnival of amorous uses, meanings, subterfuges, and guises. Its owners escape capture and imprisonment. It contains the power to separate lovers as well as to unite them; it offers protection and promises danger. It is what permits the lovers to be in and out of one another's sight.

The power of the ring is not limited to transgression, nor is

it simply a means of liberation. Rather, it is a source of unfettered creativity, unrestrained thinking, and ingenious action, and suggests that being in or out of sight can justify all manner of romantic madness. Which prompts the question: Is it time to swap out Gyges's ring for Orlando's? Has the culture of social media and our pervasive fixation on exposure brought us to the moment when the ring of invisibility might be seen as an accessory for inventive thought and action?

Although we are introduced to the concept of object permanence—or word permanence or friend permanence or relationship permanence—as children, its enigmas linger with us throughout life. How things are lost and found is an ongoing cycle. That's what so much therapy is all about. Though not equipped with a wooden spool or piece of string, I have often found myself thinking in amazement, "There it is!" when something or someone has entered my life—whether it is a friend, a job, a book, an idea, a conversation, a meal, a ticket, a chance, a sense of the past, an idea of the future, a cloud, a rainstorm, a tomato, an egg. Then, just as often, the astonished exclamation, "Gone away!"

The little boy who tossed the gold earrings out the window is now a film editor in New York City. Perfect! He spends his days adding and deleting images of people, trees, animals, houses, furniture, wallpaper, windows, faces, light, all of it. Film editing is often referred to in the industry as the invisible art because the viewer is unable to determine how the visual imagery has been shaped. Good editing remains unseen; what has been cut remains out of sight. "When you are watching a film," my son says, "you don't see the editing the way you see the characters,

say, or the lighting. You are not supposed to see it. The editor removes the barrier between the viewer and the material to provide an immersive experience." I think of him as being a specialist in object permanence. But then again, I would suspect that anyone who has ever loved anyone else has given the subject serious thought.

Happiness depends on many things, but how things come and go plays an enormous part. Being seen, recognized, and acknowledged is essential to human experience; social visibility is vital to our happiness, and when it diminishes, we suffer. We all want to be recognized. The gaze is vital to human connection. It makes sense that the words one uses in a romantic relationship are "We are seeing each other." Or when we say good-bye, "See you," meaning you are seen and will be seen again. These are givens—we live to see and be seen.

Yet I am certain that the imperative to go unseen can be just as critical. An operating room technician told me that the screen between the patient's face and the part of the body being operated on, installed for reasons of sterility and cleanliness, is also a psychological measure. Surgeons and nurses would be unable to perform the operation—to cut through human flesh, bone, and organ—were the patient's face in view. In the Catholic confessional booth, the screen that separates penitent and priest is vital to admission of fault and forgiveness. In traditional psychoanalysis, the analyst is situated behind the patient, out of view, making it easier for the patient to wander the unconscious mind. We are more likely to give up our secrets when we are out of sight.

But you don't need to be an analyst to know that eye

contact can be overrated. There are countless occasions in ordinary life when the need to visually disconnect is essential. It's why so many families do crossword puzzles together; they can talk to each other while staring at something else. A friend of mine who teaches ceramics is constantly amazed at what her students will reveal about themselves, their private lives, marriages, divorces, failures, and feats when they are throwing pots, hand building vases, or glazing platters, when they are materially engaged, hands occupied, eyes fixed on their work. I also know that the seats in a car can be as effective as the therapeutic couch. When a friend of mine well into her tenth decade began to lose her facility with speech, I would take her on long drives in the country. The maple leaves were radiant that fall, and she was happiest looking out the car window. And when we did speak, she found it easier to try to structure her thoughts and fasten them to words when my eyes were not on her. How many times when my sons were teenagers was it more rewarding to have the private conversation in the car, when I was driving, looking at the road ahead, rather than being face-to-face over the kitchen table. I didn't need to see their faces. I needed to hear the words. And it was easier for them to talk to me about the girl or the hash pipe or the speeding ticket without being *seen*.

But invisibility is not just a psychological state, literary device, or metaphor. In physics, invisibility can be real. John C. Howell, a professor of physics at the University of Rochester, devised in 2014 the Rochester Cloak, a low-tech system of ordinary optical lenses that work in three dimensions to render invisible whatever is behind them. The continuous, multi-

directional cloaking system allows light to pass around the object without distortion; by bending light around the object, the four lenses obscure it without disturbing the background.

The emerging science of transformation optics is the study of bending electromagnetic waves around an object. This uses metamaterials—engineered materials that are neither found in nor derived from nature—to curve, bend, and otherwise reroute light around physical objects, much the way water in a brook may detour around a stone and emerge as a single stream on the other side. The atomic composition of metamaterials allows for such behavior in theory, but long-promised applications, such as quantum stealth materials for military use, have proved elusive. It is possible to redirect microwaves of a single wavelength around an object, thereby rendering it invisible, but it is not yet possible to do this on a large scale. Visible light waves are short—shorter than radio waves or electromagnetic waves—and do not have sufficient length to obscure a body, a car, a building, or a jet.

David R. Smith, a professor of electrical and computer engineering at Duke University who has pioneered this field, explains that every technology has its strengths and weaknesses, and one of the serious weaknesses of rerouting light around an object is that it has to go faster than the speed of light. This can be done, but at only one frequency. And a single frequency cannot carry much information. So cloaking devices, by nature, are always narrow in bandwidth. You could cloak red, but you couldn't cloak red and blue. An additional problem, he adds, is that "these materials absorb energy. So if we were to scale this up, then it would really just absorb everything. We have scaled

this up in microwave frequencies to cloak objects and there are certain applications where you are happy with just a narrow bandwidth, and we have been able to make things useful in different projects. But the Harry Potter cloak, I think, is a ways off."

When I visit the Rochester lab, Joseph Choi, a graduate student on Howell's research team, reiterates this impracticality. Transformational optics do not work for the entire range of the visible spectrum, nor can they accommodate a range of angles. The Rochester Cloak does something quite different. Unlike earlier cloaking devices, it results in no magnification or distortion of objects around it. Using layers of lenses to focus or change the direction of light rays, it is able to function at different angles and positions. It is capable of handling the entire visible spectrum of light rather than only a few frequencies, and whatever is behind the cloaked object remains visible without distortion. "Whatever you see is the same as what is there," Choi tells me. "It is like glass, or air."

Choi takes me to a room in the basement of the university lab and wheels out a black metal utility cart. Two rows of lenses have been clamped onto its surface, and in one row, the lenses, aligned with mirrors, have been positioned at angles. Taped on the wall of the white-tiled hallway is a sheet of paper printed with a small, multicolored grid. Choi positions the cart several feet from the wall, then places his hand between the lenses, and when I look through them, it is gone. The grid taped to the wall behind the row of lenses, however, is as visible as ever, its colors and scale unchanged by the lenses.

While the original device is small and accommodates small

angles, the size of what can be obscured is determined by the
size of the lenses. The cloaking device can be constructed on a
rudimentary level (instructions are posted on Wikipedia) with
easily obtained materials that cost less than one hundred dol-
lars, thus allowing for a simple how-to invisibility kit that can
be used by ordinary people without advanced physics degrees.
Once the science of the device has been more fully developed,
its applications might include allowing a surgeon to see through
his hand to what he is operating on, or revealing blind spots to
truck drivers. But physicists, Howell tells me, "don't necessarily
think of applications. We just want to solve a problem." He is
the first to admit this is a simple optical system. "I just want to
make something invisible." The cloaking device has received
broad public interest, but other scientists have occasionally
taken him to task for the time and effort spent on investigating
a simple optical trick, and the research is not funded by any
grants.

But Howell knows that anytime you are thinking about se-
crecy, there are military applications. He knows, too, that the
subject of invisibility leads to ethical concerns about "a lack of
accountability, boys observing what happens in the girls' bath-
room," and so on. But he points out more positive uses, for
architecture and landscape, for example. Intrusive bridges, un-
sightly overpasses, and signposts might all disappear. But would
that enhance the landscape or just distort our sense of reality?
"Can you cloak a wall?" he wonders out loud. Can invisibility
be used anytime you don't want to look at one thing and want
to look at something else? Perhaps because he is not motivated
by specific applications, Howell allows his mind to wander. He

watched *Star Trek* as a child, has two young sons now, and is equipped with basic human curiosity. His interest in invisibility is much like that the rest of us have. The limitations of the Rochester device persist, he admits. "Omnidirectional broadband is not there yet. But in five or ten years, we may be there."

Clinical, prosaic, utilitarian, the black cart in the white-tiled lab hallway doesn't look like a place where revelation happens. Yet something essential is occurring here. I position my pen, notebook, and hand behind the lens, and each of them vanishes. This is invisibility not as a literary device or psychological state, but as a material experience. When I leave the lab and walk out across the campus along pathways under the trees and past bushes, benches, and a construction fence on the way to the parking lot, my relationship to the material world seems ever so slightly altered. I keep imagining being able to see around things, through them, to their other side. I realize that the ability to see through something is not the same as that thing disappearing.

When I visited the lab, my hope had been to witness the phenomenon of invisibility as substantial and quantifiable in the physical world; to experience it as an authentic circumstance in the known world. I had driven to Rochester in a blue compact car and pretty much kept to the speed limit, a sixty-two-year-old woman crossing upstate New York on the interstate. I stayed at a Holiday Inn Express situated in a vast expanse of parking lots for steak houses, crab shacks, office parks, and a Rite Aid— a monotonous and generic landscape that could be anywhere. Could anyone have been more invisible? I wondered. Yet if it is

possible to believe something so deeply irrational, I know now what invisibility *really* looks like.

In another recent exploration of invisibility, neuroscientists in Sweden have devised a way for humans to experience the effects of vanishing. The purpose of the study was to reexamine from a social and moral perspective the question posed by Plato two thousand years ago: How would humans handle the power of invisibility? As emerging technologies suggest that human invisibility is near at hand, what effect would it have on our grasp of right and wrong? Participants put on a set of virtual reality goggles through which they could see the view from a second, adjacent headset mounted at the same height. But it was a view to empty space, so when they looked down, they saw not their bodies, but nothing at all. The researcher then used a brush to stroke both the participant and the "nothingness" next to him. The participant could feel the brush on his body, yet saw it brushing only empty space, and the perception of being brushed was diminished. The brain transferred the sensation of the brushstroke from the subject's body to the empty space— which led the researchers to believe that creating an out-of-body experience is easily done. The attachment we have to our physical beings is more fluid than we think. If we visually perceive that our bodies have become empty space, our brains go along with it, accepting rather quickly the premise that we can be dematerialized.

This mind-body connection was then tested in situations likely to cause anxiety. The "cloaked" participants were tested first by being shown a knife threatening their invisible personas with stabbing motions; their stress levels, measured by heart

rate and sweat, went up considerably. In a subsequent experiment, participants who had experienced the invisible-body illusion wore VR headsets, which placed them in front of a large audience of strangers. They responded with little uneasiness. Because they could not see themselves and had the perceptual illusion of invisibility, they didn't experience the sensation of being watched. Arvid Guterstam, the scientist leading the research team, suggests assorted applications—not only in reducing social anxiety but also in helping to heal spinal cord injury patients who have phantom body experiences. How invisibility might affect our sense of self and moral agency isn't yet clear, but we do know that both our physical sense of being and our understanding of the exterior world are malleable. It doesn't take much for us to accept the proposition that we can disappear.

Does the work of physicists and neuroscientists intersect with the storytelling and mythmaking having to do with invisibility? Toward the conclusion of his manifesto on invisibility, Philip Ball suggests that these are two different spheres of experience, and that a wide and perhaps necessary gulf exists between the emerging technologies and our traditional myths of invisibility. "Transformation optics and wireless microtechnologies allow us to imagine tricks seemingly drawn from the farthest reaches of science fiction or natural magic (the place is much the same), of which traditional invisibility is just one. Yet it can be hard to fit the practical possibilities to our mythical templates," he writes, concluding that an unbridgeable divide separates the mythical narratives of human invisibility from the recent technologies that attempt to bring it into

material practice. That is, technique and metaphor inhabit separate universes.

Months later, I look at a photo Choi took of me on my iPhone at the lab in Rochester. I am holding out my hand so that it has vanished entirely. I don't simply see a picture of a woman at a university lab standing next to a piece of research equipment. I also see an image of a woman who is missing some essential part of her. The image and the sensation it generates in me are not unfamiliar. A piece of her hand is gone, and with it, the ability to do what she wants and needs to do. She is incapacitated, disabled, hindered in doing the most basic things. This is not my usual state of mind, but like most other human beings, I have had the occasional experience of feeling that some vital part of me is missing, and I am debilitated because of it. And here is a portrait of that. The cloaking device may be an optical trick, but it has captured something real. The concept of object permanence can apply to parts of ourselves.

Maybe our intrigue with invisibility comes from some intuitive knowledge that something can be there even though we cannot see it, and that other things that are right before our eyes can bypass us just as easily. Most of us seem to have an innate understanding that our perceptions can be flawed at times and other times magically enhanced. I would suspect that invisibility further engages the imagination because our feelings about it can be so mixed. There are times we would like to be unseen because we are unsure of ourselves, afraid, humiliated, and we just want to disappear. At other times, being unseen is a grave disappointment. We want to be invisible; we are crushed at

being invisible; our feelings toward it may be as variable as human identity itself.

As a young man, my husband lived in the Philippines, where accounts of the Moro people were part of the local lore. Residents of the island of Mindanao, the Moros are an ethnic people, largely Muslim, who had fought for self-determination for generations. Their conflict with the people of the mainland had reached a level of extreme enmity, and decades earlier they had launched an assault on Manila. Part of the strategy involved paddling canoes into the city harbor and launching spears toward the shore. The pebbles they kept in their mouths, blessed by a shaman, were thought to confer invisibility. The Moros were using their presumed invisibility as a military tactic, but I imagine that those stones also conferred a tribal affinity, autonomy, a way of being seen and recognized only by one another—a clan identity.

It was preposterous, of course. But is it any more absurd than the jet fighter in its ghost cloak? Or Nivea's deodorant marketed as "invisible"? Or Land Rover's reach for invisibility in a concept car with a transparent hood? Cameras installed on the front of the car film what is directly under and immediately in front of it, and streaming video technology displays those images on its hood. Photographs of the vehicle's exterior suggest that one is viewing the road beneath directly. "Advanced technology is being developed at Land Rover to create a digital view of the terrain ahead by making the front of the car 'virtually' invisible," reads the marketing copy for the system. Land Rover claims the hood gives drivers "an augmented view of

reality," which, if you ask me, is pretty much exactly what the Moro people were after too.

One is an exercise of faith and belief, the other a digital feed and corporate branding. Worlds apart, obviously. Yet both still speak to the inevitability of human engagement with invisibility. While I don't care for the car or the deodorant, I'd sure love to have one of those stones. What would that stone look like? Would it be completely transparent or mottled, flecked with color? Translucent green, like an agate? Smooth and gray? Striped? I can't say. Who wouldn't want a perceptual paintbrush that strokes us not with a color, but with absence? But I don't expect to find either of these anytime soon. I don't expect Apple to introduce the iPebble or iBrush in the App Store in the near future. Their place of manufacture is more likely to be the human imagination.

That could be the sheer beauty of it. Invisibility might be achieved through a simple construction of lenses and mirrors or objects even more basic. A *Hulinhjalmur* is an ancient Icelandic symbol thought to confer invisibility, but summoning its magical powers requires blood drawn from your finger and nipples, mixed with the blood and brains of a raven along with a piece of human stomach. This concoction is then used to draw the emblem on one's brow with a chunk of brown coal. The basketball player Tim Duncan achieved it more simply. When the five-time NBA champion retired in 2016, after nineteen years, he announced it by cell phone, bypassing the press conference, the retirement party, the media event, and the gifts. A few days later, a picture of him standing in line at an Old Navy store was

posted on Twitter. There is something in his discreet passage from the arena to the checkout line that passes for invisibility. But maybe this is the thing about invisibility: it can be a matter of myth just as easily as one of ordinary life.

In a short YouTube film Howell made to illustrate the Rochester Cloak, he used a series of mirrors to construct a larger cloak. He then employed his two young sons as subjects. The older brother is fully visible, but then the smaller boy, whose body is out of sight, pops his head up and waves his hands. The boys walk to and fro, in front of and behind the cloaking device in a little ballet of visibility and invisibility. They are laughing and playing and vanishing, and it is impossible not to be mesmerized, because Howell's appearing and disappearing children tap into something primal in us. How cheerful they are! Here is a video of the invisible friend! Here is a lively little film that captures every parent's nightmare of the vanishing child! The landscape here is not a mysterious forest with looming trees and shadows, but a well-lit lab with bland white wall tiles. Yet the three-minute film speaks to how science, myth, and storytelling can converge for an invincible partnership. The film suggests that this is how human ingenuity works, weaving together the possible and the impossible, braiding together what happens with what doesn't, and for a few minutes, folding together what we see and what we don't.

THREE
ACROSS THE NATURAL WORLD

*In the field of natural history, things escape us because
the actors are small, and the stage is very large and more or
less veiled and obstructed. The movement is quick across
a background that tends to conceal rather than expose it.*

—JOHN BURROUGHS

Resting on the windowsill above my desk for a number of years was a pot containing a small, silvery plant. A soft gray mottled with flecks of beige and rose, it was composed of elliptical forms. Its surface smooth, its bulbous leaves uniformly oval, it resembled a collection of stones. There was something pleasing in how this succulent plant—soft, yielding, porous—passed itself off as an impermeable rock. What nerve and bravado! Its elegant costume was logical. The pebble plant, as it is known, originated on the plains of Africa, where it evolved to escape the notice of grazing animals. My daily amazement had to do not only with its ingenious masquerade but also with the alternative it offered to the festival of exposure that seems so central to the way we live today. This little plant offered an opposite approach. It was expert at receding, with disappearance woven into its cellular structure. It conveyed a message about

finding accommodation in our surroundings. Its botanical inge-
nuity revealed something about the beauty, valor, and imagina-
tion of going unseen.

Usually a disinterested gardener, I was completely infatuated
with the poignancy of this plant. It was not simply a matter of
its weight or substance or color, but its attempt to be something
else on a profound molecular level. My husband had given it to
me after stocking up at the nursery on the seedlings for the
more robust garden he plants every year—tomatoes, basil, mint,
berries, flowers of every kind. "Here," he said, handing me the
flowerpot containing the thing he knew I had been coveting
and that would be mine and mine alone. "It's about the most
unplantlike thing I have ever seen." And rolling his eyes just a
little, added, "At the nursery they told me it takes forever to
grow. That sounded about right too."

It was. Known among gardeners as a "living stone," the small
oval shrub sat on the sill for months at a time without appearing
to grow so much as a centimeter. It didn't sprout, it didn't
bloom, it didn't change. In fact, true to its nature, both fantasti-
cally deviant and fully accommodating, the only time it ever so
much as resembled a living thing was when it finally did die,
turning a grotesque liver pink, acquiring a fleshlike texture and
collapsing in on itself. But until that final moment, there was
something deeply satisfying about trying to nurture this little
fraud, and I made certain that its soil was sufficiently porous,
that its spot on the shelf received ample sunlight. The idea that
its modest charade could be tended to appealed to me; for an
unenthusiastic gardener, well, what could be better than a plant
whose sole objective is to be a stone?

In the natural world, this technique is known as crypsis, that ability of an organism to meld with its immediate environment, to go unobserved and undetected through strategies that include sight, smell, sound, texture, and light. Nature is full of such advocates for the inconspicuous life: shells, plants, amphibians, insects, birds, mammals, arctic foxes that turn white before snowfall, glamorous Indonesian crabs with baroque patterning on their shells that mimics the coral in which they live, octopi with cells beneath their skin that can change color to simulate that of the surrounding marine life.

Becoming invisible is not the equivalent of being nonexistent. It is not about denying creative individualism nor about relinquishing any of the qualities that may make us unique, original, singular. Invisibility is a strategy for attracting a mate, protecting home and habitat, hunting, and defense. Camouflage in the natural world is not some exotic and picturesque trait. It is nuanced, creative, sensitive, discerning. Above all, it is powerful.

Nature loves to hide, Heraclitus declared in the fifth century BC. The natural world provides not simply the vocabulary, but an entire system with which to understand the value of compatibility with one's surroundings. Disguise and mimicry are deeply practical, but are often also accompanied by humor, courage, elegance, and wit. Consider the acoustical scams of the Australian lyrebird, capable of echoing not only the call of other birds and sounds of the natural world, but also the din of the motors of cars, trucks, and jets overhead. Nuanced birdsong and grinding machinery are both in its repertoire. With equal amounts of grace and audacity, its call promises, "I can be a

bluebird, and I can be a chainsaw too!" Or the elegant trickery of the long-tailed weasel, which molts white in winter, save for its black-tipped tail, bewildering birds of prey circling overhead as to what is its tail and what is its head.

I have not heard the songs of the lyrebird nor witnessed the ruse of the long-tailed weasel, but I am familiar with other ordinary deceptions of the natural world, as on the April afternoon when my friend Jane and I were kayaking and came across a tawny beaver, which had draped itself unrecognizably over a bog in the stream, folding its tail efficiently around the mound beneath it. The strands of its golden fur caught the afternoon light in a manner similar to that practiced by the blades of marsh grass on which it was resting. It's not that animal and vegetable were identical to one another; rather, their faint mismatch was true to the world surrounding them. Or the six-foot green tree snake I saw once in Costa Rica. My fear of snakes generally causes me to freeze, and the sight of the smallest garter snake in the stone wall behind our house is cause for retreat. But there it was, spiraling down through the leaves and bark of a palm tree, its vivid jade color and delicately scalloped pattern of scales mimicking both the decoration of bark and the leaves of the palm tree behind it. I could not take my eyes off it as it preyed on a small toad at the base of the trunk.

It's a wonder I noticed at all the walking stick insect resting lightly on a wisteria branch near the porch railing last summer. Its symmetry, hue, and twig-like lightness all disdained notice. But once I did, I could see that its elegance was not just a matter of its delicate frame and subdued color, but of its slight tremble as well, seemingly less voluntary than the result of a

breeze blowing a bit of branch. Its virtuoso reticence came from form, color, and deportment, all of these collaborating in its effort to become an entity of a different kingdom. Calling it an inconspicuous marvel is not a contradiction.

Our admiration for such deceptions seems as natural as the deceptions themselves. The British crime writer Ruth Rendell believed that the appeal of murder mysteries lies in the fact that all humans have a bit of the criminal in them, and I suspect there is something similar going on here. Envy and appreciation *must* come into it. Because if we are not quite capable of such deceits, surely we would like to be. There are psychologists who believe that when we are lied to, we are complicit, full partners in the deception. I don't believe this for a minute. Maybe every liar needs a believer, but that's as far as I'll go. I don't like being lied to any more than anyone else, but I would, on the other hand, like to be a much better liar. Most of us have some bit of the inner contrarian, coveting that ability to be someone other than who we are. If I can't take my eyes off the dozing beaver, the trembling insect, or the starved tree snake, it is because I, too, would like to be more skilled in such deceptions.

The American painter, naturalist, hunter, tracker, and taxidermist Abbott Handerson Thayer believed that "every animal carried a picture of the environment on its body." His canvases are dazzling studies of protective coloration, the means by which animals conceal themselves in their habitats to escape the notice of predators. One canvas suggests that two blue jays seen across a field of snow might easily be taken for the shadow of trees in the late afternoon, while in another, radiant pink

flamingos recede into the sky at sunset so as to avoid the notice of crocodiles. His portrait of a wood duck in a forest pool is a composition of uncertainty, the bird skimming its way along the lily pads, its dark upper feathers merging into the black surface of the water, while its paler feathers glow alongside reflections in the water. Leaves, plumage, water, and sky collaborate in a portrait of ambiguity. What am I seeing? a viewer might easily ask.

Thayer articulated the theory of countershading, which describes the unexpected coloration of many species; that is to say, pigmentation is darker on upper surfaces of the creature's body, while undersurfaces, those areas not exposed to sunlight, are paler or white. Such coloration leads to perceptual confusions of light and shade and allows for the form of the mammal, reptile, or bird to be flattened or otherwise obscured. Other forms of concealing coloration include disruptive patterning in which strong graphics cast doubt on an animal's outline and shape, thus befuddling the eye of a predator, and figure-ground blending, in which the color and pattern of the animal resemble the surrounding habitat.

Thayer's theories were used by military strategists in World War I; he had suggested that the khaki-colored uniforms evoking dust and sand might be replaced by clothing of mottled tones, the irregular patterning of which was more likely to bewilder the enemy eye. Thayer's portraits of women have their own messages of concealment. In 1918, when occupied by matters of military camouflage, he also painted the portrait of his daughter-in-law, *Woman in Green Velvet*. Here, the texture and color in the sleeve of her dress meld into the pine boughs

behind her; while the velvet dress is in the fashion of the Italian Renaissance, its capacity for concealment is like the military gear used then by young soldiers going into battle.

At the time, femininity was still regarded as a matter of reticence and reserve, and the painting may stand as a record of oppression. Yet viewing it a century later, I find that it speaks less to ideas of gender tyranny and more to a way of being, a manner of accommodating one's surroundings. And viewed collectively, Thayer's paintings suggest he valued not simply visual discretion, but deeper convictions about the need for protection, whether in tropical wetlands, in the forest, on the battlefield, or in the drawing room. Like the blue jays in the snow or the flamingos against the fiery clouds, the soldier in the mottled jacket and the woman in the green dress conceal themselves out of necessity. Art historians speculate that Thayer's paintings and his research into the behavior of animals were an effort to meld art and science in a spiritually deprived time that had issued in the horrors of World War I.

The early-twentieth-century British zoologist Hugh B. Cott assigned the most comprehensive system to the creative deceptions of natural species. His classic book, *Adaptive Coloration in Animals*, published in 1940, is an encyclopedia of reinvention in which he proposed that the three categories of coloration are concealment, disguise, and advertisement. His catalog of visual deception begins with the obvious fact that animals bear a general resemblance to their surroundings: the arctic fox is snow white, the tropical tree snake vibrant green, the woodcock the color of fallen oak leaves. Such is the basic brilliance of belonging to place. But color resemblance is only the beginning.

Shading to shift the contours of the organism and disruptive coloring to break up its outline are as essential. As is the ability to manipulate shadow, as in the case of the butterfly that rests with its wings closed, aligned to the sunlight so its shadow is "reduced to a mere inconspicuous line."

Escaping notice is not simply about color, but about improvisation that nods to time and season. Chromatic responses to landscape can happen in an instant or in days, weeks, or months, and Cott's menagerie of imposters ranges from the brilliant African insects that take on the dark color of the fields in which they live after the grass has been blackened by fires to spiders in Maine that assume the deep yellow of goldenrod in late summer. Shading and countershading, the interplay of light and its absence, help to obliterate form. Dimension is diminished, solidity is reduced, and objects can appear flattened, like a fish that presents itself as an aquatic weed or a fawn in the woods whose dappled spots evoke sunlight falling on foliage.

An animal's stripes, spots, or other dramatic surface designs of feathers, fur, or scales can further bewilder the eye of the observer. The white and black rings of fluff on newly hatched chicks of the ringed plover break up the shape of the newborns, hiding them from predators. Cott distinguishes between concealment and what he calls "aggressive resemblance," which describes, for example, the way snakes impersonate lianas, or moths present like the bark of a tree or the excrement of birds. A Brazilian butterfly with twisted filaments can evoke a torn and shriveled leaf, and mollusks have protrusions, spots, and bands of color that replicate the distortions of the marine algae

of their habitats. Not simply a matter of coloration, pattern, and precise timing, invisibility seems woven into the very structure of being and behavior.

Cott's manifesto on obscurity became a handbook in World War II for the design of battleships, tanks, and soldiers' uniforms. *Dazzle camouflage*, used first in World War I, was the common name given to the surface design of warships, which mimicked the fluff of the benign plover chicks. In both cases, the objective was to break up the form, what Cott calls, "the continuity of surface," rendering it an elusive target. Oversize black-and-white geometric patterning—huge wavy stripes, moiré, or diamond checkerboard patterns—on the exteriors of ships did not conceal them so much as cast doubt as to their speed, size, form, and direction. Adapted by an artist for the British Army, the painting method nodded to modern art techniques such as pointillism and cubism, and both Picasso and Braque took credit for its origins. It may have been a rare moment in history when military strategists, zoologists, and fine artists appeared to be engaged in like interests, but as Cott usefully observed, "in nature, as in war, conditions are rarely ideal, and they never remain so—for they change." The purpose of a disruptive pattern was "to prevent, or delay as long as possible, the recognition of an object by sight," and its success was a result of both optics and psychology.

The only time I have ever seen such military equipment was on a Hudson River cruise one autumn morning in the Port of Albany. The USS *Slater*, docked now as a museum ship for tourists, had served as a navy destroyer in World War II, and its

exterior surface had been painted in irregular swatches of dark blue, pale blue, and gray. With graphics that took into account the reflective surface of the water, time, motion, and physical distance, it came across as a cubist painting, floating and bobbing on the industrial riverscape. Looking downriver at the light shifting over the course of the morning, I found it easy to imagine how these colors and shapes, seen from a distance, might confuse the eye. Surely Braque would have been happy. The warship on the river that morning seemed a far more engaging discourse on substance, form, hue, and light than any canvas hanging in a museum.

Cott's work remains relevant today in ways he might not have anticipated. In the 2016 French Open, tennis players dressed by Adidas wore clothing with dramatic, swirling black-and-white stripes; like the plovers and the battleships before them, these athletes were decked out to confuse and distract their adversaries. In that same year, the British artist Conrad Shawcross designed the Optic Cloak, a shimmering mirage that conceals massive, fifty-meter-tall flues for a low-carbon heating plant providing energy to fifteen thousand local residences on the Greenwich Peninsula in southeast London. The sheathing is constructed of hundreds upon hundreds of punched brushed-aluminum panels, laser cut and folded into one another at varying angles to create a dazzling and disruptive surface. The faceted tower produces a moiré effect at sunrise and sundown especially, appearing to shift in the light, both there and not.

In their *Eyes as Big as Plates* collaboration, Scandinavian artists Riitta Ikonen and Karoline Hjorth riff on characters from

Norwegian and Finnish folklore in photographs of elderly people wearing the garb of the land around them—a dress made of seagrass, a cape made of kelp, a hat of woven weeds, a blanket of moss, a cap of sculpted buds. There is some unspoken correlation here between the older subjects and the dress they have taken on, some spiritual affinity between the creases in their faces and the texture of the leaves, grasses, and flowers. Landscape accommodates both geography and psyche, the photographs seem to say. Both time and nature are subjects of the images, which evoke some vague ecology of aging, some elusive suggestion about the inevitability of being folded into natural systems.

The Chinese artist Liu Bolin recently had himself painted and photographed to blend in precisely with his background in his series *Hiding in the City*. There he is, standing at a courtyard in Beijing or in a magazine shop or against the bins in a fruit market or simply against a brick wall, his skin and clothing impeccably colored and aligned to conform to whatever setting is behind him. One must squint to find his form. He may be making a political statement about the loss of personal identity in an oppressive communist regime, but the images also offer the startling beauty that can come when humans are absorbed into the background. Bolin has also camouflaged himself in photographs taken by Annie Leibovitz for the high-end clothing company Moncler, where his outline can be discerned in an old bookstore cluttered with piles of worn books, metal filing cabinets, and an antique card catalog that all convey the shabby, but apparently enviable, erudition of an earlier time. With Bolin's

face tinted blue to resemble the pane of glass behind him, his jacket and pants imitating the piles of books around him, and his boot the color of the floor, the ad seems to suggest that the real luxury in this line of quilted outerwear comes in the sense of discretion it confers.

Not long ago, I was on a walk in the Vermont woods with some friends, one of whom had in his pocket a toy for his dog, a small plastic hamburger that made a squawking sound whenever pressed. On this occasion, when the Hamburger Design Pet Squeeze Squeaker Toy let go its screech, a catbird in the woods nearby quickly answered with its own cry. Back and forth for several minutes the dialogue between bird and knickknack continued. I find it promising that a plastic hamburger can chat with a bird on a June evening. Our manners of acoustical disguise are weird, far-fetched, and unpredictable but nonetheless effective. Who knows what any of us will believe? As modern consumers, we find ways of fitting in that are volatile, capricious, arbitrary, surprising.

Bolin's photographs capture a moment in time, and his stillness is intrinsic to his costume. Cott calls this adaptive stillness and adaptive motion, and he notes the inadequacy of mere makeup: "If the disguise is to be complete, animals must *act* as well as *look* the part they are destined to play." The attitude of rest is creative, as in the lizard whose immobility evokes a dead leaf; the eel that adopts the gentle, fluid movement of the water weeds in which it lives; or fish that drift horizontally until they enter a bed of reef grass, at which point they adjust themselves vertically. These disguises are not necessarily passive, as some

insects cluster together to resemble flowers. The flight of brown Panamanian butterflies recalls falling leaves, and the conduct of a bittern on a lily pad—stillness, swaying, stillness again—is derived from fluctuations of a slight breeze. Today the ghillie suits used in hunting gear likewise simulate not only the color and texture but also the material behavior of the background environment: strips of fabric and netting are arranged so as to move in the manner of leaves, sand, dust, and snow, taking the camouflage from two to three dimensions. The digital camouflage used by the twenty-first-century military is more attentive to scale and distance. Pixelated camouflage combines the micropatterns of what can be seen at close range, such as the patterning of a leaf or blade of grass, with the macropatterns obscuring what is seen from a distance.

Camouflage is not necessarily constant and enduring, but active, instantaneous, ephemeral, and responsive to subtle changes in air and light. Squid protect themselves using bioluminescence via cells called iridocytes with platelets that contain reflectin, a light-reflecting protein, which allows the marine animal to alter its skin color. By stretching and contracting pigmented cells, a squid can control its chromatic responses to the area it is in, in effect altering its silhouette. The squid's ability to correlate its luminescence with its background was adapted by military strategists in World War II who explored the possibilities of diffused lighting camouflage using small lights to illuminate the front and edges of fighter planes, thus rendering them less apparent to those on ground and water. More recently, researchers have discovered how to isolate the protein. Using it in combi-

nation with other materials, they have been able to construct a synthetic textile that can shield its wearers from infrared detection. Already, the material has been used to make a tape that, when torn or cut into pieces and attached to military gear, can create a camo pattern responsive to wavelengths of light.

Cott states, too, that "cryptic silence is to the ear what cryptic appearance is to the eye. The silence of which I speak is not a passive condition—a mere absence of sound. It is an active quality, a significant attribute of hunting animals, rendered possible by structural modifications or achieved by adaptive behavior." A cat moving through the grass at night is silent not from absence of movement, but in spite of it. It is a difference, Cott proposes, between stillness and the suppression of sound. Such gradations of quiet recall the plays of Harold Pinter, in which actors distinguish what separates pause from silence, how the silence of uncertainty differs from that of a question hanging in the air, and how both are different from the full-stop silence of disbelief. "The speech we hear is an indication of that which we don't hear," the playwright has said.

Escaping notice is about appearance, stillness and movement, about light, sound, and silence, a bird pretending to be a chainsaw or one that remains mute. Comedy can ensue when we try to be something other than what we are. In the Charlie Chaplin film *Shoulder Arms*, the silent actor is in hostile territory dressed as a tree, branches extending from his arms, with his top hat the upper extremity of the trunk. At opportune moments he uses his assorted limbs to strike the soldier who is intent on chopping him down for firewood. The viewer is enthralled equally by the inability of the enemy private to see

what is in front of his own eyes, by the knowledge that the tree is not a tree, and most of all, perhaps, by the comedy of Chaplin's skillfully timed strikes despite the expression of pure horror on his face.

But kinship with our surroundings may not be as absurd as we think. It may simply come in acknowledging them. It is what my friend Elizabeth Sherman, a biologist, says of her approach to her work: "When humans want to see nature, whether in the forest, meadow, desert, and for me especially, underwater, we try to be actively invisible so that we can better know the place." Sherman researches the biology of coral reefs in the waters off Grand Cayman island, and when she is diving, she works in a quiet and weightless state, ignored by the invertebrates and assorted neon residents floating in the aquatic bazaar around her. When I watch her underwater films, it is not hard to imagine the invisibility a diver can experience. Her water presence reminds me only slightly of the photographs of Riitta Ikonen, but Sherman's place in the seascape is not a matter of beautifully sculpted visual props. She is not wearing a suit of seaweed or a cap of coral. Rather, it is a question of behavior. Her belonging has less to do with an allegiance *to* place than an absorption *by* place. Sherman is a respected scientist in her field and an engaging and much-sought-after professor at the college where she teaches. Yet when she is doing some of her most important research, she is all but unseen by her subjects in the water around her. The lionfish, angelfish, tortoises, and sea urchins are all indifferent to her presence. She is as much *not there* as she is *there*.

I can't help but wonder whether that deficiency of substance

can also be achieved on solid ground. Perhaps it requires the insight about place as imagined by Peter Matthiessen in *The Snow Leopard*, a journal of his quest to see the legendary big cat in the mountains of Tibet. The leopard itself, a soft gray mottled with black rosettes, is a creature of mystery, guarded, remote, unseen, and so well hidden in its chosen places that it escapes the human gaze that is only yards away. But its animal quiet is not entirely out of human reach, and Matthiessen's consideration of the feline invisibility extends to the trancelike state certain yogis achieve who are said "to still their being and its vibrations so completely that their corporeal aspect makes no impression on the mind or memory of others." His suggestion that one might aspire to *make no impression* is timely. This integration with the world around us can offer an abiding sense of wholeness, a reassuring belonging in the disconnections of modern life. Offering an alluring alternative to the self-branding so familiar today, it is a reprieve from reflexive fixations on self and image.

In an essay about booths in nature preserves that allow visitors to observe animals while remaining hidden, Helen Macdonald writes, "To witness wild animals behaving naturally, you don't need to be invisible. As scientists studying meerkats and chimps have shown, with time you can habituate them with your presence. But hiding is a habit that is hard to break. There is a dubious satisfaction in the subterfuge of watching things that cannot see you, and it's deeply embedded in our culture." She describes taking a walk in a small English town and her surprise at suddenly spotting a bevy of otters swimming in a shallow stream in a park. Elusive animals that generally prefer to remain out of

sight, the otters, undisturbed, unbothered, and oblivious to their human observers here, cavorted freely in the water. The townspeople, who grew accustomed to their presence, found them an ordinary delight, while the wildlife photographers outfitted in camo gear and equipped with long-lens cameras appeared foolish and out of place.

It may not come to us naturally, but we can be inventive in searching out a sense of belonging. The invisibility train imagined by Japanese architect Kazuyo Sejima, now only in the concept phase, is clad in a hyper-reflective skin so as to mimic the morning sky, the midday sun, the clouds at dusk, the gray outline of the distant hills, the dusty green of the fields through which it speeds. It shines with wherever it happens to be. While no one could possibly imagine that it is anything other than a metal object racing across the landscape, it attempts at accommodation. The poet Katherine Larson has written that crypsis is "for the ways that things are hidden. / How certain small truths disappear against / a larger truth." Maybe a seat on the invisibility train could permit us to disappear against a larger truth.

Lauren Bowker, an English designer with an abiding interest in biochemistry, has developed inks that respond to conditions in the landscape. Initially developing a pollution-absorbing ink that darkened from yellow to black when in proximity to certain toxins, she went on to produce thermochromic inks that respond to heat, light, moisture, air pressure, and assorted other circumstances of the immediate environment. Subsequent pieces used inks capable of reflecting the wearer's brain activity and emotional state: blue might signal sadness while white might

indicate serenity. Her company, the Unseen, produces irides-
cent rippling wraps and feathered headgear that read as exotic
luxury concoctions, one-of-a-kind novelty items, the latest
mood rings of the couture world. Make no mistake: this is fash-
ion, not crypsis. But such items also suggest that beauty can be
defined by responsiveness and by acknowledging the conditions
around us. It is also possible to imagine a different application of
her inks that is at once more prosaic and more extravagant.
What if ordinary clothes changed in response to toxins, to sig-
nal some extreme change in temperature, to function as an en-
vironmental warning system? Or what if they simply changed
hues to allow us to visually recede into the immediate land-
scape? Is it possible such attire would help us to recalibrate our
troubled relations with the world around us?

Chemical inks and invisibility stickers have a certain allure,
but going unseen is unlikely to be about such trick materials. I
can't say just how; my pebble plant remained mute, and Cott's
species speak in languages incomprehensible to us. Yet if any of
them could clarify their opaque enterprises, perhaps the senti-
ment would be familiar to what the poet and essayist Wendell
Berry notes after spending a few days camping in the Kentucky
woods. "I am reduced to my irreducible self," he wrote in his
essay "An Entrance to the Woods." "I feel the lightness of body
that a man must feel who has just lost fifty pounds of fat. As I
leave the bare expanse of the rock and go in under the trees again,
I am aware that I move in the landscape as one of its details."

Berry moves as a detail of the landscape not because his
camping gear included a roll of invisibility tape or a jacket dyed

with thermochromic inks. His cryptic dress is instead about observing stillness and silence, some changed weight of step, some revised watchfulness and sentience, some acquired agility of presence. It is, as Berry also says, a matter of being "absorbed in the being of this place, invisible as a squirrel in his nest."

An earlier writer offers another point of access. In his famous letter to his friend Richard Woodhouse in 1818, the English Romantic poet John Keats speculates on the idea of the poet as a chameleon, a creature without a character of its own, but one that instead "enjoys light and shade; it lives in gusto, be it foul or fair, high or low, rich or poor, mean or elevated—It has as much delight in conceiving an Iago as an Imogen. What shocks the virtuous philosopher, delights the camelion Poet." Lacking an identity of his own, the poet is able to take on the persona of "the Sun, the Moon, the Sea, and men and women." Keats's chameleon letter, as it came to be known, suggested that it is through the creative imagination that one becomes a member of another species; he believed that without a distinctive self, the poet could be more adaptable in being, more responsive to experience, more capable of imagining the identity of his subject, whether it was a nightingale, an English garden, or a woman.

It is a shame that John Keats was never able to have a conversation with Hugh Cott. His letter and Cott's inquiry into the coloration and behavior of animal species represent one of those intersections of art and science that could convince us we are all engaged in similar enterprises. Both of them knew about the precise and profound artistry required to recognize fully the world outside the self.

In the Sahara, there is a species of silver ants with coats precisely calibrated to adapt to the harsh landscape around them. Their tiny radiant armor is made of triangular, reflective hairs on their midsection that dissipate heat through thermal radiation, thus enabling them to survive in the greater than 150 degrees Fahrenheit temperatures during the twenty minutes or so each day when they leave their nests. By midcentury such examples of extreme adaptation may have increasing significance for us. How we are able to become constituents of a broader landscape will gain more relevance as the earth warms and its population reaches the nine billion mark. Our deeply held values about individuality may even become passé.

Which takes me back to my little pebble plant. Radical adaptation was its very being, intrinsic to its identity. Its splendor probably also had to do with its ability to express two basic, but very different, impulses: the desire to fit in and the desire to be transformed. Maybe my fascination with the stone plant, the walking stick insect, and the beaver comes from their ability to do both of these things so effortlessly. The simultaneity of purpose seems to come naturally to them. I would like to think they have the imagination to recognize the world they live in. These species mesmerize me with their quiet and sure sense of fit, their compatibility with their environs, and their firm grasp of what it is to belong. Their message is one of quiet accommodation. Whether you call it crypsis or simply a sense of belonging, the measure of our humanity may be derived not from how we stand out in the world, but from the grace and concord with which we find our place in it.

INVISIPHILIA

*They surfaced. The green water showed nothing of what
was beneath it. By the sun she realized that they had not even
been down for an hour. With no weight you lose your self
as a point of reference, lose your place in time.*

—LUCIA BERLIN

A yellow tang is loitering to my left. A school of iridescent purple reef fish shines into view. A royal-blue queen angelfish glides out of sight. Despite our proximity, I am beyond the notice of a massive southern stingray sweeping along the seafloor, the drape of its thin pectoral fins following and folding over the ripples of the sand bed. All of these remain oblivious to me. It may take Wendell Berry three days to become a detail on the landscape when he is in the Kentucky woods, but forty feet beneath the surface of the Caribbean Sea, it takes me more like three minutes. Which is strange, because generally speaking, things seem to happen in the water world a lot more slowly than they do on land.

Elizabeth Sherman's diving videos—mesmerizing, flickering images that nonetheless document those ways in which the human presence shifts underwater—drew me here. She might

be floating through a school of parrotfish or photographing a lionfish, unquestionably *there*, *present*, *engaged*, but she was also diluted in some essential way. That transformation seems essential to being not invisible exactly, but unperceived. Within minutes of submersion, I begin to understand how we carry ourselves differently in water. Our presence changes. We are there and not. It is not just the shift in gravitational pull, but that the material environment is intrinsically more familiar to us. If the composition of our own beings is 60 percent water, it only makes sense that it is easy to be absorbed, or at least *feel* absorbed, by the marine environment. We recognize the particles in which we are submerged, as though the blood in our own veins has found it possible to flow in congruence with the currents streaming around us. It is not quite a molecular kinship, but close. Underwater, we have a different relationship with our surroundings.

It leads, I find, to a sense of indifference. Forty feet beneath the surface, the striped parrotfish are oblivious to me. The yellowtail damselfish and flurry of silversides couldn't be less interested. The school of tiny iridescent purple gobies flutters past with utter detachment. A yellow goatfish lingers at the fringe of a giant pink sea anemone, seemingly aimlessly. We all know that sensation of life slowing down, of being suspended in time, of being outside the rhythm of ordinary life, but underwater, that is the way *things really are*. There is a sense of vast remove, even though we are all occupying the same turquoise chamber; our amphibian selves are alert to both the immeasurable distance from and profound connection to the water world around us. Submerged, I have become a refugee from the visible world.

Underwater, the exterior world is recalibrated, our relations with it both limited and expanded. Water changes the way we see things, at once magnifying and distorting them, and altering colors as well. We are unable to smell. We are unable to speak, and that stills us in some essential way. The human voice is absent, replaced by the sound of breathing, a gentle repetition that induces a further calm. Other sounds are more muffled. Our ears are designed to function in air, and underwater, it is difficult for us to recognize the direction from which sound is coming or to untangle its vibrations. We can hear, but not very well.

But the sense of touch comes alive. The water temperature is in the high seventies, and different sets of skin receptors allow me to read its gentle coolness, its motion, texture, vibration, and pressure. Touch is said to be ten times stronger than verbal or emotional contact, and when I move, it is gradual, fluid, leisurely, multidirectional. When the young woman who is my instructor on my first dive excursion gives me hand signals conveying such prosaic information as "check your air gauge," "go up," or "ear problem," her gestures have all the liquid grace of a Balinese dancer. My sense of physical presence is transformed, almost as though my body has dematerialized in some intrinsic way, conforming to the currents as best it can. The aquatic world offers invisibility that is less about being unseen and more about a dilution of self and the sensation of assimilation and adaptation. As odd as it seems, I might even say that being underwater confers a sense of solidarity.

The sense of physical being is also transformed by the mammalian dive reflex. When the body is submerged, the human heart rate slows anywhere from 10 to 20 percent. Blood

circulation slows as well, redirecting flow to the vital organs. With heartbeat and circulation reset, our nervous systems are also recalibrated, and the sense of physical suspension has a psychic corollary. It is one reason people speak of feeling tranquil, peaceful, and meditative when they are in deep water. It is why human beings in a condition of emotional upset or trauma are sometimes advised to immerse their faces in a bowl of cold water. And why free divers who go into water up to two hundred meters for minutes at a time on a single breath speak of feeling serene; in their case, without the rhythm of breathing, the sense of time is even further diminished. The free diver Tanya Streeter has said that deep diving was a way to find herself, but it could just as easily be a way to lose yourself completely.

Propranolol, a beta-blocker designed to lower blood pressure and reduce anxiety before moments of anticipated stress, has a similar effect. On the occasions I have taken the drug, I have found that my heart is no longer pounding, nor my hands shaking, nor my stomach churning, nor my mouth dry. I am present, but with a body that has become just slightly less substantial, less *there*. But how corporeal diminishment affects composure becomes infinitely more real to me on these dives in the Caribbean Sea. Wear a tank, mask, regulator, and some weights; drop beneath the surface; begin to breathe; and see how easy it is to consider yourself as something *less*.

A tourist among the brilliant residents of these deepwater currents, I find myself making all the usual social missteps and mispronunciations of gesture. I don't remember the correct way to tip my mask to drain it of seawater and am slow to manage

the series of simple hand signals used underwater to convey essential information. As a swimmer, I use my arms, which are of no practical use in diving, nor will kicking as a swimmer help much; in diving you kick from your hips. I have trouble with buoyancy and needed to add another weight to my belt, and then another. I am going through my supply of air quickly. *Equalizing* is the term used for the rote act of pinching your nostrils or swallowing to correct the air pressure on the outside of the eardrum when descending into deep water, and it is second nature for experienced divers to manage this. I find the term applicable as well to the effort required to maintain the psychic equilibrium in passing from one realm of experience to another—I am not doing this correctly either.

But no one in the coral palaces noticed or cared. The writer Robert Macfarlane has noted that to enter water "is to cross a border. You pass the lake's edge, the sea's shore, the river's brink— and in so doing you arrive at a different realm, in which you are differently minded because differently bodied." Differently bodied, almost disembodied, really—readjusted, that is—to take yourself more lightly, you may find that other things lose their sense of weight as well. Expectation, hope, desire, fear, worry— all of these have a tendency to lessen. A sense of physical belonging is conferred.

Sherman knows all this. For more than twenty years, she has researched the biology of the reefs lying off Grand Cayman island and is familiar with the avenues of coral and their many species of residents. She is precise in regard to the behavior of marine organisms at specific water temperatures, the number of juvenile parrotfish on a given morning, the percentages of live

coral on a particular section of reef, and the rate of decline in
the population of sea urchins. But she also references that inef-
fable, unfathomable quality of diving, saying that "listening to
the ocean, I feel as though I am hearing the earth breathe."

That sense of languor extends to one's thoughts and impres-
sions. Observations come and go unhurried. A plume of anem-
one waves quietly in the current. A three-foot webbed lavender
sea fan flutters almost imperceptibly. A turquoise parrotfish drifts
by me. An army of small fairy basslets, violet with brilliant
yellow tails, streams beneath me. The aquatic world revises the
way we appraise direction, take measure, and ascertain a path. It
is possible to swim in a linear route from one place to another,
but why would you? In the Italian novelist Italo Calvino's cata-
log of imagined communities, *Invisible Cities*, Esmeralda is a
watery city whose system of canals and streets continually
merge and intersect with each other, "the network of routes
[that is] not arranged on one level, but follows instead an up-
and-down course of steps, landings, cambered bridges, hanging
streets," he writes. "The ways that open to each passerby are
never two, but many," and he suggests that the map of Esmer-
alda "should include, marked in different colored inks, all these
routes, solid and liquid, evident and hidden." That multiplicity
of pathways, the infinite possibilities of passage, come to me
now as I watch the traffic of the angelfish shimmering their way
through the arcades of this aquatic kingdom.

The closest I have seen human beings come to wandering
and floating in the manner of these marine species is in a You-
Tube video a friend showed me a few years ago, in which a
group of Japanese teenagers, dressed up in brightly colored

full-body suits, drift and hover and sometimes bump into one another. A brilliant blue boy is wrapped up with a shiny yellow girl. Another boy suited in vibrant green drifts alongside them. In attire that obscures their identities, they have parties, sometimes enfolding themselves in stretchy material in groups because the anonymity is said to heighten the senses. The faceless exhibitionism at such Zentai parties, as they are known, is not always about bondage and erotic fetish; sometimes it is simply about anonymity and the uninhibited behavior it can allow for. Those stoned teenagers come to mind now, but in the marine world, anonymity, exhibitionism, and inhibition are distant and abstract terms. Being accommodated and absorbed by the waterscape is effortless. For all their dazzling color, these marine species are experts at discretion, intertwining flamboyance with reserve.

Charles Haskins Townsend, a director of the New York Aquarium in the 1920s, recorded the way tropical fish in his exhibitions changed both color and markings. In his 1910 essay "Chameleons of the Sea," written for the New York Zoological Society, he documented the way color cells beneath the skin of some tropical fish are triggered by different behaviors—capturing prey, courtship, signaling danger. But the more varied the environment, the more varied the assorted color. The harlequin behavior of his subjects was due to both background and disposition, he observed, and it was not simply a matter of the rock, sand, or water, but of the fish's "moods and artificial excitements." Alarm, fear, surprise, and distress along with the color and pattern of the aquatic habitat made for a complex system of coloration.

That palette begins simply with the school of blue-gray bar jacks whose silvery hues fade quickly into the color of the water. But others have flashier strategies. The yellow trumpet fish shifts vertically to assume the structure of the stalks of coral surrounding it; or it may align itself with a larger fish shadowing its feeding spot. The rosy hues of the channel crab echo the bejeweled pink patches of crustose algae on which it rests. The delicate brown rosettes on the skin of a flounder are nearly indistinguishable from the pebbly surface of the seafloor. The speckled patterning of the moray eel is in sync with the color and texture of the encrusted coral crevices it inhabits. The multicolored mottled surface of a scorpion fish is indistinguishable from the algae in which it has taken up residence. The dots on the spotted butterfly fish are directional decoys, existing to confuse predators as to where, exactly, their eyes are. Parrotfish secrete a membrane of mucus at night to conceal their odor from nocturnal predators. For all their gaudy displays, each of these is a master of the inconspicuous. There are probably as many strategies for concealment as there are organisms.

Far from the shore, rocks, and coral reefs, the deep ocean offers a more advanced course in invisibility. Without a place to conceal themselves, organisms have developed strategies of transparency, which have nothing to do with pigmentation but instead with patterns of light. Fish might be flat in shape, allowing only a minimum amount of light to pass through them directly. Or they might depend on counter-illumination, a system of tiny, silvery vertical scales that work like mirrors, reflecting the light outward. Or they might emit a glow of their own with photophores, light-producing organs that disorient the predator

species floating above them. Other fish have the ability to scatter polarized light in the water. The marine environment is a polarized light field, a place where light waves travel in a single plane. The lookdown is a fish species that can detect that light and use it to its advantage. Microscopic platelets in its skin enable it to reflect that polarized light to confuse predators, a visual maneuver of interest today to military strategists studying submersive camouflage.

For all the dazzling marine biota here, something ordinary is happening. It is not, of course, a ballet of indifference, but one full of purpose, function, and reason, as well as predation, consumption, reproduction, and all the familiar activities of everyday life. The blue tang floating to my left is looking for algae to feed on; the spotted butterfly fish is foraging for tiny invertebrates; the threads of fire coral will sting me if I happen to brush up against them; and the yellow-bearded fireworm resting on the floor of the reef is equipped with bristles that will inject me with a painful toxin if I happen to touch it. There is a quotidian aspect to the unseen life. Invisibility in the aquatic realm is ordinary and essential to survival.

After a dive one morning, Sherman mentioned the six-foot nurse shark she had spotted. She had swum closer to it to get a good photograph. "I would have been scared," she said, "of course, if it had been a great white. Or a tiger shark or bull shark." Of her demeanor underwater, she says, "I am present, but not self-conscious. I am aware of everything, but I am a part of it." On a swim several days later, we encounter a reef of staghorn coral, a fast-growing species, diminished on these reefs in recent years. Their unexpected proliferation here thrills

her, and even underwater, I can just make out her exclamations of joy. Swimming in and out of its olive-green branches and the clusters of yellow pencil coral flourishing alongside them is a school of French grunts, small yellow-and-silver-striped fish, not so different in coloration from the branches of coral, and their flickering, shimmering presence makes the entire reef feel animated, vibrating, almost electric with interspecies energy.

Moments later we find ourselves swimming alongside several giant barracuda, the largest nearly five feet long, floating gently in that casual manner with which menace so often approaches. It is near dusk, their feeding time, and they are looking for smaller prey fish. We swim slowly in the opposite direction. A spotted porcupine fish with its absurd oversize head floats just above the seabed beneath us. Not long afterward, I encounter an immense hawksbill sea turtle scuttling along the sand, grazing on the algae and seagrass in its path, its three-foot carapace and massive spotted legs advancing with an elephantine poise. "Diving, I lose *me* a little bit," Betsy has said, and this little deficit of self suddenly seems key. It makes sense to me that we take such pleasure in the state of weightlessness. Perhaps it comes not just from the sensory novelty, that thrill of zero gravity, but from some sensation of having a spirit self, some innate knowledge that it can be a good thing to lose the materiality of everyday life.

The aquatic world is as surreal as anything imagined by Salvador Dalí. But the invisible man he painted in 1929, with golden hair made of clouds, legs fashioned by waterfalls, and a torso constructed of architectural ruins, was painted during

what the artist called his paranoia phase, and reflects a horror of being consumed by one's surroundings. The artist's sense of identity was under siege, dissolving, on the verge of being devoured by his environment. It is too bad Dalí never made any diving trips in a tropical sea. Or knew anything about the mammalian dive reflex. What would he have made of a basket star that wraps itself in strands of coral? Or a star-shaped sponge? Or one that looks like an orange elephant ear? Or others in the shape of balls and barrels, tubes, vases, ropes? Or worms that present themselves as silvery feather dusters? Or coral that comes in the shape of pencils, leaves, lettuce, knobs, corkscrews, antlers, fingers, candelabra, wires and strings, dinner plates and doorknobs, cacti and cups, brains and buttons, feathers and fans? Would he have persisted in his paranoia? If he had observed such a carnival forty feet beneath the surface, his invisiphobia might likely have become invisiphilia.

Later, onshore, Sherman says, "I am insignificant, and at the same time, part of something extraordinary." I take it as a reference to this continuity of experience from land to sea, from human to animal to plant, from being above the surface to beneath it; an acknowledgment of a perceived diminishment of a distinct and separate self. It turns out this sense of oceanic concord has a physiological basis, and in recent years, researchers have made advances in their study of how, exactly, we find this sense of membership in the aquatic realm. As in other forms of exercise, swimming and diving generate adrenaline, endorphins, all of them our feel-good neurotransmitters. But immersion also triggers a shift in the balance of catecholamines,

hormones that govern the flow of blood and our involuntary reactions to stress. Which is to say, simply being situated underwater seems to generate a feeling of serenity.

Elizabeth Straughan, a research associate in geography at the University of Glasgow, studies haptics, the way human beings process sensory data. Her work considers touch, orientation, balance, movement, and other ways the body both recognizes its own condition and absorbs information about its place in the immediate environment. Among what she studies is how skin contributes to our impressions of the exterior world. In mapping touch, she observes that our attention to this sense "requires an understanding of how the body acknowledges and negotiates space via visceral, unconscious, and cognitive means." Straughan investigates how our haptic senses engage, influence, and otherwise shape our thoughts and feelings; and the way in which the materials, textures, space, and assorted physical properties of the exterior environment affect human perception and experience.

Straughan suggests that how we remain oriented when submerged is both tacit and active. Kinesthesia, our ability to know which parts of our body are moving and how—our sensory awareness of our physical place in things—comes into play as well. Because water is denser than gas, the gases inside the body become compressed in immersion, and that sensation of physical compression, which divers feel from the water around them at forty feet beneath the surface, intensifies the sense of connection to the immediate environment. "The material texture of the environment—encounters with waters, gases, technologies and the body's visceral and exterior spaces—can bring about

intensities of sensation that diverge from the habitual sensations associated with terrestrial environments," she writes.

Those intensities of sensation are furthered by the essential relationship between breathing and buoyancy. Divers use the first to manage the second: breathing in and filling one's lungs with air may cause the diver to elevate slightly, while exhaling, or removing air from the lungs, causes the diver to go a bit deeper. How one breathes, then, has a direct effect on body position and placement. Above the surface, such attentiveness to slow, measured, and continuous breathing is generally practiced in meditation, but underwater, this connection between breathing, motion, and placement is more intrinsic. Along with buoyancy, the sense of spatial orientation in immersion is governed by our vestibular system, that part of our inner ear that regulates how we maneuver ourselves in physical space. Add to that the body's horizontal axis in diving, a position that for many people evokes flying, and Straughan suggests that the textural qualities of water, along with depth, and relative silence— the kinesthetic experience of place underwater—revise our psychological state. All these sensations, she says, have the potential to "mobilize emotion." Which is why, she suggests, the aquatic world serves for many as a therapeutic landscape, a place conducive to healing.

This is not about vanishing so much as some vital rearrangement of weight, substance, and space. When we see nothing but a vast blue abyss, it is possible for us to associate this limitlessness with freedom. We are affiliated with our surroundings, experiencing inclusion and placement in a wider world. It is not only our sense of space that is under revision here, but also

our humanity. The *overview effect* is the term used in space exploration to define that cognitive shift that astronauts experience when they see the earth from outer space. Viewing the blue marble from orbit, they reevaluate life on earth, reconsidering the significance of regional and national boundaries and our status within them, inevitably reassessing the importance we give ourselves; not surprisingly, when photographs of the earth as viewed from outer space were first taken in the late 1940s, they signaled a shift in human consciousness. Immersion in the deep sea seems to offer some corollary, an "underview effect" perhaps. Although it is a view from beneath rather than from above, from water rather than from space, and an experience of absorption and connection rather than of distance and detachment, it still enables us to reassess our place in things.

Straughan contends that emotional experience can be environmentally specific. Once we have experienced such sensations, can we retain them in some fundamental way? Can memory summon them up or even apply them to other experiences? We don't always need to be recognized. The journalist Lillian Ross once said that it would be foolish on the part of the reporter to assume invisibility. You are there, she said, you are present, and you are probably part of the story and your observations may even affect what is happening. But despite that, you are not central to the story. Or as Betsy says, "You have to notice you're not at the center of things." Or as divers suggest when they say the practice "takes me out of myself."

A yellowtail snapper drifts past. A blue parrotfish skims by beneath me. My presence means nothing to them.

INVISIBLE INK

~~everything~~ *is (in) erasure.*

—FRED MOTEN

Like a lot of kids, I was introduced to the disappearing word through the simple alchemy of lemon juice and lightbulbs. Learn to follow a recipe and you can make words evaporate, and thus followed my archive of invisible letters, poems, journal entries, and confessions, all written with a toothpick. I don't remember what any of them were about, because what they were really about was learning that words can have a physical presence, that they can come and go and sometimes vanish altogether. But when I was a teenager, a more advanced lesson in the ephemerality of language came the morning my father's declassified CIA files arrived in the mail. He was a journalist and biographer, had written for *Time* magazine and later reported as a war correspondent for *Life* magazine. During the fifties, he had lived in Japan, then Thailand, establishing the Bangkok office of the Asia Foundation, an organization founded in an effort to negotiate postwar relations between the US and emerging Asian nations. Now considering writing a memoir,

he was curious about information from this time in his life that had been collected in the CIA archives.

The report was indecipherable. Words, sentences, and entire paragraphs had been blacked out. One page after another was a seemingly random composition of text and geometric shadows obscuring it. I remember my father raising an eyebrow before shrugging it off and gesturing at the file with a dismissive wave of the hand. I remember my mother hooting with laughter. I remember the farcical text lying there on the living room table, an unreadable book that quickly became a family joke. Of course, we wondered at those patches of obscured words. It just never occurred to any of us to *do* anything about it.

It's not that we weren't curious people, but the unknown was also routinely accepted in our household. We even savored it. As a biographer, my father knew about disclosure and how details could be gathered, organized, and discarded to reflect a life. As to those years in Southeast Asia, he knew whom he had met, with whom he had had drinks, what he had seen. I think he had some mild curiosity about what the CIA considered classified. But we all knew to the bone that family life—ours, yours, anyone's—often trafficked in the unknown and the unknowable. What was covert may have been ordinary, banal, but still it deserved its own respect. This ridiculous text was in sync with the culture of the late sixties—the mute button on the TV remote that had been introduced only a few years earlier, the Theater of the Absurd, and the plays of Samuel Beckett in which elusive silences and interruptions carry weight and meaning. And all of these were on the frontier of contemporary litera-

ture, because today the vanished word can resonate just as deeply as those on the page.

"You don't see it, but it's there," says the Dutch book designer Irma Boom, speaking of her 2013 tribute to the scent Chanel No. 5, a book in which no ink has been used. All the text and images in the three hundred monochromatic pages, from the words on the copyright page to the outline of rose and jasmine petals to the quotes from Coco Chanel and Picasso, have been embossed. Each page is pure white, a study in how words can be imprinted without being quite visible. Faint, suggestive, tenuous, an expression of the ineffable, such pages may be suitable for the biography of a perfume, but more than that, they are part of an emerging library of the twenty-first century in which the printed word is, in one way or another, in the process of disappearing. Perhaps Calvino's map of different-colored inks includes those that cannot be seen at all.

The ice library built in the winter of 2017 in Baikalsk, Russia, was a maze of walls constructed of ice blocks, the 420 books in its archive expressions of the wishes and dreams of people around the world; scored into the frozen surfaces in January, the words melted in April. Growing up in a family with limited means, the Chinese artist Song Dong was encouraged by his father to practice his calligraphy by dipping his brush into water and writing on a stone so as not to use up ink and paper. Years later, as an adult, he resumed the practice as a more routine exercise having to do with the evanescence of words, and his writing surfaces have included stone tablets, streets, and sidewalks. In 2005 he came to Times Square and painted on the

concrete pavement a text that evaporated almost instantly in the heat. When I look at the photographs of his work, I see words in the process of disappearing. They are there, and then they are not.

There is nothing new about the vanishing word. Throughout history, it has served imagination, practicality, and sometimes dire need. The Roman poet Ovid urged lovers to write their letters in milk; recipients could then retrieve the messages with powdered charcoal. During the Revolutionary War, George Washington wrote covert messages in tannic acid extracted from gallnuts. Linus Pauling tried to make invisible ink from bacteria. Among the 930,000 recently declassified CIA documents from 1969 were assorted homespun formulas for invisible ink, many of them surprisingly lyrical. "Take a weak solution of starch, tinged with a little tincture of iodine. This bluish writing will soon fade away," reads one suggestion. Elsewhere, letters written in a solution of cobalt chloride can become visible simply from the heat of the human body; upon cooling, the writing will vanish. And writing "made with vegetable oil or fruit juices, such as onion, leek, artichokes, cabbage, lemon, etc. [may] become visible by being ironed with a hot flatiron." A different form of necessity drives other erasures. Prisoners sometimes use urine. During her exile in a labor camp, the Ukrainian poet Irina Ratushinskaya used the end of a matchstick to write her poems on bars of soap, washing them away later, after she had memorized them.

The value of the vanishing word in human communication has only grown in the age of information overload. In an unexpected kind of way, the blank page, the faded word, the deleted

sentence all seem to suggest that fugitive expression has become cogent and timely, taking a greater hold on our imagination. It only makes sense. We may not be prisoners trying to get our messages out, but we are captives of the information age, which has multiplied immeasurably the volume of communication. The perpetual exchange of data—whether through Twitter, Facebook, Instagram, Tumblr, or Pinterest—is now part of ordinary life. Where there was once the evening news, there is now the twenty-four-hour news cycle. When I check for winter weather bulletins on my local forecasting website, the storms have all been given names that pop up on the screen along with banners for animal rescue agencies, ads for orange juice, and money market rates from a local bank. A friend of mine who is an actor tells me that it is no longer enough to see the film; to absorb the full cinematic experience, one must see the director's cut with the backstory and alternative endings. At one time magazines were published with a single cover; today I received in the mail a magazine with three covers.

Why wouldn't we develop a taste for the blank page? Deleting text and images has become as much a part of contemporary communication as creating them, whether it's the fast-forward function on a DVR or ad-blocking software. *Of course* my iPhone has an Invisible Ink feature that allows text messages to be concealed behind blurry animated pixels; when tapped, the circus of dots only momentarily coalesces into recognizable words and images. *Of course* there is now a messaging service, called Signal, that deletes user data and that encrypts electronic messages in such a way that they are unintelligible to anyone but the intended recipient. (Customers for the service

reportedly increased by 400 percent after the 2016 presidential election.) *Of course* there is now a device that blocks the news crawl. *Of course* my local Staples superstore has an entire aisle of high-performance, auto-feed, jam-proof, crosscut power paper shredders. *Of course* the elimination of words and images serves as an antidote to the blizzard of those surrounding us. *Of course* we talk today of "unseeing" things and "unsaying" things, as though these were things humans could actually do.

But for all the ingenuity of such emerging technologies, artists and writers may argue most persuasively for elusive expression. In 1953, Robert Rauschenberg, a bottle of Jack Daniel's in hand, went to visit the painter Willem de Kooning to ask him for a drawing that Rauschenberg might then erase. De Kooning reluctantly offered up a drawing he had made using ink, crayon, pencil, charcoal, and oil paint. Using dozens of rubber erasers, Rauschenberg spent months eradicating the marks. The final work, *Erased de Kooning Drawing*, has been called everything from a protest against abstract expressionism, vandalism, and defacement, to patricide and an act of nihilism, but Rauschenberg himself described it as "pure poetry." The marks—rubbed, scraped, ground down to next to nothing, and in the end only a ghost of the original—suggest that the material process of drawing could be subverted, reversed; and that undoing can be graceful, selective, skillful, and refined.

Cy Twombly's calligraphic canvases seem to have been scribbled and erased in the manner of chalkboards, quick and improvised disappearances, and instantaneous and fleeting gestures. Bruno Jakob's series of invisible paintings bear only the

imprint of light, air, and water—exercises in the indelibility of the unseen. Zhang Huan uses ash, the very epitome of material reduction, collected from the incense burned at Buddhist temples, to transcribe sections of the Bible in braille, a language that is intended to be unseen. Jenny Holzer's redaction paintings blow up declassified war documents into an exploded scale, highlighting prisoner abuse, government secrecy, and ways in which military information is hidden, obscured, and otherwise reshaped for public view.

Each of the monochromatic date paintings of On Kawara simply bears its date, the white letters and numbers painted in a sans serif typeface on a red, blue, or gray ground; the headlines and facts of the day are sealed inside the box created for each painting. Influenced as a child by the bombings of Hiroshima and Nagasaki, the artist was consumed by the act of marking days, memorializing the passage of time, and the work suggests that human experience can be framed by containment and reserve. Not surprisingly, the artist rarely gave interviews or appeared in photographs.

The artist Ann Hamilton's 2004 installation *Corpus* at MASS MoCA featured a ceiling-mounted mechanism that methodically scattered millions of sheets of blank translucent onionskin paper, one at a time, across the floor of a large empty room, where they collected in drifts and piles; later, the machines retrieved them. The cycle repeated itself for days, weeks, months. "You can see the paper as empty of words or full of space . . . for the blank paper, like the open mouth, is the possibility of speaking or writing," the artist wrote of her installation. But the

afternoon that I walked through the space, the way the white squares floated to the floor suggested that the physical presence of unspoken things is enough sometimes to fill a room, or a life.

But quiet may have its greatest urgency in contemporary poetry. *Frolic Architecture* by Susan Howe takes its name from Emerson's description of the random chaos of snowfall. The poems, composed after the sudden death of Howe's husband, are collages of words and sentences taken from the writings of Hannah Edwards Wetmore, an eighteenth-century woman who recorded her own privations. The snippets and scraps have been reconfigured, words lifted off the page by "invisible" Scotch tape, others overlaid across each other, some centered on the page, others sliced up and scattered at the far edges of the margin, different lines of type following different axes, but all of them tentative, fragmented, seemingly layered with silence. And in her book *Nets*, artist and poet Jen Bervin has used Shakespeare's sonnets to produce her own series of poems. The original text remains recessive, floating faintly on the page, but Bervin has lifted some of the words out in darker ink, in effect both distilling and reimagining the original.

Mary Ruefle's erasure books transform the meaning of antique texts—handbooks, forgotten novels, almanacs, books of ancient advice—by the absences of words. Using correction fluid and bits of tape, she disappears words, leaving only a handful on each page that, once realigned, convey a new, different, elusive meaning. The books speak to the way in which words, phrases, or entire texts can become reconfigured in time and memory, and to the idea that experience itself may be written with a soft pencil, its marks easily rubbed away. I own one of

these books, a small manual for the game of Patience published in 1870. In a chapter called "The Legitimist," all the words on one page have been obscured by Wite-Out, but for "You must be very careful to observe when you are inattentive." Page after page, one such ellipsis is followed by another and another, a record of how thought, knowledge, and awareness might be omitted over decades, and perhaps most of all, how patience, the act of waiting, is itself an erasure of time.

"Life is much, much more than is necessary," Ruefle has said when speaking of this work, "and much, much more than any of us can bear, so we erase it or it erases us, we ourselves are an erasure of everything we have forgotten or don't know or haven't experienced, and on our deathbed, even that limited and erased 'whole' becomes further diminished, if you are lucky you will remember the one word water, all others having been erased; if you are lucky you will remember one place or one person, but no one will ever, ever read on their deathbed, the whole text, intact and in order." Despite being manifestos on the ephemeral, Ruefle's work is tactile—these are real, tangible books a reader can hold in her hand, material proof that words are susceptible to erosion. That explains why she says, "When I am working on these, I don't feel like I am erasing anything. I feel like I am creating something, bringing it into existence. It is not about some negative takeaway. And I am thinking more of visibility than invisibility." Inevitably, the absence is weirdly palpable, substantial even.

Other erasures are more conceptual. In his poem "Home Force: Presumption of Death," the poet Joshua Bennett removes words from the text of Florida's so-called stand your ground

law, reconfiguring those that remain into a powerful indictment of the violence visited on the undefended. In his poem "Seven Testimonies (Redacted)," the writer Nick Flynn has reshaped the testimonies of Abu Ghraib detainees to compose a new and searing record of those ways in which torture expunges identity; honoring the spoken words of the prisoners, he includes the original transcripts of their depositions in the back of the book. Jonathan Safran Foer's *Tree of Codes* is a die-cut reconfiguration of *The Street of Crocodiles* by Polish-Jewish writer Bruno Schulz, a series of stories about a mythic city; the street in question is represented on the map as having the whiteness of an unexplored polar region. In Foer's iteration, erasure is a tactile matter, a visceral cutting that borders on literary violence. Absence comes with its own sharp, brittle edges, the carved-out pages fragmenting the text. Foer has described the process as akin to making a gravestone rubbing, or transcribing a dream that the book might have had, saying, "I've never memorized so many phrases or, as the act of carving progressed, forgotten so many phrases." Vanished words convey as many meanings as those that are visible.

By now, fooling around with disappearing words has shown up in more prosaic, commercial enterprises, such as all those gag books that have been left blank, with titles like *What Every Man Thinks about Apart from Sex*, *The Joys of Getting Older*, or *The Wisdom & Wit of Sarah Palin*. In 2006, the Croatian advertising agency Bruketa & Zinic designed an annual report titled *Well Done* for the European food manufacturer Podravka. Tucked inside the pages of the larger financial report was a booklet with

recipes and illustrations. First appearing blank, the smaller book was printed with thermo-reactive ink and could be read only after it had been wrapped in tinfoil and baked in the oven for twenty-five minutes.

On its website the literary publisher Wave Books offers a link that allows visitors to compose ghost poems by reshaping original work from such authors as Virginia Woolf, Henry James, Herman Melville, and Immanuel Kant. "Erasure is a process by which you can take any text and from it, create a poem," the website explains. The authors' original text appears on the screen, and by simply clicking on the word, the visitor can make it disappear or reappear. Visitors to the site can see the reconstructed poems, click on the original, and if they choose, work on further iterations of the existing erasure poem. The site also offers a random poem capability that simply does it for you: click on the link, and 50 percent of the words on the page disappear, though without any apparent logic, order, or regard for text. Voilà! A found poem!

Like the words that need to be baked before they can be read, it all seems a bit facile or weirdly presumptuous at first, a glib exercise, a parlor trick for the literati, a novel dinner party game or some variation of Scrabble or Boggle. Except, in this case, it is not simply the letters you are juggling but the space around them. But if the act of stringing words together can be impromptu, quick, and improvisational, so, too, can vanishing them. I visit the link more than once, finding it a mesmerizing reverse crossword puzzle in which one creates blank spaces instead of filling them. I am not by any means writing a poem, but

discovering a handful of small facts about how silence is part of language and how different absences on a page can convey meaning.

Erasures are generally thought to have begun with censorship, with the significant words cut out of war letters and with redacted war reports. But in 1973 the gaps in the story became the story itself. The discovery that over eighteen minutes of a tape-recorded conversation between then president Richard Nixon and his chief of staff, H. R. Haldeman, had been erased fueled a criminal investigation that ultimately forced Nixon's resignation. Questions persist to this day as to how and by whom the erasure was made, but there is no doubt about it helping to demolish a presidency. That minutes as well as words, time as well as language, evaporated seems to have given the incident further power. The gap in the tape was a landmark not only in political deviance but in broader human exchange just as surely as Rauschenberg's eradication of the de Kooning drawing had been in art twenty years earlier. Even today, the phrase *eighteen and a half minutes* conjures not simply a lawless president but also the enduring and enigmatic power of which erasures are capable.

Walk through the streets of New York, and you will see the ghost signs—advertising messages once painted on the sides of brick buildings—hawking oil, paper, and clothing. Now they have become faint vestiges, a typographical archeology. Many of them are landmarks beloved by preservationists for their very frailty. Faded words, those almost but not quite forgotten, can have status in the human imagination. WOLF PAPER & TWINE Co., reads one such sign in a neighborhood I often visit, the

ephemera both of the goods and the fading letters underscored by the solid brick building.

How many different ways are there to lose words? They can vanish through ordinary disinterest or casual disuse, or carelessness, indifference, and shifts in attention. In his book *Landmarks*, a title that refers to language and landscape alike, Robert Macfarlane notes the decision by the editors of the new edition of the *Oxford Junior Dictionary* to delete some words, *acorn, adder, ash, beech, bluebell, buttercup, catkin, concert, cygnet, dandelion, fern, hazel, heather, heron, ivy, kingfisher, lark, mistletoe, nectar, newt, otter, pasture, willow,* and to add others, *attachment, block-graph, blog, broadband, bullet-point, celebrity, chatroom, cut-and-paste, MP3 player,* and *voice-mail*.

In her book *When Women Were Birds*, Terry Tempest Williams describes the way her mother left her journals wrapped, instructing her daughter to look at them only after her death. A month after her mother died, Williams finally braced herself to approach "the three shelves of beautiful clothbound books, some floral, some paisley, others in solid colors," only to find that all of these, one after the other, were full of blank pages. To give her disclosure full force, Williams follows it in the book with twelve blank pages. Williams then finds their myriad identities, among them a transgression, a scandal in white, a collection of white handkerchiefs, a harmony of silence, a projection screen, a blinding light, a paper cut, a wound, a stage.

She thinks of them as paper tombstones as well, and I suspect that the tradition of erasures began in the cemetery, with names and dates on gravestones long since eroded by centuries of rain, snow, sand, wind, and other forms of weather

censorship. Because time is what redacts the facts most. My parents both died more than thirty years ago, and the imprint of their names and the dates of their lives remain clear on their granite headstones. But it is an old cemetery, and just a few feet away are markers made of limestone that have been pitted with acid rain and others made of sandstone now powdering with age. The letters and numbers etched onto them have become indecipherable. Sometimes it helps to touch the stones, to feel out the letters, but not always.

What becomes extinct first—the object or the word? Is it possible for one to rescue the other? That was a question posed by *Seeing Red..Overdrawn*, a 2016 exhibition addressing global conservation in the David Attenborough Building, a research center for biodiversity in Cambridge, England. In an effort to recognize the increasing threat of extinction to some eighty thousand plant and animal species, the show looked to a reverse process originating with erasures that might be made visible. A wall of text, twenty-two feet wide and nine feet tall, cataloged the 4,734 species currently at greatest risk, their Latin names printed in nearly imperceptible letters: *Niceforonia adenobrachia*, a species of frog found in Colombia; *Partula guamensis*, a tiny tropical land snail; *Murina tenebrosa*, the gloomy tube-nosed bat found in Japan. In a process not unlike the one used by Jen Bervin to bring forward selected words in Shakespeare's sonnets, viewers were invited to overwrite the letters with an indelible pen, thereby bringing the barely discernible names of the threatened species into sight, into visibility, into public awareness.

We are all conversant with words that should have been, but

were never uttered; words that have been forgotten or those we wish had never been said. I once received a poignant quiz sheet from a student who had not done the reading. At the top of the page in tiny, cramped lettering were the words *I did not do the reading and I don't know anything about this*, and beneath them, as proof of his ignorance, the vacant page. I considered framing the quiz. It could belong to any one of us. But the blank page is not necessarily empty of words. The power of human speech comes in knowing what to say and knowing, really *knowing*, not everything can be said. The very phrase *read between the lines* refers to this universally accepted fact. "Speech—in literature as in life—can crucially suggest what is not said," the novelist Shirley Hazzard once said. Ernest Hemingway devised an entire style of writing based upon intentional omissions, explaining, "The dignity of movement of an iceberg is due to only one-eighth of it being above water."

There is something about being alive during a time called the information age that means we need to be reminded of this. It could be some interior voice that has the inflection of something your mother once said, the words of your best friend from fifth grade, some doubt or fear, some piece of background music or a noise in your head, some echoes from all the interior messengers we listen to—and don't—that remain vaguely present in the way we think now. And when Irma Boom says, "You don't see it, but it's there," she is reminding us of that. She is reminding us of the beauty of the implicit in the age of the explicit, and she isn't just talking about the history of a French perfume, but about all those things you hope to say, all those things you will never say or that you wanted to but didn't or

that you did but needed to erase, all those things that are impossible to say, all those things you said to me but that I have since forgotten, all those things I hope to say someday to you or you or you, all those things that may just as well be written with water on stone.

The unspoken has an accuracy of its own. The unreadable book of my father's life had an obscurity that made it a precise and articulate profile, and no personal branding strategist of 2018 could have done a better job than those CIA staffers half a century ago. As a New Englander, my father had a reserve that was the product of both genetics and geography, and his interest in how human experience is shaped by memory was lifelong. He understood that memory and loss are inseparable, and barely bothered to read another novel after Proust. When I was growing up, he told me more than once that the human mind was designed to forget, designed to filter information and select the things that mattered, and that it sometimes succeeded at this, but not always.

I thought of him recently when I read of a scientific paper proposing that one of the functions of sleep is to distill memory, thus allowing the brain to recharge by reviewing the neural connections made that day, sifting through them and shedding the extraneous. The brain discards so much more than it keeps, my father would say. With all its shadowy omissions, the redacted file captured him perfectly.

AT THE IDENTITY SPA

*I feel I'm anonymous in my work. When I look at the pictures,
I never see myself; they aren't self-portraits.
Sometimes I disappear.*

—CINDY SHERMAN

Not long ago, a classmate from high school emailed me an old photo of our graduating class. The usual range of reactions—nostalgia, delight, curiosity, wonder—washed over me. Who were we all then, that assembly of some sixty girls in our white dresses, lined up on the chapel steps on a spring morning? Some were looking directly at the camera, some laughing; others were distracted, looking away and hair blowing, one with her back turned entirely.

Of course, I looked for myself in the photograph. The face of one girl with long brown hair is partially hidden, and I wonder whether that is me. Another is looking away from the camera, and another is barely more than a smudge. I search for my own face, enlarging the photograph on the screen of my laptop to the point at which its magnified pixels become distorted, abstract shapes empty of information, before it finally comes to me: I had skipped the photo shoot! Anxious to be out of high

school as fast as possible, and as irate, impatient, and dismissive of such pointless sentiment as only a teenager can be, I had bypassed the entire enterprise. Perhaps I had imagined that being out of the photo could put me out in the world more quickly and efficiently. Now, decades later, I would like to be included in this panoramic portrait of the past—which, I realize, is typical of the ambivalence we so often feel about our own disappearance. Sometimes it is what we crave and sometimes what we regret.

Even all those years ago, I knew the emotional power of slipping out of the picture. What was a minor act of transgression back then might today be a small piece of digital art. Absence as a social statement, possibly. Or today, I might just as easily photoshop myself into the picture, as a feminist assertion maybe, or an effort to reinvent the traditional graduation ceremony. Or perhaps I would do none of this, indifferent to this particular absence with the knowledge that my image was strewn across a variety of social media sites. Today, identity and images of coming and going, appearing and disappearing, have become part of visual culture. Since the eighties, Cindy Sherman's self-portraits have offered a primer on the extravagance of modern personas. She poses as a faded film star, a renaissance painter, a *Playboy* centerfold, a clown, a career girl, a housewife, a socialite. There is no end to who she can claim to be through the use of makeup, costumes, prosthetics, darkroom technology, and digital manipulation. And if she is suggesting the self can be a mixtape, she also notes her own sense of anonymity and her knack for vanishing within the multitude of characters she has invented.

Since then, issues about identity have only become more prominent. We recognize variabilities in race, ethnicity, and gender. Since Michael Jackson pioneered this field of enterprise—child or adult, gay or straight, black or white—the plasticity of self has become more routine, and in the time of Caitlyn Jenner and Rachel Dolezal, we increasingly accept that pliability. Sexual identity is less fixed than once assumed, and traditional gender binaries have become obsolete; sex is biological, but gender is a social construct that reflects cultural attitudes and behaviors. Race and ethnicity are nearly as mutable. In 2015, according to a report from the Pew Research Center, close to 7 percent of all adults were multiracial, a number expected to triple by 2060. But how such identities are formed is not limited to genetics. "It was kind of an eye-opener to us that multiracial identity, it's more than just the people who make up a family tree, it's also a product of experiences or attitudes," says Kim Parker, the director of social trends research at the center.

But in that disquieting manner in which contemporary culture so often seems to move in opposite directions at once, it seems that the more we acknowledge the fluidity of our identities, the more ways we find to detect and classify our characteristics. Video games, digital media, and social media platforms allow us to imagine avatars and contrive new selves. While many of these are purely aspirational, Facebook admitted in 2017 that some sixty million accounts were based on invented identities. And *deepfakes* is the term used for the emerging practice of stitching fictional digital material into images of known and recognizable people; voices, gestures, and facial expressions can all be digitally replicated to create the credible double, whether for

purposes of propaganda or porn. But for all the advances in electronic disinformation, other emerging technologies work just as hard to confirm our genetic and biological selves. Facial recognition technology routinely used for security, surveillance, and smartphone passwords relies on such measurements as the distance between the eyes, the slope of the nose, and the angle of the chin, then matches the calculations with information in its facial-data bank. Biometrics—templates that use such facial dimensions and contours, along with fingerprints, iris scans, ear shapes, skin patterns and luminescence, voice recognition, heart rate, hormone levels, and brain waves, to confirm identity—is increasingly used, and not just for surveillance. DeepFace, the name given to Facebook's comprehensive pattern recognition software, is capable of considering aging, pose, illumination, and expression and can make a match even when a face is obscured or turned away from the lens. Though largely unregulated and used without subjects' consent in the United States, facial recognition technology is error-prone, more adept at identifying white men than darker-skinned women. Rekognition, Amazon's facial recognition service, purportedly intended for use in law enforcement, has been decried by the ACLU for its threat to civil liberties—none of which has slowed the use of such programs by sectors of American enterprise ranging from finance and healthcare to entertainment and retail marketing.

But the human need to be seen has its limits, and no sooner is such technology developed than privacy is imperiled. The more difficult we make it for hackers to find our most identifying traits, the more we collect and surrender our most essential information. Of course this raises questions. Why leave the

nuances of biometric recognition systems to political opera-
tives, marketing executives, and security staff at the mall? Visual
imagery is what helps us to think through not just identity, but
also how it comes into being, how it emerges and vanishes.
Contemporary digital media may offer myriad ways to ex-
plore identity, but the conclusions remain ambiguous: identity
is plastic, but all the same, you are who you are. Identity is both
fixed and fluid. And the range of graphic possibilities has come
a long way since the midnineties when Tibor Kalman, editor of
Colors magazine, presented the pope as an Asian man, Queen
Elizabeth as a black woman.

The compulsion to assemble and disassemble identity is as
old as the camera itself; images have always helped us reconsider
and reinvent family history. In my husband's collection of family
photos, a black-and-white picture has been ripped down the
middle, his mother as a young woman, smiling as she looks at
the camera, alongside an abrupt tear in the paper, the figure of
her husband excised after the divorce. Vanished partners, alien-
ated parents, and estranged siblings can be edited out of family
pictures with a material rip as brutal as the rupture of the break
itself.

But technology now allows for addition as well as subtrac-
tion. At an annual gathering of my college friends in Vermont's
Green Mountains, those unable to make it up for the weekend
are photoshopped in by one friend; though absent, they are still
sitting only slightly awkwardly on the steps or by the porch rail,
reaffirming the inclusive spirit of our extended family. We
can not only imagine that the full assembly is present, but also
prove it. In one such photo taken several years ago, a man who

happened to be in New York City that weekend appeared on the Vermont porch tossing a basketball to some hoop outside the frame. This magical realism was consistent with the way our longstanding friendships are integrated—seamlessly, unpredictably, and mysteriously—into geographically remote lives and experiences.

The amended photo and dissolving self-portrait are becoming familiar emblems of our time. Shortly before his death in 1987, Andy Warhol printed a series of acrylic silkscreen self-portraits in which his face, floating against a black ground, was printed with military camouflage patterns. With his face broken up into irregular color patches, some in mottled greens and beiges, others in pink, scarlet, turquoise, the image spoke to how we remain remote, hidden, unseen, unknown to each other, all the while projecting identity.

In his 2016 series of black-and-white paintings, Japanese artist Tomoo Gokita recalls the glamorous photos of film stars and celebrities of an earlier age, offering images of lounging women, Playboy Bunnies, geishas, pinup girls, women in cocktail dresses, entire families, and wedding parties. But the faces of many of these characters have been obscured by a splotch of paint, a smear, an object. So we know these masked figures by their clothes, their objects, their mannerisms, their accessories, and by the people they are with, all of which have replaced facial characteristics, the primary means by which we have always identified one another. What, exactly, constitutes identity today? the artist asks.

In 2016, for a fashion shoot for *New York* magazine titled *Self-Less Portrait*, Maia Flore served as both photographer and

model; throughout the series of images, she concealed her face, hiding it in a wrap of shining hair, turning away from the camera, stepping behind a closing door. This is not about coy discretion. In an age of spyware and deepfakes, even fashion models might deserve a bit of obscurity. Photographer Stephanie Syjuco also became her own model in her series "Applicant Photos" which riffed on the ID pictures refugees must submit for immigration and asylum applications. Shrouding herself in vividly patterned textiles, she constructed faceless personas depicting both the migrants' social invisibility and their need to be hidden. The vibrant graphics of the fabrics evoke dazzle camouflage as well, causing further misconceptions about the subjects' identities. Conveying the anguishing enigma that arrival and acceptance also often require disappearance, the seemingly casual portraits speak to greater human concerns.

Ed Atkins, an artist who has constructed portraits that use what is called "performance capture technology," used facial recognition software to document one hundred people reading a script he had provided, recording their voices, gestures, and facial expressions. He then downloaded all this information— the words, the intonations, the features of their faces—into a single avatar, where they converged in one virtual and disembodied (male) figure. The ghostly head and limbs float on the vacant screen, as though he might be the creepy distant uncle of the kid in the Halloween black bodysuit. As one critic wrote:

The body we see is an amalgamated avatar and just like the
vocal notations, facial expressions once confined to an individual,
are now universal. As some artists reach for a pen or paper,

Atkins has delved into the fingerprints of what makes us each unique but stripped of memory and familiar body structure. It is the ultimate doppelgänger of nothingness, a proposal of existence and the allusion of reality, with a singular amputated body.

The self-portraits of Alec Soth propose a visit to a kind of identity spa. Posted on Instagram, his "unselfies" capture Soth's face veiled by all manner of ephemera: water, mist, snow, ice crystals, a cloud of steam, a glass of water, a sudden movement, a reconfiguration of pixels, a ball tossed into the air, a camera he is holding up in front of his face, a lily pad on the surface of a lake. The elusive head shots suggest the polar opposite of facial recognition technology, maybe facial amnesia technology or facial dissolution technology; rather than pinpointing the measurements of facial characteristics, they obscure them with a poetic overlay. His images remind me of the kitchen facials that my mother used to concoct, boiling a huge pot of water on the stove, tossing in a handful of herbs from the mountains of Switzerland, and then putting a dish towel over her head to let her skin absorb the aromatic steam. Or she might use egg whites or yogurt; bits of sand; a handful of minerals; a green paste made of seaweed, honey, oatmeal, and papaya, as though any of these ordinary household ingredients might be enough to rearrange the human face. Transform it, even. Any of these, it seemed, might be a mask capable of realigning one's skin cells, facial muscles, expression, and at times, even one's very way of being.

Soth's self-portraits suggest a different kind of cellular reconstitution. His images exist as some distant alternative to facial recognition systems. What is it that obscures our identities?

the photographs ask. A puff of smoke, a ripple of water, sadness, anxiety, fear? And under what conditions do we vanish? What is it that makes us known? And unknown? The evanescence of the pictures also implies that there are times that being unseen and unidentified require imagination, the same ability and precision that go into being seen. Soth's self-portraits are evidence of something easily forgotten in the age of transparency. Who we are is not just how we are seen, but how we are unseen. Opacity may be a legitimate way of reimagining ourselves. Our presence has to do not only with how we reveal ourselves, but also with how we conceal ourselves.

Perhaps the most powerful images of the unseen face are those found in the paintings of American artist Kerry James Marshall. Riffing on Ralph Ellison's image of the invisible man, the face of Marshall's subject vanishes into the ground of black pigment, though his eyes continue to gleam, his smile continues to glow. He may not be seen, but he can speak and he can see. He is there and not there, and if he happens to be receding into the ground, the shining whites of his eyes confirm that he is fully occupied by *seeing*. He may be invisible, but he is equipped with voice and bright vision. Marshall's subject is simultaneously absent and present, his immateriality conjoined with radiant authority.

In his 1821 essay "On Living to One's Self," William Hazlitt wrote of being "a silent spectator of the mighty scene of things" rather than an object of notice and attention. He advocated taking an interest in the affairs of men without seeking their notice. And if one takes in the world through "the loop-holes of retreat," Hazlitt said, one

sees enough in the universe to interest him without putting
himself forward to try what he can do to fix the eyes of the
universe upon him. Vain the attempt! He reads the clouds, he
looks at the stars, he watches the return of the seasons, the falling
leaves of autumn, the perfumed breath of spring, starts with
delight at the note of the thrush in a copse near him, sits by the
fire, listens to the moaning of the wind, pores upon a book, or
discourses the freezing hours away, or melts down hours to min-
utes in pleasing thought. All this while he is taken up with
other things, forgetting himself.

Pay attention to what's around you, he's saying. And im-
merse yourself in your immediate world. And while you're at it,
get over yourself.

What would Hazlitt have had to say about biometrics?
Would the team of researchers at DeepFace consider hiring him
as a consultant? Hazlitt was about as politically and socially en-
gaged as possible, a philosopher, a critic, an essayist. Yet he ad-
vocated not just for contemplation and solitude, but also in fact
for "forgetting himself." Such amnesia probably fell out of vogue
when in 1900 Freud published *The Interpretation of Dreams*, but
its appeal seems to be returning. A European high court in
2014 demanded search engines grant users the right to be for-
gotten when their archived information has become outdated,
incorrect, and irrelevant.

Contemporary identity politics ask for a deep appraisal of
what makes us who we are. We all want to be recognized and
identified precisely and accurately. We want the images we
have of ourselves to be true. We want language to reflect this

and ask that the pronouns used in gender identification be the correct ones. But is there a phase of identity politics we have yet to acknowledge? Perhaps even more critical, in the end, is thinking about identity less. Decide who you are. Then let it go. Ancestry tourism is big business, and Ancestry.com and 23andme.com have offered us precise portraits of our ethnic heritage and genetic stock. Facial recognition systems, retinal scanning, and biometric tools that can read everything from voice and heart rate to hormone levels and brain waves have given us nearly infinite new ways in which to know ourselves. Now if there were only as many ways to forget ourselves.

In a picture of David Bowie circulating on Twitter after his death, he is wearing baggy cargo shorts, a T-shirt, and a baseball cap, walking down the sidewalk in New York City, seen by no one except the photographer. For all the myriad personas the musician and cultural icon was known for throughout his career—Ziggy Stardust, the Thin White Duke, Major Tom, Aladdin Sane—he was also the poet laureate of invisibility, capable of passing unnoticed. No one understood the creative possibilities of inventing identity better than Bowie, but he valued vanishing just as much.

Perhaps this skill most endeared him to his fans. Disappearing is hard won today. I suspect it remains a novelty to my sons, as antiquated to them as my grandmother's silver asparagus forks once seemed to me. The boys are in their late twenties now, and social networking captivates them less than it once did. But as one of them tells me, "I could delete my Facebook page, my Instagram posts, Snapchat, all of it. But technically, it's always there. Someone *could* find it. Even if it's not there, it's

psychologically there." My sons could detach from social media, forgo online banking and Gmail, stop using electronic devices that signal user location, and post misinformation about themselves online. It still wouldn't be enough. Digital identity has permanence. The General Data Protection Regulation—adopted in 2018 in the European Union to allow individuals to control online information about themselves—includes "rights to erasure," but no such privacy legislation has been passed in the United States. There has not yet been a determination as to whether it is a basic human right or a suppression of free speech; whether it offers a practical digital eraser or violates the First Amendment. It makes sense, then, that ghosting has become a verb, something that is *done*, vanishing without notice, whether it is leaving the room abruptly or ending a romantic affiliation brusquely. Drop out of sight, become a phantom, go home to do the laundry and don't return. Maybe the perpetuity of one's digital persona justifies—or at least explains—the wishful finality of stepping out of the room.

Ripples is a new technology that uses 3-D printing and an ink-jet to allow baristas to reproduce photographic imagery on the foam in a cup of cappuccino. The image used in the marketing is, not surprisingly, of the customer. Of course, sitting in a coffee shop, gazing into the surface of the cup, is often a moment for self-reflection. But an inkjet image of your face surely goes to an extreme where self-awareness becomes self-involvement. Narcissus appears in each culture and each generation in his own particular guise. But is this evidence that we are capable of stamping our personal imprint on anything? That we are capable of seeing our own reflection anytime, anywhere?

Or does it suggest that our identities may dissolve as easily as latte foam? And that who we are is a matter of evanescence?

And I take another look at the high school class photo. The DeepFace recognition technology I envision has algorithms capable of considering time as precisely as it considers the geography of a face; and it is one that would be capable of putting me in the picture, revealing the face of the girl I might have been on that graduation morning. It would capture her age, pose, expression, the illumination of the day; take in the precise measurements of her facial characteristics; whether she was smiling or frowning or just looking into the distance. I am curious about that past self and would like to see her again, know her dimensions.

Yet I'm glad she's gone. I remember how important it was to my sense of being that spring morning so many years ago, to excise myself, to be *out of the picture*. I was only then beginning to learn how weirdly reaffirming it could be to *not be there*. I was only then beginning to learn about the power of absence. Perhaps I was playing some teenage version of hide-and-seek. I learned then that vanishing was a privilege and the ability to disappear, a gift. I picked up some sound advice about both not long ago from James Burns, an Episcopal minister. About as powerful a petition as I have ever heard for invisibility, his suggestion is to "first learn to love yourself. Then forget about it and learn to love the world."

THE ANONYMITY PROPOSAL

*For the growing good of the world is partly dependent on
unhistoric acts; and that things are not so ill with you and me
as they might have been is half owing to the number who lived
faithfully a hidden life, and rest in unvisited tombs.*

—GEORGE ELIOT

I generally cherish my rural life in New York's Hudson Valley
and know that my sense of who I am is derived in part from
the subdued landscape—the view to the grove of black locust
trees just out the window, the marsh across the road that fills
with cattails and purple loosestrife in midsummer, the sweeping
curve of a distant ridgeline against the sky. But part of me still
knows there is no better way to begin the day than in Grand
Central Terminal in midtown Manhattan. On those mornings
when I find myself swept along by the stream of humanity
pouring through the station's main concourse at rush hour, I
confront the strange comfort of losing myself completely.

The constellations are mapped in the vaulted ceiling 110
feet overhead, the stars, themselves in gold leaf, and the color of
the sky, said to be modeled after that of the southern Mediter-
ranean from October to March. But that remote celestial order

is nothing compared to the concord on the 450-foot-long concourse below, where some 750,000 people a day manage to maintain their sense of momentum and direction as they pass through. There is no single direction, no collective brain or superorganism, and yet the vast sense of social congeniality is something to marvel at.

Though carried by the currents of commuters streaming through the vast marble corridors and canyons, I rarely bump into anyone. Instead, we are all turning and swerving in an improvisational choreography, our pace quickening and slowing in sync with those around us. I am certain it is sustaining for regular commuters to experience this each morning, to be a member of the ordered crowd and to be reminded of our aptitude for social cohesion. Whatever disturbances and frictions we may experience later in the day, for a few moments in the morning, we are entirely capable of moving through this world as one of many. Our place in things shifts.

Grand Central was completed in 1913, when a rapidly growing urban population coincided with the emergence of industrial transportation. The terminal proposed a visionary strategy for accommodating crowds, viewed more routinely then as chaotic, threatening, and unmanageable. The crowd's capacity for spontaneous collaboration had yet to be studied, but with its cerulean heavens charted overhead, the main concourse especially presented itself as a majestic interior public square for the emerging metropolis, a civic space designed not simply to accommodate large numbers of people, but also to celebrate their capacity for improvised order.

The idea of the gorgeous multitude had been articulated a

few years earlier in an essay in the *Atlantic Monthly* called "Making the Crowd Beautiful," by Gerald Stanley Lee. In an anthem to what he calls crowd civilization, Lee salutes the human potential for collective behavior, suggesting that it is through the arts that our numbers achieve their greatest accord. He hailed the modern orchestra as a "republic of sound, the unseen spirit of the many in one." An urban block constructed of steel-framed buildings is "a masterpiece of mass, of immensity, of numbers," and the phonograph was "an invention which gives a man a thousand voices; which sets him to singing a thousand songs at the same time to a thousand crowds." The Brooklyn Bridge, because "it expresses the bringing together of millions of men," is a symbol of our modern genius.

When Lee wrote his hymn to the multitudes, the population of the world was about 1.5 billion. One hundred and twenty years and nearly six billion people later, the conduct of crowds has become a field of science. Swarm intelligence looks to the flocking behavior of ants, starlings, migrating fish, and, of course, humans. Physics, behavioral science, and engineering all study crowds and our instinct for social collaboration. Video technologies and computer modeling allow us to track and document the self-organizing dynamics and fluid movement of groups. Unorchestrated crowds can be orderly, and although less rhapsodic than Lee's prose, quantifiable data have been compiled about those ways in which spontaneous order can be engineered and programmed. In a crowd we are simultaneously taking in the density and direction of the people around us, and by trying to get to our own destinations as efficiently as possible, we intuitively observe the same rules of motion as those of

swallows, herring, and ants. It is a simple formula of avoidance, alignment, and attraction; that is, sensitivity to the proximity of others, avoidance of them, alignment with them, and moving at a like pace.

Alignment is sustaining, emotionally as well as physically. Michael Lockwood is an architect for Populous, an architectural firm that designs large spaces accommodating massive throngs of people, such as sports stadiums, arenas, civic buildings, and convention centers. Grand Central gets it right, he tells me. Order and momentum make people feel comfortable.

> *It's a pretty primal event when thousands of people are getting where they need to go. Individual life can be pretty rough. Collectively is where we have made progress. There is a safety there, a benefit of community. We can accomplish more as a group. Everything you see has been made by thousands of people working together. In the world we live in, we have an inherent dependence.*

Lockwood is familiar with the way in which people in crowds are willing to put aside personal differences, pointing to the humanizing effect of going to a ball game.

> *There is a level of respect and appreciation for people doing their best. When you are at a large event, if it is about you, it throws off the mojo. It's reassuring to be part of the collective. People are willing to be anonymous, because there is the expectation that everyone else is also willing. Because the experience is shared,*

your comfort—or discomfort—is shared. It's why you want to help somebody find their seat. Any emotion in that event is shared. That's why people help each other.

But this sense of mutual concord is practiced increasingly in other venues. When a journalist revealed the identity of the writer known as Elena Ferrante in 2016, her devoted readers reacted with a surprising contempt. Ferrante's assertion that "the titles of [her] novels are better known than [her] name" was proven by her readers, few of whom joined in the media orgy. Instead, they chastised the reporter for not respecting Ferrante's anonymity, which had empowered her work. Her readers were willing accomplices to her anonymity. They had agreed to it as essential to the covenant between the author and themselves. For many, the mystery of her identity had become integral to reading Ferrante's books; writer and reader remained wholly unknown to one another, sharing only the story of imagined lives. The depth of the resentment felt by Ferrante's readers likely had to do with the repudiation of the gift she had offered them: a sense of mystery, a moment of private reprieve in a culture with a seemingly insatiable appetite for self-promotion and exposure.

Ferrante is on record as saying she did not choose anonymity—the books are signed—but rather absence. Her choice, she explained, was aimed at the conventional, if misguided, media notion of ignoring quality in literature for mediocre books written by brand-name authors. "What counts most for me is to preserve a creative space that seems full of

possibilities, including technical ones," she said. "The structural absence of the author affects the writing in a way that I'd like to continue to explore."

Ferrante is not alone in finding appeal in anonymity. My friend Allan is an architect and woodworker who makes his own furniture. In his shop is a lathe, which he often uses to turn salad bowls of tiger maple, walnut, and white oak burl. The largest bowl he has made, a vast wooden crater three feet wide, would be suitable for serving tossed lettuce to visiting titans. But most of his bowls, constructed on a lesser scale, are given to friends. Their gracious curves, both distorted and amplified by the wood grain, have, in some cases, been interwoven with layers of improvisational cracks and fissures epoxied back into place. For all their artistry, none have his signature. "I like thinking of my friends' families using these bowls," he has said, the kids and then the grandkids and great-grandkids not knowing where a bowl came from. He is certain that the bowls are better off for the anonymity of their origins. Perhaps gathering at meals and enacting ordinary household rituals, day after day, year after year, for so many generations is what renders the signature of a single individual extraneous. Or maybe it is that the imprint of his hand is already implicit in every grain of the shaped bowl. Either way, contemporary ideas about authorship, branding, and prestige become obsolete.

Soetsu Yanagi was a Japanese philosopher who advocated for anonymity in folk art. In his 1972 book, *The Unknown Craftsman*, he includes the absence of the artist's signature in his list of what confers beauty on an object. Along with use, the imprint of the human hand, simplicity, low cost, and regional tradition, the

anonymity that comes in deflecting attention from maker to user is part of what infuses physical artifacts with value and meaning. Certainly those criteria apply to all those handcrafted household artifacts made of wood, clay, textiles, metal; all those utilitarian plates and spoons; all those touchstones of domestic life, tables, chairs, knives, tools, hinges, and quilts, all shaped, carved, molded, and sewn at a time when such things were made by hand. The names of their makers are largely forgotten, but this archive of objects carries its own collective effervescence over the centuries. In an odd way, it might even be the very absence of the signature that confirms the humanity of the work.

In 2015, the Reddit button experiment suggested that anonymity in the digital world is not all about transgression and secrecy. The social exercise on the reader-generated news site was about as far removed from handcrafted objects as you might get: a one-minute digital stopwatch was set, with participants able to punch a button to reset the timer, though each could press the button only one time. Over a million Reddit users entered into this game for no apparent reason. It took sixty-five days for the stopwatch to run its full sixty seconds. The idea that people will interact for no obvious purpose—no recognition, no financial gain, no clear consequence or outcome—suggests there may be something innately appealing about community, something inherently sustaining about working as a group. There is some evolutionary component here, some ancestral clan instinct regarding the safety and security of community, some part of ourselves that acknowledges how our tribal instincts can be to our benefit.

Since its inception, Alcoholics Anonymous has offered anonymity as sanctuary, but it is one that comes with an abiding
sense of responsibility. A self-supporting fellowship called a
"benign anarchy" by one of its founders, Bill Wilson, AA offers
a structure for compassion and empathy, a scaffolding for healing. But its acknowledgment of identity looks to two seemingly
opposite impulses, suggesting the paradox that finding one's
identity is often a matter of losing it first. While the use of last
names is discouraged, members look inward to reflect upon
interior motives, choices, and actions, those intrinsic qualities
that are the very markers of personal identity. "There is an
equality in anonymity," says my friend Michael, a poet. "The
key to anonymity is that it creates an opening to identify with
other people. The voice is both finite and mysterious. Like in a
poetry workshop."

Anonymous is about something else entirely. A confederacy
of coders, protestors, and hacktivists wearing Guy Fawkes
masks, it targets political, religious, and entertainment entities.
In snubbing the hierarchy of conventional organizations and
subordinating individual identity for the collective, the group
claims it can be more extreme, more outrageous, and, presumably, more effective.

These two organizations offer profoundly different perspectives on anonymity, but both reflect the power of collective
belief. Both require a kind of radical imagination. Both suggest
individual identity and behavior can be redefined, and offer
ways to reimagine oneself and one's place in the world. Both
are effecting social change, the one through recovery, the other
through political and social activism. Both suggest that it is

possible to have a voice without a name. In both cases, anonymity provides a framework in which personal identity is not subordinated so much as reinvented. Neither is simply about collective effort, but about reducing the presumed value of individual identity for a more advanced objective.

Anonymity is gaining traction. Some states now allow lottery winners to maintain it. Game administrators have long argued that keeping winners in the public sphere guarantees the integrity and authenticity of the lottery, offering proof that the vast amounts of money exist and are distributed. The winners' personal stories also keep the lottery in view, and thus profitable to the states' coffers. Jackpot winners, however, are less keen on their windfalls becoming a matter of public record. Their marriages, divorces, vacation plans, mortgages, fantasies realized and failed, fortunes and foreclosures all become news, and they are besieged for years by solicitations from family and strangers alike. In response, the anonymity proposal introduced in the North Carolina state legislature in 2015 puts forward a time frame for the disclosure of winners' names and, possibly, monetary conditions for nondisclosure.

But the anonymity proposal is increasingly made in smaller venues as well. At a college where I teach, an anonymous poets' society is so true to its name that I am unable to find any of the writers or their work. In the spring of 2015 a group of young designers showing at New York Fashion Week insisted on anonymity, on the grounds that brand names in fashion obscure design and thwart innovation. "Being anonymous has a nice appeal to it," one of them said to *The New York Times*. "There's something really rad about it."

That same spring, students in the theater department at the Masters School, a college preparatory school in Dobbs Ferry, New York, worked on an interactive project with the theme of anonymity. In the production, five black-clad, masked figures writhe, get up from the floor, prowl about, then guide audience members outside to witness assorted vignettes reflecting the power of namelessness. A guitar player conducting an improvisational sing-along gathers the voices of strangers into a harmonious chorus; a jury considers the facts of a criminal trial; passersby on a street witness a scene in which a woman is— possibly—being assaulted and confer on what action to take. At the conclusion, the performers read a series of unsigned confessions made by audience members that describe everything from episodes of petty dishonesty and friendships frayed by depression to thoughts of suicide.

With a minimum of authorial direction, the performance looked at anonymity's power and at its threat. Francesca LaPasta, one of the student directors of the production, admitted to the allure of anonymity, suggesting it could be equated, at times, with privacy:

The millennial generation has been so connected to social media, and I feel like there's a push back, a kind of a movement towards staying anonymous and trying to keep yourself private, because it feels like everyone else is trying to tell you that you can't be. Once you put something on the internet, you can never get that back. It will always be kept somewhere. And I know that a lot of people my age haven't really considered the implications of all

their actions, and how there really is no privacy once you let
things out to the whole world.

On a remote dune on North Carolina's Bird Island, the
Kindred Spirit Mailbox offers a different kind of pushback. For
over thirty-five years it has been a destination for visitors who
leave inside it love letters, marriage proposals, confessions, en-
treaties, notes of grief, appeals, prayers, apologies, farewells, and
impressions of the surrounding seascape—messages that touch
on every nuance of human feeling and experience. Its appeal
may have to do with its gracious accommodation of anonymity
and the solace of relinquishing, albeit briefly, our identity, and
likely has to do as well with its proximity to the endless cycle of
incoming waves. The ceaseless rhythms of the tide and the sand
that is swept smooth daily by wind and water suggest implicitly
that the next coastal storm may wash the whole operation out
to sea. But the mailbox still has a Facebook page, hundreds of
online followers, YouTube videos, and dozens of photos on
Pinterest. That this poignant monument to anonymity has its
own social media presence says something about the mixed
feelings we seem to have about going unknown, being unseen.

The conventional belief that anonymity is an invisibility
cloak allowing its wearers to disregard ethical standards is losing
ground. We often assume that when we no longer see the faces
of others, we lose sight of their humanity as well, and that the
ensuing faceless online interactions result in trolling, swatting,
and other common assaults of digital exchange. To some de-
gree, that's true. Threats of abuse and sexual violence are easily

tweeted, and when the social networking site Yik Yak, which
doesn't require usernames, first appeared, it quickly enabled
cyberbullying and malicious online trolling. The web message
board 4chan operates without accounts and usernames, which
means anyone can post anything without consequence. Widely
recognized as the ugly side of anonymity, it allows its subforums
to serve as a locus for hoaxes and conspiracy theories and to
generate misinformation; disinformation; messages of racism,
sexism, misogyny; child sex trafficking; and hate speech of
nearly unlimited range. But it has also become the norm in our
culture of openness and exposure to correlate anonymity not
only with malice and wrongdoing but also with secrecy and
shame. Even AA is now pressed by some members for greater
openness. Asking whether anonymity serves the public health
crisis of addiction, the writer Susan Cheever has noted that it
"protects but it also hides" and questioned whether recovering
alcoholics might not revel openly in their identity with public
pride in much the way some gay Americans have come to cele-
brate theirs.

Anonymity's extinction, though, may be premature. Its sol-
aces are ever more vital in our culture of transparency. In 2015,
a team of data scientists reviewing the credit card transactions of
over a million consumers found it could identify some 90 per-
cent of them using only a handful of behavioral clues, such as
the date of the purchase, its cost, and the store at which it was
made; despite the fact that shoppers' names, addresses, and ac-
count numbers remained unknown, such tips were enough to
reveal their identities. The mailbox, the salad bowl, and the
button are reassuring, then, confirming the appeal we can all

find in remaining nameless. Finding assimilation in some larger community is a basic human need and desire. I would prefer to think that anonymity is "the new celebrity," which is what Ruth Ozeki suggests in her recent book, *A Tale for the Time Being*. Ozeki imagines a digital spider that is able to infiltrate search engine databases, cleansing them of personal information, malicious videos, moments of shame and humiliation that the online world so naturally memorializes. Mu-Mu the Obliterator, as the spider is known, devours online identity. Its fictitious creator suggests that "the mark of new cool is no hits for your name. No hits is the mark of how deeply unfamous you are, because true freedom comes from being unknown." Which makes me think it's time to invert Andy Warhol's prophetic statement about fame. Perhaps we might now imagine instead our fifteen minutes of absolute anonymity.

In 1901, Gerald Stanley Lee wrote that "nothing beautiful can be accomplished in a crowd civilization, by the crowd for the crowd, unless the crowd is beautiful." A century ago, artists, architects, and designers found a way to shape urban experience in a manner that conferred grace and order on a seemingly uncontrollable and chaotic public. The shining avenues of Grand Central, the scale of its main concourse, the soaring space and gleaming balconies all managed to instill civility on what was often perceived as an ungovernable horde of humanity.

On my most recent trip through Grand Central's main concourse, I find myself swerving past teenagers taking selfies, a group of students on a class trip trailing after their teacher, a speed-walking woman who is nonetheless gazing into her phone. A group of Asian tourists are staring rapt at the zodiac

overhead. Others are lingering at the information kiosk, waiting for trains or people or time to pass, and their sense of leisure is a counterpoint to the frenetic energy elsewhere. I nearly collide with a businessman in a suit, and he holds out his arms as though asking for a dance, but we both stay in stride. At one of the track gates, a woman is saying good-bye to a young man whom I take to be her son. Tears are streaming down her face, and I am reminded of how this vast public space not only allows for intimate moments but also reinforces them; and if the departures and arrivals innate to transit generate extremes of feeling, there is solace in the continuity of life going on around you.

We are all avoiding, aligning, attracting. We are going with the flow. We are all simply engaging in that basic human enterprise of accommodating each other. In the passageways of Grand Central it comes to us easily. In a world with 7.5 billion inhabitants, the idea of the beautiful crowd surely has new meaning. Perhaps there is a way to construct some virtual equivalent of those gorgeous marble passageways, soaring ceilings, and majestic columns. It would not be a way of building as much as a way of thinking, a willingness to believe the crowd is a place to find rather than to lose ourselves.

REREADING MRS. DALLOWAY

The body becomes an easy channel for the invisible.

—FANNY HOWE

Not long ago, I received an email from my friend Christina. She is in her sixties, a dancer and a choreographer, and for much of her professional life has been accustomed to moving in rooms with walls lined with mirrors. But now she has moved to a seaside village in southern Spain where she knows no one, is known by no one. She is not fluent in the language and tells me:

> I have no identity, no role to play. And I make so many mistakes,
> little social errors, mispronunciations. And the local people do not
> see me, as though they are saying, "You are not in my way." I
> feel like I am air. I don't feel unwelcome. They just do not see me.
> And that is a huge part of why I am here, as though this is a
> blank canvas, a new painting I can start. And I really do believe
> that when we have a reason to be seen, then we will be seen.

Christina's sense of moving through the world like air is familiar to me. Though immaterial, the invisible woman is

surprisingly recognizable, reflecting evolving ideas about women and their place in society. In the work of illusionists and magicians of the nineteenth century, a woman's ability to navigate the route between the worlds of substance and spirit got high billing. The tricks came with their own gradations, and distinctions were made between women who were simply unseen and those made to vanish—under sheets, blankets, and bed linens of all manner, of course, but also in trunks, boxes, closets, beneath trapdoors. A woman might simply be made to float, her body diminished by the wave of a hand. In the early twentieth century, as women became more present in the public sphere, their modes of expulsion—without reason, logic, or consequence—become even more inventive. A woman might be seated on a chair with a blanket tossed over her; when the blanket was pulled away, she was gone, only to reappear in a seat in the audience.

In Alfred Hitchcock's 1938 film, *The Lady Vanishes*, a young woman on a train becomes disturbed by the sudden disappearance of a kindly older woman, a governess and music teacher. The latter, a spinster, is introduced to the viewer when she writes the letters of her name in the condensation on the glass windowpane, only to have them evaporate almost instantly. Within minutes, she is gone. At which point, the other passengers, steward, and conductor claim to have never seen her. It is not just that she is absent; she never even existed. Asked to describe her, the young woman can only say she was "middle-aged, older" before admitting, "I can't remember anymore." Later in the film, the older woman is reduced to "a hallucination, a subjective image, a character in a novel subconsciously

remembered," and even "nothing but lumps of flesh," all before she is revealed as a British spy, the movie's ultimate heroine in the final scene.

Today, women appear—or disappear—in any manner of guises. In photographer Patty Carroll's series *Anonymous Women*, it is household artifacts and traditions—upholstery fabric, curtains, telephones, slabs of bacon, leaves of lettuce, a braided loaf of bread, rolls of wallpaper, pillows, and plates—into which she disappears, swallowed whole by the python of domesticity. In Whitney Otto's book *Now You See Her*, the vanishing woman works in an office, present, but unseen. Coworkers, men, younger women come and go, leave notes at her desk, use her supplies. "Of course I saw you, but I didn't," one of them says. Her cat is indifferent when she trips over it, and when she presses her palm to her forehead, it is "only to notice her hand fading away with the motion, from fingertips to forearm." The woman thinks she is "quietly losing her colors like a bright painting or vivid rug left out a little too long in the sun." In the more recent film *Hello, My Name Is Doris*, Sally Field plays an older woman who develops a crush on a younger man with whom she shares an office; at the beginning of the story, he adjusts her crooked glasses. As one reviewer wrote, the young man's spontaneous gesture of kindness is transformative: wrinkles, apparently, "have a way of making women disappear one crease at a time," and when she is noticed momentarily by a younger man, such recognition evidently "makes her visible, most importantly to herself."

The invisible woman might be an actress no longer offered roles after her fortieth birthday, the fifty-year-old woman who

can't land a job interview, or the widow who finds her dinner invitations declining with the absence of her husband. It might be an older woman in a restaurant who is ignored by the waiter, unable to get a glass of water when she sits down at the table, or later, the check when she is ready to leave. When she pays for a purchase in the store, a cashier might call her "honey." She is the woman who finds that she is no longer the subject of the male gaze, youth faded, childbearing years behind her, social value diminished. Referring to her anticipated disappearance on her upcoming fiftieth birthday, the writer Ayelet Waldman said to an interviewer, "I have a big personality, and I have a certain level of professional competence, and I'm used to being taken seriously professionally. And suddenly, it's like I vanished from the room. And I have to yell so much louder to be seen. . . . I just want to walk down the street and have someone notice that I exist."

Her words evoke another woman walking, unseen, down the street nearly a century ago. As Clarissa Dalloway shops in London for flowers on a June morning, Virginia Woolf speculates about her subject's transitory identity. Mrs. Dalloway moves like air as well, considering her place among the people she knows, and finds that "often now this body she wore (she stopped to look at a Dutch picture), this body, with all its capacities, seemed nothing—nothing at all. She had the oddest sense of being herself invisible, unseen, unknown." She recalls that she is known now simply by her husband's name, and a few sentences later, considers how sometimes it is simply by their gloves and shoes that women are identified. She knows nothing, she thinks, no language, no history, and hardly reads books

except memoirs. She realizes then that "her only gift was knowing people almost by instinct."

Clarissa Dalloway has a flickering sense of presence. She is in and out of view, reflecting the emerging, though still somewhat unclear, role of women in public life and place at the time. Woolf traces her subject's steps, her pauses on the curb, her stops to peer into shop windows, and her quickening pace not unlike a tracker might examine the prints made by a wild animal in the snow.

One's identity, Woolf seems to say, is transient, and perhaps all the more so with age. As women become older, they entertain a wider set of choices about when and how they are seen. This vanishing can occur more rapidly or be felt more acutely. Clarissa Dalloway's sense of fleeting self was described more explicitly decades later by the writer Francine du Plessix Gray in her essay "The Third Age." If the gaze of others wanes, Gray suggests, one might choose to "acquire instead a deepened, inward gaze, or intensify our observation of others, or evolve alternative means of attention-getting which transcend sexuality and depend, as the mentors of my youth taught me, upon presence, authority, and voice."

Gray may be talking about the difference between being a subject and an object. It is a cliché to point out that ours is a culture in which men routinely objectify women, but as psychologist Alison Carper says, if a woman is complicit in this practice, that is, viewing *herself* as an object, she cannot help but be acutely aware when that object loses its desirability. "As humans, we all need to be recognized," Carper adds, "but as we grow older, the manner of recognition we search for can change.

A subject is someone who experiences her own agency, who is aware of how she can and does have an impact on others and how she is, ultimately, the author of her own life. She is aware of the responsibility this carries." A woman without fully developed interiority might continue to objectify herself.

Clarissa Dalloway is clearly a subject. She realizes that her body is simply something that she wears, then a sentence later, finds it is really nothing, nothing at all. Woolf correlates invisibility with knowing people by instinct in a single paragraph, and since she published *Mrs. Dalloway* in the mid-1920s, more prosaic studies of human nature have come to similar conclusions. A reduced sense of visibility does not necessarily constrain experience. Associated with greater empathy and compassion, invisibility directs us toward a more humanitarian view of the larger world. This diminished status can, in fact, sustain and inform—rather than limit—our lives. Going unrecognized, paradoxically, can help us recognize our place in the larger scheme of things.

In a recent series of studies published in the *Proceedings of the National Academy of Sciences*, psychologist Ana Guinote and her team of researchers found that it was social status—prestige and reputation—rather than background or personal disposition that often determined our degree of altruism. "Even though humans are the most altruistic species, disparities in prosocial orientation are common and occur across social groups that vary in education, sex roles, biology, and financial resources," the study states, before concluding that those people identified with lower social status tended to be more egalitarian than those

with greater stature and recognition. Members of disadvantaged social groups—ethnic minorities, women, and those with low socioeconomic status—tended to have a greater sense of fairness and empathy.

In one study, subjects were assigned a ranking in their academic department. Those subjects were then present when a pack of twenty pens were, seemingly accidentally, dropped on the floor. Those participants randomly assigned to the lower ranking department readily helped to pick up the pens, while those of a more elevated rank didn't. In another study, a group of undergraduate art students were arbitrarily assigned status positions with regard to the prestige of the schools they attended. They were then asked questions about their life goals. Those students who imagined they were attending the high-status schools spoke of power and prestige, while those who believed they were enrolled in the low-status schools spoke of helping others, engaging in public service, and otherwise contributing to the well-being of society. The researchers found that even the altruism of young children reflected social rank. Pairs of preschool children were presented with a valued toy and a worthless toy, and asked to choose one. The child with the more valued toy was dominant. Later the children were regrouped with different partners of the same rank and again competed for a more valuable toy. New hierarchies were formed. All the children were then given stickers and asked if they would like to give these stickers to a child who didn't have any. The low-status children were more generous. Those with low socioeconomic status, the study concluded, are more

socially attentive and affiliative, and can better identify with the emotional states of others. Women affiliate more and endorse more benevolent values than men.

"Affiliating more" may be colorless prose, but it is not so far removed from Clarissa Dalloway's experience a century ago when she found that being unseen was not a matter of being ignored or dismissed, but of being intuitively present and fully integrated into the world around her. "Affiliating more" may also be what she considers, sitting at her dressing table, looking at her own face in the mirror and seeing

> one woman who sat in her drawing room and made a meeting-point, a radiancy no doubt in some dull lives, a refuge for the lonely to come to, perhaps; she had helped young people who were grateful to her; had tried to be the same always, never showing a sign of all the other sides of her—faults, jealousies, vanities, suspicions . . .

It is a theme Woolf returns to again and again, as in a few pages later when Clarissa Dalloway considers the "odd affinities she had with people she never spoke to, some woman in the street, some man behind a counter—even trees or barns."

Clarissa's unseen status has a shine to it. She is hardly a person of low social status: her shimmering green dress is made of silk, and at her London dinner party, the table is set with silver candlesticks and roses. Yet as a married woman beyond child-bearing age, her standing is diminished. Despite this invisibility so familiar to older women, she recognizes that our lives can be

measured by what we have done to touch the lives of others; she is attuned to how human associations can be formed with complete strangers. And to the enduring value, indeed power, of such alliances.

Clarissa Dalloway knows she is surviving "on the ebb and flow of things." Increasingly indistinct, obscure, possibly unknowable, she is aware of "being laid out like a mist between the people she knew best." She knows we are ephemeral, not always seen, but that this very evanescence is what makes life real. Were it possible to have a portrait of Clarissa Dalloway, it might be in the style of one of Alec Soth's "unselfies," as though she were equipped with an iPhone as she walks down Bond Street, recording her place in things just as a small gust of London fog suddenly obscures her face.

Her modern counterpart might be Mystique, the shapeshifting mutant from the X-Men series played by Jennifer Lawrence, who also has a similar knack for odd affinities. She has no physical self beyond her blue body and instead morphs into the forms of others, among them an assassin, a German secret agent, a professor, a young girl, a senator's wife, a fashion model, and a member of the US Department of Defense. Her power is her indistinct appearance; it is what enables her to assume other identities. Some combination of emotional imagination and a lightness of being allows these women to fully imagine the lives of others, sometimes even inhabiting one of those lives, whether it is that of a fashion model or some man behind a counter.

But another likely counterpart to Clarissa Dalloway might be the famous 1960s model Vera Lehndorff, popularly known

then as Veruschka. Toward the conclusion of her career, she collaborated with the German artist Holger Trülzsch, painting her body in patterns, colors, and textures to match different backgrounds. Lehndorff then posed in a series of camouflage arrangements, in order to identify with the objects and atmosphere around her. The images make for their own collection of odd affinities. Far from the catwalk, she is disappearing instead into the rusting pipes of an abandoned factory; a faded, whitewashed wall; the weathered gray boards of a wooden door; moss-covered ground; or an old barn with windows. In one photograph, we see only her head, painted to resemble the pale, scoured, pitted beach rocks around her. Whether she is pictured in a vacant warehouse, an old barn, or leafless woods, her image conveys erosion and decay, dramatizing the aging and attrition of both the place and the person in it.

In a text accompanying the photographs, Lehndorff recalls her unhappiness as a child upon realizing "the unbridgeable distance between myself and other people. I had wanted to be able to merge with whatever I found beautiful," and she recalls her futile efforts to be transformed into a tree or a pool of light. Decades later—with photographs divided into such categories as Mimicry-Dress-Art, Signs and Animals, Nature—she seems to have resumed that effort. "When I started to paint myself," she writes,

> the colour and I were one: there was no "between." My work was now consistent with my conviction that there had to be a coherence between things: the object and the created picture . . . This experience of coherence between us and the world around

us is one of well-being; it produces a sense of affinity with what-
ever it is with which we come into contact.

It is an idea of female beauty that has nothing to do with the
dramatic pose and everything to do with assimilation, integra-
tion, and adaptation; that is, with becoming part of the scenery.
Introducing the photographs, Susan Sontag writes of "the
desire to dissolve the self into the world; the desire to reduce
the world to matter . . . to become fixed; to become demateri-
alized, a ghost . . ." I read these words and revisit the photographs.
There is Lehndorff, lying on gray sand or receding into a dark
doorway or leaning against a white wall. In the last, her body
has been stippled white up to her shoulders, but her head seems
to have been dyed a bright azure to match the sky behind it. It
is an image of the female body going from object to air, from
material to immaterial, from thing to nothing. It is camouflage
that has nothing to do with escaping prey, avoiding danger,
finding food or a mate, and everything to do with finding a
coherence!

I reread Christina's email, her words echoing those of an-
other friend who has said to me, "I find that I am seen by the
people I care about." Christina wrote of settling into her life
with her husband and daughters, concluding that,

It occurred to me today that the invisibility I'm feeling is also
useful in the way it was so useful to stop having mirrors in
dance studios. Instead of having your reflection coming back at
you, your external self could disappear from view. I look out at
this stretch of sea, and since all waters are connected, see you in it.

She, too, is engaged with the coherence between things, existing on their ebb and flow. Looking out over the harbor from her window in Spain, she's probably affiliating more as well.

Whether it is the mist glimpsed by Mrs. Dalloway, a woman's body that is on its way to being a piece of bright blue sky, or a retired dancer looking at the sea, all may speak to a revised etiquette of invisibility. Opacity itself can work as a connective tissue. If we are leaving a mark, it is just some quick and temporary elusive imprint, nothing more than a fugitive logo or insignia. And it's probably not the worst thing for any of us to imagine identity as an arrangement of letters written for a few moments on the clouded glass on the window of a train that is speeding out of view.

THE VANISHING SELF

The mind is a kind of theatre, where several perceptions successively make their appearance; pass, re-pass, glide away, and mingle in an infinite variety of postures and situations. There is properly no simplicity in it at one time, nor identity . . .

—DAVID HUME

One morning in the summer of her sixtieth year, my mother woke up unable to write. She could hold her thoughts and grasp a pencil but was incapable of maneuvering it to shape letters. She assumed it was some kind of sprain or muscle spasm in her arm, and it wasn't until the following day when her doctor sent her for a CAT scan that it became clear she was suffering from glioblastoma, an aggressive brain tumor the size of a lime in her left frontal lobe. The origin of such tumors remains unknown, but they can have a debilitating effect on communication. The frontal lobe is the brain's center of speech production. It is also where concentration, judgment, and emotional traits are centered.

The subsequent surgery was only partially successful. Chemotherapy and radiation treatments followed. During that time, I lived in San Francisco but would visit my parents on the

East Coast often, and somewhere late in the first year of her ill-
ness, it became clear to all of us that a deepening depression was
accompanying the growing tumor. She lost interest in food,
among many other things, and I found myself one afternoon
pleading with her to eat a bit of sandwich. "Please," I begged,
sitting at the table with her. "Just try to take this little bite." She
snapped at me then. "You can go back to California if this is the
way you are going to be." My eyes stung. I was stunned. She had
never spoken this way before. Her kindness had evaporated.
She was a woman who had always known who she was. She
had gone to Bennington College, had edited articles for *Partisan
Review*, was twice married, and was an inventive thinker and
a generous mother. Now she was snarling at me about a piece
of toast.

Who can say exactly from where the fury had come. Cer-
tainly it could have been a reaction to her emerging language
disorder and the helplessness that came with it, both a part of
the anguish she felt at confronting mortality. But it might have
come from the physical fact of the tumor itself. The frontal lobe
is also a center for emotional traits, and the dysphasia that often
accompanies such tumors brings with it not only the tendency
to muddle words and lose the names of things, but also such
emotional effects as isolation, loneliness, frustration, and anger.
The woman we knew had disappeared, not simply from her
family, but from herself. The rearrangement of cells that was
ravaging her brain, her mood, her equilibrium and empathy
also seemed to assault her very identity. She was unrecognizable.
That she was "no longer herself" was a phrase I used often then,
following that convention we so often rely on when we talk

about neurological afflictions of all sorts. Those suffering from depression, Alzheimer's, autism, personality disorders, strokes, or any number of other forms of mental disarray are commonly described as being "no longer themselves." Yet when I think back on that time and at those words that formed in my mind, I realize now I had no idea what I was talking about.

We know more today about the vast range of disappearing acts that the brain and nervous system are capable of, that catalog of impairments that make it easy to think that we, or at least parts of ourselves, have vanished, the myriad ways we can withdraw from those around us, not entirely perhaps, but in random bits and pieces. When I think of my mother's illness, the idea of the invisible self loses its allure. In my infatuation with invisibility and the benefits of taking identity less seriously, I have willfully ignored something so deeply obvious, which is that such absences of being, when anatomical, involuntary, and imposed, are visceral and real, and often accompanied by a sense of debilitating and shattering loss.

Disappearing does not seem to come naturally to us. If the inconspicuous grace of the pebble plant, the walking stick insect, the moth is rarely available to us, the brain has its own ingenious strategies when it comes to obliterating different parts of identity. Scott Grafton, a professor of psychological and brain sciences at the University of California, Santa Barbara, gives me a road map to some of these, and I come to realize that the more we understand those functions and abilities that define identity, the more ways we can likewise understand how such identity can be disassembled. Most of us generally assume that body and mind collaborate—if not in a unified process

exactly, then in some kind of improvisational and disjointed partnership—to make us who we are. But this collaboration can be easily interrupted. We think we have a self that is a single entity, when it is more like a haphazard and random collection of genetic traits, learned behaviors, habits, and responses. "In both behavioral neurology and cognitive neuroscience," Grafton writes me in an email, "we have come to the point of viewing 'self' and the sense of self as a grab bag of processes, brain modules and ad hoc evolutionary solutions. While we can talk about our self in the singular, that singularity is an illusion."

Invisibility, then, can be about the way this random collection of brain functions shifts, morphs, diminishes, and sometimes ceases to operate altogether. The borders of "self" are more fluid than we generally think, and identity can vanish through any one of a variety of disorders. As Grafton points out, it is also easy to distort body schema, which governs how we carry ourselves and move through the world. When it is disrupted, our sense of physical autonomy, of position and movement and how we inhabit space, can all be rearranged. What we see and what we experience are no longer in alignment. Even those of us in robust health can find convictions about body ownership slipping away easily; and even the most basic physical sensation is open to suggestion.

In the landmark rubber hand experiment of 1998, cognitive scientists positioned a rubber hand alongside the real hand of a healthy participant; a partition hid the view of the real hand, though the rubber hand remained in the participant's sight. The scientists then stroked both the rubber and human hands

simultaneously with two paintbrushes. Unexpectedly, many of the participants stated with certainty that they "felt" the rubber hand being stroked. The sense we have of our physical selves is impressionable, ever at the ready to accept flawed information from questionable sources.

Cognitive impairment only underscores the frailties of human perception. Personal neglect is the name for the condition suffered by stroke patients who experience a restructured sense of bodily self. When cerebral lesions damage the right hemisphere of the brain, the patient experiences a disruption of perceptions on the left side of the body. Such patients are no longer able to fully translate sensory experience into coherent perception. One-side neglect eradicates not only the awareness of one side of the patient's body, but also the objects inhabiting the adjacent space; along with the arm and the leg, the table, plate, and door have vanished too. As well as affecting one's visual and spatial experience, such neglect can also upset memory and recall; a patient asked to draw the image of an apple or a bird or a house might draw only half of that thing. It is a condition that denies the entire existence of the world on one side of your body. As Grafton says, "Half the world becomes invisible, whether it is a social world, object world, or self/body world."

Frontotemporal dementia is a neurodegenerative disease that attacks nerve centers in the brain's frontal and temporal lobes. As with my mother's tumor, it strikes that part of the brain that governs language, judgment, and communication. When those brain cells die, the emotional characteristics, which make us who we are, evaporate. Self-awareness and empathy wane, and emotional memories fade. Apathy and detachment set in.

Patients become depersonalized and detached. "What is left is a terrifying hollow shell of a person," Grafton says. The wonderland syndrome, meanwhile, can visit those with epilepsy, migraine, fever, and forms of schizophrenia, altering and distorting body image. Perception of size is disrupted and deformed; scale is radically amended, making for imagined shifts in the shape, distance, and placement of ordinary objects. A person can become taller or shorter, detach from her body entirely, feel herself floating, or find that time has inexplicably speeded up or slowed.

Depersonalization disorder is a different manner of estrangement that establishes a distance from one's emotional being. That psychic detachment is a useful defense mechanism for those who have suffered trauma, whether from childhood abuse, the stress of war, a violent accident, or some other form of extreme assault. The dissociative disorder can last for minutes or years. It can remove the driver from the scene of the car accident, while in cases of psychological trauma, it can be manifested as a numbness that makes those parts of ourselves that are unbearable to confront invisible, unknowable, and remote.

Out-of-body experiences are likely to be brief episodes of physical disengagement in which one's perspective shifts from the body to a place outside of it, sometimes leading to the perception of a visual double. Such a duality of body and mind is sometimes viewed as evidence that we can manage spiritual detachment from mundane earthly reality, but neuroscientists suggest it is actually a result of the brain's temporary inability to process somatosensory information, stimuli from sensations that can occur anywhere in the body, such as extreme pain, heat, or

pressure. If we are unable to process tactile, visual, and vestibular input, our spatial cognition is thrown off. And such uncertainty disturbs our body schema.

Such vanishing acts of the self can bring about a disquieting sense of mutuality. A pediatric neurologist with whom I spoke describes the social absence he senses in many of his young patients who have autism by saying, "They practically disappear." With compromised communication skills—an inability to grasp the meaning of body language and social cues, limited eye contact, an aversion to human touch, and often, selective mutism—they are, he says, "sometimes just not there." And then he concludes of the psychic distance he often finds lies between him and his patients: "I feel invisible myself."

The dissolution of self can, however, also be a cause of joy. Temporal lobe seizures, which cause epilepsy, are sometimes associated with the phenomenon of ecstatic seizures, and it is not uncommon for sufferers to be subject first to a temporary rapture, a feeling of universal connectedness. In her essay "How the Light Gets In," author Elissa Schappell has written of the experience that

I am silent and serene. For the first time in my life, I feel complete. I am radiant, suffused with joy and awe, and I am rising. There is the unseen life, the illuminated world, shimmering, glorious, flooded with more light than seems possible, rushing into my palms and the soles of my feet, the air liquid with light, so much I should be able to scoop it into my hands like water. It fills the corners of the room, runs down walls.

But if you really want to feel invisible, Grafton writes me in an email, "get an injection of Versed. Pure amnesia for eight hours. No memories = invisibility for that time period. You erase your own existence for that block of time." Versed is a benzodiazepine, a family of antianxiety medications that includes Xanax, Valium, Librium, and Ativan, and its patient information tells me that it is "given to produce amnesia so that the patient will not remember any discomfort or undesirable effects that may occur after surgery or a procedure." I recall being injected with this medication a number of years ago before minor surgery. The thirty seconds during which I remained conscious before the sedation knocked me into a tunnel of oblivion were among the most blissful I have ever known—pure existence without any tangible connection to the immediate world and its worries and a sense of ineffable accommodation by a larger and supremely benign sphere of existence. I was in a state of profound affinity with the world around me—with the anesthesiologist in his green scrubs, the blinking blue lights of the medical equipment, the beige corridor and the infinite universe to which it led. My gratitude was boundless. Versed was my appointment with the cosmos. All these years later now, I wonder if those moments of bliss were in some way derived from loss of memory. Is it possible that the state of amnesia can provide rapture as well as despair?

I wish I could be more specific about that condition of euphoria, decode it precisely, but further research is unlikely. Receiving such an injection is only possible when one is extremely agitated, preoperative, or willing to buy street drugs, and I am none of these things. But such an injection is not necessary to

get a better grasp of the temporary amnesia to which Grafton refers. I occasionally take Xanax to sleep more soundly, and it is capable of inducing anterograde amnesia, the loss of the ability to form memories *after* the event that induced amnesia (as opposed to retrograde amnesia, which refers to the inability to evoke any memories from one's past). I remember on one occasion reading *The Age of Innocence*. When I woke up many hours later, the book was on a table on the other side of the room. Why had Countess Ellen Olenska sent a note? What had Archer said? Why was May Welland standing under the magnolia? I could not recall any of the events or conversations. Though I could see I had turned its pages, I was unable to recall the words in the book. Along with those sentences and paragraphs, that mini-chapter of my own life had been erased.

I remember, too, one vodka-drenched summer when I was in college. Alcohol interferes with recall, in some situations preventing the brain from forming new memories. In other words, it's not that you can't retrieve what happened but that the memory never even took shape in your brain. In alcoholic blackouts, one's actions, words, and memories can all be obliterated. An unfamiliar key is found on the kitchen table. A book is lying in the garden. The front door is wide open, and the dog is gone. There is no way to explain any of it. Stitches of experience are dropped, never to be picked up again. Words fade, events vanish, and the self becomes an ocean strewn with islands of exact recall and other islands of vagueness; identity becomes a vast and mysterious archipelago, surrounded by fog and with unknown currents and tides and indecipherable shorelines that are almost impossible to chart or navigate.

Grafton's reference to the way one can "erase [one's] own existence for that block of time" seems like a precise way of describing those periods of vanishing. Experience is not imprinted. The components of ordinary human experience do not register. Life on earth passes by you. You are invisible to yourself. Surely this is the definition of a curse. And when I think back on that summer now, it is with disbelief. I was barely more than a teenager, a time when one's identity is a subject of constant intrigue, curiosity, and fascination, a framework for existence with which one is only beginning to become familiar. Choosing to obliterate even a tiny piece of it seems now, some forty years later, like a form of insanity.

When memory goes, it can vanish down an assortment of pathways—dementia, brain injury, stroke, substance abuse, or just the passage of time itself, to name only a few. But what parts of us remain when memory is lost is an inexact science. As is the degree to which our memories define us. When we forget those crucial moments of our lives—the swimming lessons at the lake, the rain falling against the window in your first apartment, the road trip to Southern California, the taste of the salt water in the bay off Cape Cod—is identity compromised? Our self-awareness, our sense of agency in this world, and the knowledge we have of our physical beings can be disrupted and disfigured. We can vanish from ourselves through neurological impairment, trauma, sedation, substance abuse. Sections of ourselves can be wiped out, obliterated. Something is gone. Something remains. It is not always easy to define what is what. Just as my brief moment with Versed induced something near

ecstasy, someone in the prelude to an epileptic seizure might experience the bliss of becoming unknown to himself. But a stroke patient might mourn the pieces of her body and her world that have vanished.

My mother's brain tumor diminished her ability to speak, reduced her capacity to express love for her family, and filled her with a confused rage. It robbed her of what we thought of as her identity. But such notions of identity are outdated. Catastrophic affliction is not required for the self to be upended. Even without such grave disruptions to our cognitive well-being, we know now that human character perpetually revises itself. Just as our bodies are in a state of constant renewal, with some 242 billion new cells produced each day by the average human adult, so too do the particles of personality that we consider markers of our *selves* continually become realigned. Identity is sly. We sneak around on ourselves.

The social psychologist and writer Daniel Gilbert suggests that human beings are far more plastic than we think, "works in progress that mistakenly think they're finished. The person you are right now is as transient, as fleeting and as temporary as all the people you've ever been. The one constant in our lives is change." Time is a powerful force, he says, and one that perpetually revises our values, personalities, our preferences in everything from music and the places we would like to go to friendship.

Researchers at the University of Edinburgh conducting the longest-ever study of the stability of human character have come to a similar conclusion, finding that those qualities that

seemed to mark us as teenagers could be all but gone in our later lives. Traits might appear stable over short periods of time but waver over decades. The researchers used data taken from a subset of the 1947 Scottish Mental Survey that tracked development in a pool of 70,805 children. The smaller sample of 1,208 fourteen-year-olds studied personality stability in the kids as they went from being adolescents to adults. The survey identified six particular traits: self-confidence, perseverance, mood stability, conscientiousness, originality, and the desire to learn. In 2012, that same pool of participants was tracked down, and of those found, 174 of the original subjects agreed to take part in the continued research. They were given questionnaires asking them to rate themselves about these same six traits and the degree to which they remained dominant factors in behavior; family members, partners, and friends close to the participants were also asked to assess the continued presence of the earlier traits. The results determined that while some of these traits remained steady in shorter periods of the subjects' lives, most of them, with the exception of mood stability, had changed markedly, sometimes vanishing entirely.

The philosopher and essayist David Hume, another Scotsman, who lived some two and a half centuries earlier, speculates in *A Treatise of Human Nature* on the transience of human identity, noting that

> *self or person is not any one impression, but that to which our several impressions and ideas are suppos'd to have a reference. If any impression gives rise to the idea of self, that impression must continue invariably the same, thro' the whole course of our lives;*

since self is suppos'd to exist after that manner. But there is no impression constant and invariable. Pain and pleasure, grief and joy, passions and sensations succeed each other, and never all exist at the same time. It cannot, therefore, be from any of these impressions, or from any other, that the idea of self is deriv'd; and consequently there is no such idea.

Only a few sentences later, anticipating the subsequent words of neurologist Scott Grafton, Hume "venture[s] to affirm of the rest of mankind, that they are nothing but a bundle of collections of different perceptions, which succeed each other with an inconceivable rapidity, and are in a perpetual flux and movement."

People change. Human character is less stable than presumed. The self is a perpetual refugee, always migrating from one state of being to another. Whatever those qualities are that we may consider intrinsic to our being are, in fact, malleable. The data behind such findings may be recent, but ideas about the doctrine of transience predate even Hume and the Enlightenment. A foundational concept of Buddhist practice is *Anitya*, the idea that all of existence is in a state of perpetual change. All things material and spiritual alike are evanescent. Impermanence— in thought, feeling, belief, behavior—is the very condition of being.

I had always assumed one's self had a core essence, some sort of solid bedrock which could be changed only by massive quakes, extreme circumstances capable of causing a shift in its fundamental shape. Now, though, I understand it as something else, some other alluvial geology, not bedrock so much as some

aggregate of sand, silt, and clay deposits, along with rifts of shale, collections of gravel and stone; all of these affected by rain and snow and ice, temperature, weather, time, and the varying inherent characteristics of the materials themselves. We change in ways that are constant and ephemeral. If there is no basis for saying a woman is "no longer herself" after she has suffered a brain injury, Alzheimer's, or dementia, it could be quite accurate to say those same words every morning after she wakes up from a vivid dream or when she has read a compelling book or had a meal or gone for a swim or had dinner with her husband. On the flip side, if you happen to find yourself saying "I am a whole new person" after sleeping for ten hours or having knee surgery or going to Iceland or dyeing your hair blue, that could, in fact, be true.

Do we engage with invisibility because of this? Do we have some intrinsic familiarity with this circumstance, some molecular knowledge of our vanishing identities? Maybe it is a lesson that visits us minute to minute, day to day, as bits and pieces of us come and go unpredictably. I think of the rearrangement of cells in my mother's brain. Sometimes, when she sat outdoors on summer evenings looking at the roses she had planted years before, a calm would visit her. Some of those had grown from cuttings taken from rose beds her father had planted decades earlier. At the time, I liked to think the pleasure in her face reflected a sense of continuity, some skein of heritage, a few slender threads of family identity that remained unfrayed. And that she was herself again. But I know now that the self has no single steward that summons and organizes its parts, its habits and beliefs and impressions, into a cohesive whole. And if I am

tempted to believe that she was also her*self* again, it is only be-cause I understand the self as something both old and new, de-rived both from particles of one's earlier life and from other bits that might have come into being at just that very moment in the dusk.

THE GEOGRAPHY OF INVISIBILITY

*The stories of the land also drew the listeners to consider
the powers and forces that lived just out of immediate view
within these same rocks, streams, waves, and waterfalls,
and behind the mists and sand clouds of the desert.*

—TERRY GUNNELL

On first impression, the Icelandic harbor town of Hafnar-
fjördur, a suburb south of Reykjavik, doesn't seem like
anything special. The houses, most of them corrugated steel
painted in bright colors, have a straightforward charm. Wind-
swept streets give the place a kind of spare elegance, as though
anything extraneous has been or will be blown off into the sea.

On second glance, though, one notices more lavish con-
structions scattered throughout the streets. The town has been
built almost entirely on and around a seven-thousand-year-old
lava field known as Burfellshraun, and its geography is dis-
tinguished by its exaggerated, jagged, dark stones, which vary
from pebbles and fist-size rocks to massive boulders in a vari-
ety of shapes and formations. Roads and buildings have been

constructed around its craters and crevices. Hellisgerdi Park, composed almost entirely of rock grottoes, is a landscape of caves, recesses, and outcroppings of the black stone; waterfalls stream from clefts and crevices in the rock, brooks cascade over stilled lava flow, its black walls softened only slightly by lichen and wild thyme. Even a gnarled and twisted beech tree near one of the park's main paths seems to conform to the aesthetic of the lava.

Popular belief holds that such rocks serve as the residences of spirit beings and that their extravagant rifts and fissures are apertures for the comings and goings of a hidden population known as the Huldufólk, or Alfar; even the contorted beech tree is thought to be alive with these friendly presences. A few blocks away from the park, a street called Merkurgata takes an unexpected turn to conform to the shape of an incongruous boulder jutting out into the street. On the day I visit, the rock is abloom with buttercup, wild thyme, yarrow, and dandelions that have taken root on it. The contemporary house on one side has been built to accommodate it, and when the driver of the black Volvo parked on its other side backs out, he does so carefully. Life goes on around it. On nearby Vesturbraut is another similar rock, though this one appears more groomed, decorated even, with its tended moss garden and oversize whalebone. Even the town's Fríkirkjan, a century-old Lutheran sanctuary, is built atop an outcropping of lava flow believed by some to be occupied by a Huldufólk settlement.

Hafnarfjördur, though, is not a remote rural village clinging to pagan tradition, but a contemporary suburban town. A map of the town documents Huldufólk residences, but I sensed that

the rocks are not perceived as being especially magical or super-
natural. The presences inhabiting them are somewhat admired,
respected, a little bit feared, but not very much. Incorporated
into the texture of daily life, the lava stones appear to be ordi-
nary street furniture much the way other cities might convey
regional identity with kiosks, food carts, banners, or fiberglass
moose.

But the stones, of course, are not part of a branding effort
dreamed up by some design strategist. Hafnarfjördur is defined
by the range, magnitude, and sheer number of its volcanic
rocks, but similar specimens are found elsewhere throughout
the Icelandic countryside, on the hills and meadows where
sheep graze, in villages and cities, and many of these are be-
lieved to be the geological residences of the country's alternate
and unseen population. The Huldufólk are acknowledged not
only by individual homeowners, but also by zoning and plan-
ning boards and other civic agencies. Disturbing their residences
not only in stones, but in cliffs, caves, hillocks, and all manner
of rifts in the earth is an affront that can cause machinery to
break down, schedules to be disrupted, workers to be injured.
To avoid such events, roads are diverted and construction resit-
uated. In 2015, when construction workers clearing a road after
a series of storms in the northern fjord town of Siglufjördur
were dealing with floods, mudslides, debris, and endangered
crews, it was discovered that a rock favored by the Alfar had
been covered with dirt. The rock was uncovered and power
washed, and order was restored.

Throughout Iceland, the supernatural is often acknowledged
with a nod. The Hraunavinir, or "Friends of the Lava," is the

name of a national organization committed to the conservation of both natural resources and cultural heritage. Its members work with municipalities, the Icelandic Road and Coastal Administration, and other civic agencies to ensure the preservation of such stones. In 2014, when the Icelandic road commission built a new road through the Gálgahraun lava field on the Álftanes peninsula, the group worked with the agency to carefully relocate a twelve-foot-long rock thought to be a gathering place for the hidden people.

Because protecting them is necessary to preserve the country's lava fields, glacial plains, and stunning mountain waterfalls, the Huldufólk are often viewed today as effective accomplices in contemporary conservation efforts. But their presence in Icelandic culture goes beyond being fanciful props for modern environmentalism. Their hold on the popular imagination speaks to something deeper, more complex, and more pertinent to us now. Iceland is a place where invisibility is recognized—in clefts and fissures in the hills, lava rocks, sod huts. At a time when we have become increasingly familiar with mediated realities and accept those ways in which virtual technology can intersect with real-life experience, these objects, places, personas, and the hidden world they represent suggest that such convergences can occur without a disconnect. And that the integration of such experiences can, in fact, enhance human experience.

Icelanders carry the DNA of both early Celtic settlers and Nordic Vikings, and myths of the Huldufólk in the Middle Ages reflect spirit beings from both cultures; they are the cousins of Nordic elves, many of whom live inside the earth, and

kin to the fairy folk of Ireland known also to reside in animal burrows, caves, and tree trunks. Some historians speculate that while Icelandic landowners were Nordic and their servants Irish, the character of Iceland's spirits was influenced more by the latter; it was nursemaids and nannies, after all, who told the stories that perpetuated the beliefs. But as with all their predecessors, stories of the Huldufólk came into being at a time when living conditions were grim, fishing and farm work were grueling, the winters were ruthless, and the climate was harsh. Icelanders understood themselves to be tenants at the mercy of a perilous world.

But the Icelandic hidden people have a character of their own. They are social creatures with lives much like ours. They eat what we eat (though flowers may be included in their diet) and wear similar clothing. The nineteenth-century garb they are generally thought to wear is attributed to the time their narratives shifted from oral to written accounts. The Huldufólk are not enchanted, magical beings; they are like us, but just a bit better. Their houses are like ours, just a bit finer. Their livestock is slightly better, too, their coats thicker and shinier. The cows produce better milk; their horses are a bit faster and more graceful. At a time when the harsh realities of everyday life threatened human survival, the lives of the hidden people resonated with order, civility, safety, decency, and prosperity. The Huldufólk offered a kind of pragmatic persona of the otherworldly.

The continuing belief in this shadow race has something to do with the country's chaotic geography of the unexpected, a landscape suggestive of the unknown. Iceland's topography is

one of constant and dazzling disruption. The country is situated on the mid-Atlantic ridge, a fault between the tectonic plates of North America and Europe, and the two plates are constantly drifting apart, the first toward the east-southeast and the second to the west-northwest. The land itself is in a constant state of animation, if not explosiveness. Earthquake activity—there can be hundreds each week—is described in terms of swarms, a word I had not understood before to apply to seismic events. Volcanoes remain active, and it is not difficult to find something animate in hexagonal basalt columns, in the softer, more rounded pillow shapes, or in any of the other exotic forms taken by igneous rocks. The freak formations in lava flow you might encounter in a single day range from molten, fluid swirls to crusty geometric crystals. But the lava fields might just as easily be barren lunar plains, covered in pale, thousand-year-old moss, or striped with swaths of purple lupine.

Glacial ice also covers some 11 percent of the country's landmass, making for a topography of disturbance that offers ice lagoons, ice streams, and ice caves just as regularly as it does scalding geysers, hot pools of mud that bubble and stream from the earth, and steaming, sulfuric geothermal pools. The entire landscape appears to exist in a state of suspended animation, and even before climate change, the manner in which glaciers unfurled themselves down to the plains has a sense of immediacy to it. At Jökulsárlón in the north, icebergs that are a surprisingly tropical shade of turquoise, some of them stippled with ash, drift from their frigid lagoon toward black beaches in a hallucinatory pageant. How the physical environment plays a role in the ways the human psyche is formed is an unsure science, but

it does not seem like a stretch to imagine a correlation of geography and sensibility here. Or to think that Icelandic culture reflects an abiding familiarity with the unexpected and uncertain forces of an unstable earth. The association between beauty and the unseen is fully recognized here.

If the geography advocates for the unknown, so too does the country's climate and light. At a latitude of 65° north, Iceland is cloaked in shade for months on end, often further obscured by blinding snow, all of it a darkness that might or might not be alleviated by a sudden luminescent stream of the northern lights, a magenta, turquoise, and green glow streaking across the night sky. Sightlines remain ambiguous. Recalling a visit to the countryside during the winter, the poet Mark Wunderlich told me of "the howling gales and two feet of snow. It was dark, and you couldn't see anything. I had gone there to ride, but assumed that in these conditions we would stay indoors. But why wouldn't you ride? my friends asked me. And so we just suited up and went out. We couldn't see anything. But the horses knew where we were. And then, suddenly, we could see."

Phantom populations are not limited to the shadow race of hidden people. Icelandic myth includes sea cattle able to breathe underwater, a dappled gray waterhorse able to vanish into the waves and take on different animal shapes, and a *skoffín*, a fox/cat hybrid that can disappear into the earth as a worm. Stories help us make sense of place, and according to Terry Gunnell, a professor in folklore at the University of Iceland, they also

turn a space into a place, and a place into a living place. . . .
They served as maps of the geographical, mental, historical, and

spiritual surroundings that these people inhabited, [working] to
remind listeners of place names and routes. They also gave his-
torical depth to the area, populating it with memories, ghosts,
and supernatural beings of various kinds.

It is impossible to separate the landscape and light of Iceland
from its legends, so many of which center on the unseen power
of the land around them. A sense of mystery prevails, which
helps to explain why literacy has been nearly universal in Ice-
land since the close of the eighteenth century. Not only does
everyone read, many write as well. Current statistics suggest
that one in ten people will write a book. The ubiquity of un-
seen geologic forces and the months of obliterating darkness
probably have something to do with the country's ingrained
literary tradition. It is a place where the human imagination
thrives. All these stories and beliefs may also persist because of
the innate character of island culture. The comparative isolation
of any island can result in what Oliver Sacks calls geographic
singularity, a kind of separateness that allows not only for the
evolution of animal and plant species that can be found no-
where else, but also for systems of thinking and belief that de-
velop with limited external influence and intrusion; islands
cultivate what is unique on this earth.

All of which may be why stories of the invisible people have
been absorbed so seamlessly into contemporary culture. Oli
Gunnarsson, a farmer in the south, points out for me an old turf
hut adjacent to his barn. Today, its roofline is neatly folded into
the sod beneath it, but it is generations old and was inhabited

by a family of hidden people when his grandparents were alive, he tells me. After a winter blizzard had damaged the hut, the family moved into the adjacent farmhouse with his grandparents. His grandmother, inclined to enjoy a glass of sherry in the evenings, noticed the level of the sherry bottle diminishing. "You'd better fix the roof on the sod house," she told her husband, "so the guests will move out quickly." Her husband repaired the roof, and life returned to normal. Oli laughs at the obviousness of the tale, but when I ask him if they continue to live here still, he says, "Yes, I think so." He believes in them, he tells me. "I do not see them, but it is the way people believe in God, even though they cannot see him." It is a relationship of respect, he says. His daughter played with several invisible children in a rock grotto when she was three, and he points to a fissure of stone at the foot of the grassy hill behind the farm. In the afternoons, she returned to the farmhouse and her parents only when the unseen children were summoned home by their own parents.

A farm woman in the north tells me these stories are more common in the eastern part of the country where she grew up. And as a child, she says, she was closer to the experience: "When you are young, there is less of a difference between what you see and what you believe. But most of us here now, we still have some belief in it." We are speaking in her cottage in mid-July, and the countryside has been bathed in pale northern light for many days and nights. Illumination is unrelenting, shifting only in degrees from a soft, diffuse gray to an overcast pearly dusk. A dense fog has settled in around the cottage,

however, and I can't see a thing. Such are the conditions of visibility here. Ambiguous conversations about the unknown in Iceland are naturally reflected by what is going on outdoors.

A few days later, a desk clerk at the hotel tells me that her five-year-old son plays frequently with a young Huldufólk boy. "Often he wants to bring his playmate home," she tells me. "But I tell him, 'No, no!'" She believes her son's stories but is not eager to have the elusive playmate in her house. "This is just something we live with," she tells me. She lives on a farm with her husband, and there are rock castles where the hidden people live on the hill behind her house. As she speaks, I look out the window at the hill scattered with gray stones and ask her how she is able to identify those that serve as residences for the unseen. "It is just the composition of the stones," she tells me. "Sometimes you will see a larger one, arranged just so with a smaller one. They stand there together. It is not unlike the way we build things ourselves." The tone with which she tells me this is beginning to become familiar to me, a combination of practical accommodation and pure, ancient belief. Later that morning, I drive to another hillside where the Huldufólk are said to converge. It is an ordinary hill, strewn with stones, sheathed in moss and grass. No other markers designate it as a place of any significance.

Adelgeir, a sheep farmer in the north, well into his eighties now, tells me through a translator about an encounter he had as a twelve-year-old boy. He was near a rock and met a woman dressed in blue clothing. She was friendly but she did not speak to him. It never happened again. But many farms have such rocks. It is part of ordinary life here. He gestures vaguely up the

hill where the animals are grazing. His son, who has taken over the operation of the farm and speaks English, tells me he grew up knowing about the rock. "But really, that is all."

Our exchange reminds me of James Tate's poem "The Invisible Alligators," in which a man and a woman discuss the alligator the man does not happen to have. Their conversation is both absurdist and affectionate. "I'm the only one without an alligator," he says in the puzzling conversation about unseen presences, oddball companions, and how *seeing* and *understanding* are words used interchangeably. Tate's poems often read as clouds of small bewilderments, full of the ordinary perplexities of daily life and the innate funny beauty these can have, and the stories I hear now seem to have a similar quiet acceptance of eccentric and undecipherable personas.

When the rocks of the Huldufólk are relocated, it is done with respect and restraint. In the village of Breiddalsvík is something called the "Power Rock," transferred there from a nearby ravine by a local hotel proprietor for use at a strongman competition. Identifying himself as a psychic, the proprietor had asked the Huldufólk living near the 22,000-pound stone for their permission to move it. They apparently agreed, with the condition that the stone be used for its healing power alone. The eventual transport involved a lightning storm, apparitions, the glow of candlelight. Simultaneously weird and ordinary, the massive rock is now a village landmark and sits in the middle of town next to a picnic table where tourists can eat their sandwiches. A small sign encourages them to absorb the rock's healing power through touch.

Of course, I touch the rock. In astrophysics, invisibility is

sometimes used as a placeholder, a stand-in for unidentified knowledge; physicists know that the information is there, but not knowing just what it is, think around it. Dark energy is a placeholder. Dark matter is a placeholder; it neither absorbs nor radiates light. There is no meaningful analogy for explaining how the universe is expanding. There is no metaphor for its edges that is applicable. We do not have the information for this. And so they remain as placeholders for the unknowable, and scientists think around them. The invisible world is a place in which the human imagination has not yet found a clear path. So we use a chunk of rock or inert piece of lava, some fissure in the ground, some dark space or object that is reserved for the inconceivable. Then we think around them. Which is likely why to this day I carry in my coat pocket a little round black volcanic stone no more than an inch in diameter, which I picked up on a beach near this town, a souvenir of the dark energy of which I have some knowledge but no comprehension.

A few days later, I find myself in the fishing village of Bakkagerdi. Tucked into the far end of Borgarfjördur, one of the country's eastern fjords, it is a remote fishing and sheep farming village. Gemstones are churned out of the earth on a regular basis, and the gift shop there offers bins of jasper, agate, and other assorted kinds of quartz. The village is known even more for its legends of the Huldufólk. A small white farmhouse at the edge of town is believed to have been the residence of a woman who lived among both humans and the hidden people, and local folklore describes her manner of negotiating life and marriage in these two separate realms.

Other stories suggest the kind of economy that villagers en-

tered into with the hidden folk, exchanges between the seen and unseen worlds that involve the transfer of goods and services, good fortune given in return for a pitcher of buttermilk or a prize ewe offered for the assurance of safety in a snowstorm. Themes of equitability in a harsh and inequitable world remain consistent. Writing about such lore and landscape in Nordic countries, Gunnell suggests that legends emphasize

> the often forgotten fact that people in the rural community regularly lived on the borderline between life and death of various kinds. They were well aware that something can come out of nothing, and that it can easily revert back to its original state. The world for them was a complex place of simultaneous being and nothingness, the visible and the invisible, something that, once again, few government documents from the time reflect.

Set back from the town center is a rocky outcropping known as Álfaborg, believed by many to be a city of hidden people as well as the home of its queen, Borghildur. I climb to the rock's summit along a path that is strewn with buttercup, wild geranium, wild thyme, moss, lichen. The elevation of the rock is slight, not more than fifty or sixty feet, and confers on visitors a sense of removal—but just barely. To the east is the edge of the harbor, and to the north and south, towering snowcapped mountains. It is one of those places where one can feel both connected and disconnected. A community of shadow presences is said to exist here, and that may be so, but it is also one of those geographic features that generate a sense of affinity. The position of the rock in its little valley and its slight elevation

make for a configuration of comfort, an order, a symmetry, a sense of belonging. It is easy to understand why residents of the village see it as so central to their lives.

Celtic tradition holds that the earth's geography contains "thin places." Heaven and earth are only three feet apart, the adage goes, but in such liminal zones, the distance is even less. Thin places are thought to be those areas where the temporal and spiritual converge, where the invisible and visible worlds coalesce. It could be a mountain or a river, some geographic axis, some threshold of rock, earth, or water, some pleat in the river or fold in the land that has the capacity to advance human spirit. It might be a place that becomes the site for a temple or monastery or shrine, but it could just as well be the snow settling on a frozen lake, an eclipsed sky, an unexpected conversation. Thin places refer not simply to geographic features but to how these allow people spatial and psychic realignment. This small rise of stone, framed by mountains and the harbor to the east, seems to qualify as just such a place.

Not far away is a small hill where a large volcanic boulder is surrounded by many smaller stones. Local lore has it that the area serves as a crossroads for the invisible population, and, later that afternoon, I meet a schoolteacher in the village who speaks with a distinct pragmatism when she tells me of taking her students there from time to time. She gives me directions to the field of stones and with her pen traces the road there and circles it on my map. "Who knows," she says, shrugging. "There are so many things we cannot see."

The writer A. S. Byatt takes this sense of affiliation to an

extreme in her short story "A Stone Woman," which describes a cellular coalescence of human and rock. Grieving the death of her mother, a woman finds that her body is calcifying, aggregates of her flesh, bone, and muscle replaced by greenish-white crystals, nodes of basalt, fire opals, black opals, dark blue labradorite, alabaster, silica flakes. Insects, butterflies, and ants attend to her. "I think you are a metamorphosis," a man tells her. She finds her mineral self a shining entity that is eventually absorbed by the earth around her. The story captures something about the surreal way one can identify with place, about how kinship with landscape can be a kinesthetic process, and about how it is possible for human beings to enter into an emotional relationship with natural phenomena.

It is easy for visitors to wink and roll their eyes at the notion of the Huldufólk, dismissing them as sentimental cultural relics, as many Icelanders do themselves. Yet there is something enduring and universal going on here. During the weeks I am in Iceland's empire of invisibility, the mobile game Pokémon GO grips the United States, and the ingenuity of the game seems akin to what I have witnessed in the north. From time to time, Icelandic people living in remote rural areas would look for support to Gudrun, Borghildur, the dwarf in the elf rock, and the chimera beings who are their co-inhabitants. But the kids with their augmented reality apps who are trolling urban neighborhoods to catch fictitious beings are involved in a similar exercise, involving invented characters on the very real physical landscape. These characters, too, have a regional specificity. And although they may be pop culture inventions constructed

strictly for entertainment and commerce, the kids searching them out are nonetheless reconciling the actual and virtual worlds to locate imagined personas with names like Snorlax, Weedle, and Rattata.

One is a digital overlay, the other a more entrenched system of belief. Yet both celebrate the possibilities, the challenges, the pleasures that may come with superimposing fictional personas onto real places. Both recognize how these can animate landscape. Both ask us to experience place through the imagination. Both ask for a suspension of disbelief. Both are integrally engaged with physical place and exploit a readiness to install invented beings in very real topography. Both rely on a shared language of landscape, landmarks, and objects. Both seem to recognize that invisibility is not necessarily about vast supernatural mystery, but about ordinary curiosity, ingenuity, uncertainty. Both exploit the universal human inclination to engage with an imagined world.

Pokémon GO is only one way the tectonic plates of the virtual and real worlds collide. Other hybrid experiences are more contemplative. Already, slow-game apps—noncompetitive, less time-sensitive—allow users to pass time serenely in the virtual world doing things that are more ordinary. Flower Garden is an app that allows users to quietly grow a virtual garden, selecting seeds, planting them, watering them, moving the pots around to catch better light, and, finally, picking the flowers and sending bouquets to friends. PocketPond is a similarly tranquil app that lets users create and fill a virtual backyard koi pond. There is no chase, no race, but simply the choice between, say, a brown teal hikari and a red grass sosani. Stock the pond, feed

the fish, raise them, watch them ripple through the water. That's it.

As we advance into the digital age, there is more to learn about how one reality can be overlaid upon another. Jeremy Bailenson, an associate professor and founding director of the Virtual Human Interaction Lab at Stanford University, explores VR for its social benefits. The mission of the lab is to understand how humans react in VR environments, both in terms of how they perceive themselves and how they interact with others; and to explore how such engagement with the digital world can benefit human behavior. Visitors wearing headsets in his lab experience not the ability to vanish, but rather, the ability to be absorbed—completely—by another environment, another persona. A VR tour into endangered coral reefs can heighten sensitivity to environmental abuse. In another experiment, participants looking into a virtual mirror see an avatar reflecting them as a different age, race, or gender. When a second avatar treats them in an abusive manner, participants found their sensitivity to prejudice was intensified. As Bailenson has said, "You can become 70 years old, a different race, or a different gender, and have to walk a mile in that person's shoes and experience discrimination against that person. . . . I see my job as using VR to teach people how to like each other, take each other's perspectives, learn about other cultures and learn about the environment."

Likewise, DeepStream VR is a start-up in Seattle that has researched virtual reality applications for health care, specifically in stress reduction, pain management, and rehabilitation. MRI scans have shown that the cognitive distraction offered by

virtual reality programs, when combined with biofeedback, can help patients to reduce pain levels. DeepStream's COOL! program allows users wearing VR headsets to choose idyllic landscapes, sometimes populated by fantastic creatures, which absorb the patient's attention, taking it from the exterior perspective viewed on a monitor to a greater assimilation inside the frame. Caves, streaming rivers, a sunrise, a snow arch, an otter—such are some of the components of the imagined world that allow patients to better handle their pain.

As VR comes out of computer labs, its potential for applications in ordinary life is only growing. As cities become ever more crowded, urban planners are already researching how smartphone apps and devices can assist inhabitants of the modern city with transportation, communication, and other kinds of information flow. The idea that virtual reality can offer salves for compromised living conditions does not seem terribly remote from what Icelandic culture has been practicing for centuries. The ability to call up an illusory landscape, object, or persona serves us well, whether the conditions are a product of volcanic eruptions, unrelenting winters, and earthquakes, or human overcrowding, extreme weather, and a toxic environment. We, too, are beginning to recognize ourselves as tenants of an unruly universe.

A belief in the Huldufólk requires a mix of imagination, endurance, and vulnerability. It's a useful combination. The hard facts of the stones and the ephemeral spirits said to inhabit them don't reflect any kind of disconnect, but rather, some coalition of the matter-of-fact and the fantastic. When it comes to

our willingness to inhabit alternate universes, an artist in Brook-
lyn stocking her virtual koi pond or an army veteran learning
to manage his chronic pain by playing with a virtual otter in an
ice cave are engaged in imaginative thinking not so different
from that of a young girl at play with her invisible friend in the
rock fissure or of a twelve-year-old boy encountering a woman
in a blue dress on a hill at his family's farm. I'm almost certain
that old sheep farmer does not think of his experience as virtual
reality. But it has stayed with him for his entire life.

WITH WONDER

How much larger your life would be if your self could become
smaller in it ... you would find yourself under a freer sky,
in a street full of splendid strangers.

—G. K. CHESTERTON

Virtual reality offers users a world of immersive computer simulations, but augmented reality (AR) superimposes digital content on real-world terrain, combining the two landscapes in a more elusive hybrid. AR is understood to be a means of constructing an alternate vision of what is real, but Mark Skwarek, an artist and the director of the Mobile Augmented Reality Lab at New York University's Tandon School of Engineering, is more engaged with deconstructing the familiar; erasing it, that is. Interested in how digital experience can be translated into the material world, he has developed what he calls erasAR technology, software that appears to remove objects from the landscape. He has lifted the Statue of Liberty off her base, rearranged the New York City skyline, and restored Virginia coal mountains. It is technology, he suggests, that, in effect, turns the user's mobile device into a looking glass.

The project is designed to allow people to both acquire new

identities and enter new landscapes. Interested in the social and political implications of such possibilities and driven by a commitment to social justice, Skwarek created his erasAR program as an app for a mobile device that can produce a 3-D collage. His *Augmented Reality Korean Unification Project* restores the demilitarized zone between North and South Korea to a pristine natural landscape. All guards, military buildings and equipment, fortifications, and checkpoints have been digitally removed, allowing visitors to use their laptop screens or smartphone displays to view the landscape as it existed when the country was unified and to appreciate the zone simply for its natural beauty.

To document the zone, Skwarek traveled its entire length and describes it as having the spatial grandeur of the Grand Canyon, though it is a verdant green valley resting between two mountain ranges. But the high emotional charge was even more affecting. "When you go there," he says, "they show you films of people being murdered. You can't wear sandals. You can take pictures, but no videos." His own goal, he says, was to erase the scars of war, allowing a younger generation to envision a unified Korea and to have some sense of what it might feel like to walk freely from one side to the other. It is his hope that the immersive engagement with the restored landscape will provide not only a visual but also a more profound emotional connection to ideas of unification. A similar project led him to digitally raze sections of the Israeli-Palestinian separation barrier in the Gaza Strip, a virtual demolition that broke open a hole in the wall, exposing groves of olive trees. "Some of these people have never seen what is on the other side," he says. "There is a reaction of

wonder, excitement." This, he suggests, can reconfigure our understanding of the real world.

Skwarek's recent project, *Open Telepresence*, is an open-source tool that works something like an immersive 3-D version of Skype. It makes a more comprehensive effort to remove barriers, in essence vanishing walls, and is similar to Google Tango, the augmented reality platform used with mobile devices that allowed for indoor navigation, environmental recognition, 3-D mapping, and other forms of measuring space in the virtual world. Skwarek's project, meant to engage a wider base of users, combines 3-D motion tracking with depth sensors to allow a mobile device to track its passage through space, and he describes it as an embodied experience, which lets people in remote locations share the same space. When a user puts a 3-D video of a room online, others can use their own mobile devices to see her, virtually entering the room in real time.

Such 3-D networked communication could have applications ranging from indoor navigation and mapping to conveying practical, complex information on a small scale—giving instructions on how to repair a motor, for example—to larger, in-the-moment crisis interventions in which first responders at a disaster site could receive input from health-care professionals half the world away. Skwarek views it as technology that essentially allows the user to be in two places at once. And that democratizes knowledge with technical expertise. It is Skwarek's ultimate intention for the user to wear a simple pair of lightweight AR glasses (rather than the clumsy oversize headsets currently used that inevitably isolate the user from the immediate

environment). The objective, he says, is to use AR video feeds to overlay digital information on the real world, allowing users to see more and to experience a deeper connection to the surrounding world. Skwarek envisions the project as a platform for instant and constant connectivity. Urban spaces are so densely populated now, he says, that removing walls might make them more bearable. "Spaces open up; you can look through buildings. It rearranges our experience of space in a fundamental way."

My own experience with Skwarek's work in the Brooklyn studio is limited. We stand in the hallway outside his small office and wave to Yao Chen, one of his assistants, who has remained inside. There is a wall between us, but because we are looking at the screen on Skwarek's laptop, that wall has vanished, allowing us to virtually share the space with Chen. The digital feed is uneven, and some colors read more clearly than others. Still, it is an early prototype for a larger system of connectivity. Skwarek envisions a time when all of us will be equipped with such AR devices, their capabilities stitched together to provide a virtual copy of the entire visual world. Get one up in Iraq, he suggests, and we will have a better idea in real time of how people live there, experience the suffering of others in a more embodied way. Or Syria. It would give us a different understanding of the refugee crisis. "But I'd also like to see huge waves from the surf in Hawaii crashing in on my desk now," he muses. "And I'd like to have my dinner table up against the wall in my apartment, disappear that wall, and have my sister at her dinner table. Both our walls are gone, and we can have dinner together, sitting at the same table." It is the shared sense of wonder that Skwarek anticipates most.

Skwarek doesn't hesitate to acknowledge the innate paradox of his work: vanishing walls makes one thing less visible, another thing more visible. The process requires not fewer but more video feeds; and any technology that removes barriers can be used, or misused, for everything from spam to surveillance. But while Skwarek recognizes the potential for intrusion, he maintains that his own commitment to the project is rooted in its capacity "to create an experience that pushes people in a socially conscious way." He believes in its promise as a set of tools furthering positive human communication.

For all the futuristic confidence implicit in Skwarek's work, there remains something timeless in his association between connection and wonder. Whether he is removing military paraphernalia in North Korea or evaporating the walls in an ordinary office cubicle in Brooklyn, his forays in AR investigate how human presence can be configured and reconfigured in physical space. And, ultimately, how it may be the sense of wonder derived from such experiences that gives the condition of invisibility its greatest value.

Invisibility can range from disappearing to simply being hidden, from practicing visual discretion to confusing the eye to a diminution of self. The last is Paul K. Piff's field of study. A professor of psychology and social behavior at the University of California, Irvine, he has pioneered the psychology of awe. Among the locales he has studied is the night sky, surely the prime acreage of wonder and one that is available to nearly everyone. If we don't all have access to the ocean or giant trees or the Grand Canyon, he has said, we have all looked to the night sky to imagine our place in the universe. Regardless of

one's background or location, the night sky has had a role in shaping human consciousness and in fostering transformative human experience. Piff has gone beyond this, though, connecting awe with principled human behavior. His research has led him to believe that awe generates a sense of altruism and that transcendent experience connects us to a sphere outside of ourselves, taking us from self-interest to a sense of greater inclusion in the human community.

In one recent study, Piff and his team situated participants in a grove of Tasmanian eucalyptus trees over two hundred feet tall, known to be the tallest stand of hardwood trees in North America. The group was asked to gaze at the stand of trees for a minute, while a second group fixed their gaze on a tall building nearby. The participants were then asked to identify their feelings, options ranging from amusement, anger, and awe to disgust, fear, sadness, and happiness. Not surprisingly, those looking at the trees reported greater awe than those gazing up at the tall building. But the study also revealed that those participants experiencing awe were also on record as feeling less entitled, less self-centered, and more generous.

The feelings of self-diminishment that came from being in a natural setting eliciting awe and wonder also resulted in more generous and prosocial behavior. "Our research finds that even brief experiences of awe, such as being amid beautiful tall trees, lead people to feel less narcissistic and entitled and more attuned to the common humanity people share with one another," Piff has written. "In the great balancing act of our social lives, between the gratification of self-interest and a concern for

others, fleeting experiences of awe redefine the self in terms of the collective, and orient our actions toward the needs of those around us." Piff has written extensively about those ways in which awe is central to exercises in spirituality, art, nature, music, and political activism, all endeavors in which shared engagement confers "a more acute sense of collective identity." In lessening one's sense of self, awe enables us to find membership in some broader coalition of human enterprise. It realigns our frame of human reference.

The closest I have come to this was on an early morning swim across a wide New Hampshire lake. It was late summer, and I knew the days of open-water swimming were winding down. As I took my strokes across the vast, gray lake, I tried to stay submerged, holding my head beneath the surface for as long as I could manage in a futile effort to take the feel of the water with me into the coming cool season. When I finally emerged, I heard a sound, a voice from some other realm, an eerie call somewhere between laughter and mourning. Only a few feet away was a loon, with its elegant black-and-white checkerboard plumage, bobbing along as it, too, skimmed and ducked beneath the surface; when diving, these waterbirds can remain immersed for well over a minute, and if you are watching a loon from the shore, it is always a guessing game on where and when it will reappear. Now a co-tenant in its sphere of water and air, I shared for a moment the uncertainty of presence and absence, the mystery rhythm of both being there and not. Yet despite the ambiguity, or perhaps because of it, the moment also afforded a brief affinity with some larger sense of order.

It was enough to find myself experiencing some startling and spontaneous congruence of sensation: the impression of water, the touch of late summer air, the sound of the wilderness siren. But beyond that, it was the possibility of inclusion in some greater citizenry, and just for that instant, a sense of affiliation between the residents of the wild and social worlds. I may have been present in every way, but being there was also a matter of self-erasure. I can't say that I became more altruistic, more kind, more generous, but I would like to think that sense of alliance has remained with me and has had some effect on my sense of place on this earth. Piff suggests that awe can "trigger an almost metaphorical sense of smallness of the self," and the self-diminishment that is so emergent in his research was surely part of my experience that August morning. I was there in every way, but still, at the same time, gone.

Piff writes often about the small self, the feeling of physical diminution, our reduced place in things that is so intrinsic to the experience of wonder. Does wonder make you feel small? Or do you have to be able to feel small to feel wonder? It is a sequence we are unlikely to pin down. I did not vanish that August morning, but certainly felt my status reduced, and there is something sustaining in knowing that the mathematics of self can accommodate such variations. We so often encounter the world in terms of physical scale, moving through life with that primal instinct to assess ourselves in relation to those things around us—people, houses, rocks, plants, clouds. Our own human dimensions are so often the basis for how we take measure of things; our size, our volume and bulk are what the physicist Alan Lightman calls "the first carrying cards we present to the

world." But perhaps it is in the nature of transformative experience, from time to time, to step outside of these equations. Perhaps it is a shift in weight similar to what philosopher Jacob Needleman calls the "sacred erasure" that takes place when one's mental and emotional certainties vanish. It is the place, he suggests, where freedom begins.

Acknowledging the unseen has been central to the practice of human faith across time and history. The belief that there is a deeper connection between man and the universe than what is experienced in the everyday world we inhabit informs the human search for meaning. And the idea of a dematerialized being is central to the search; the quest for significance mandates that, somewhere along the way, we confront our insignificance. In his lecture "The Reality of the Unseen," the nineteenth-century philosopher and psychologist William James observed "the existence in our mental machinery of a sense of present reality more diffused and general than that which our special senses yield," and that conviction seems common to human metaphysical inquiry. James suggests that spiritual practice at large depends upon the belief of "an unseen order" and that human good lies in adjusting ourselves to the idea of such accord. If there is an argument for reevaluating invisibility, it may lie in the fact that what he calls the human ontological imagination comes to life when it acknowledges the unseen and unknown.

Surely that imagination was in play on August 21, 2017, when the total solar eclipse traveled its seventy-mile-wide arc across the continental United States, inducing something close to a collective rapture. That the sense of wonder was shared by so many intensified it all the more, and the national celebration

seemed to signal not only an acceptance but also an exhilarated embrace of darkness as intrinsic to our sense of earthly order. Perhaps the vast shared excitement also came in its reminder of the unknown forces around us, the dark energy and dark matter that make up so much of our universe. Perhaps it was due to a fundamental human need for obscurity that has gone unrecognized in recent years. Indeed, perhaps the revelry surrounding this particular eclipse was due in some part to recognizing the discreet beauty of the shadow world as an alternative to perpetual illumination.

It may be just as well that efforts to construct an invisibility cloak have not yet been successful. Transformation optics, invisibility cloaks, rearranged lenses, and augmented reality headsets all offer skirmishes with the physical condition of being unseen. None of them are especially foolproof or effective, but all suggest a growing engagement with visual reticence and an acceptance of the idea that we might be not unseen so much as simply absorbed and assimilated by the world around us. It's no wonder that *The New York Times* instituted its own space calendar in 2017 that users can sync to their mobile devices, enabling them to stay tuned to meteor showers, eclipses, supermoons, comets, and equinoxes; we seem drawn to tracking our place in the gargantuan. But the technology that most appeals to me is a kind of glass I have seen used for the windows of some contemporary buildings. These windows appear to be ordinary transparent glass, yet the exterior face of the glass has been overlaid with patterned ultraviolet film, a reflective coating that makes the surface visible to birds, thus preventing them from flying into it. The patterning has been described by its

manufacturers as something akin to visual noise, yet when I squint hard at it at a particular angle of light, the crosshatching of UV threads becomes just visible and looks more like a delicate lace.

I imagine some corollary designed for us, some faint filigree that can prevent us from crashing into those things not immediately apparent, some subtle design that reminds us of the 95 percent of our world that remains out of view. Maybe it requires that particular angle of light. Or maybe it just gets us back to the human ontological imagination. Or maybe it's what the poet Mark Strand refers to in his final book, *Almost Invisible*. Strand writes of an immense journey he anticipates, "to travel night and day into the unknown until, forgetting my old self, I came into possession of a new self, one that I might have missed on my previous travels. But the first step was beyond me." He feels incapacitated and lies on the bed, disabled, staring at the ceiling until he "suddenly felt a blast of cold air, and I was gone."

I think Strand is talking about some manner of *being* deeply inward, some fully realized practice of discretion. Becoming less present has its own language, with a vocabulary, structure, and syntax that is acquired through use and practice. After the publication of the book, Strand was asked by an interviewer, "You half-jokingly said a few nights ago, 'I'm always trying to be almost invisible.' Is it because Mark Strand is so visible or not visible enough?" He answered, "This is a tall person's desire to be small . . . No, that's too neat. As you become older, you become less present. You feel that the world is going along very well without you. And I'm fine with it."

I find that I am fine with it too. In becoming less present, I

find my own mental machinery picks up a beat. Maybe it is nothing more than some ordinary friction between the individual and the collective. We spend so much of our lives learning how to simply be ourselves. We try to understand ourselves not out of some narcissistic impulse, but because we know that self-knowledge and self-awareness, a sure sense of identity, are what allow us to create a path toward a full and generous life. To say, "I am here," or "I see you" or "I love you," to be ourselves to the fullest degree is what makes it possible not just to experience life at its fullest but to give ourselves most completely to the causes to which we are committed, to our children, to the people we love.

Yet I am astonished that our most affecting experiences so often have to do with a sense of psychic diminishment. The acceptance that each of us is a bead of mist in the weather of the world is what connects us most. Our finest selves are what Piff calls the small self. The smaller we become, the less we are, the greater our sense of connection and our sense of humanity. It is almost as though finding our place is a matter of losing it first. Perhaps the ability to navigate our way through these twinned circumstances of exposure and erasure is what is required of us.

I am convinced more and more that understanding how to disappear is part of understanding who we are. How to *be* depends on knowing how to be fully present and how to disappear as well—which is why I find myself becoming an advocate for a kind of elective invisibility. For some of the events that shaped my life most deeply, I all but disappeared. That month in June when I fell in love with the man who would become my husband, I lost myself. The February afternoon my

twin sons were born, their existence made me forget my own.
A morning spent swimming across the Hudson brought me to
understand that the current of the deep, gray river, its relentless
tide and perpetual flow, could consume me in the best of ways,
and I spent months and years after that day swimming one river
after another. I didn't have that pebble in my mouth, nor was I
wearing a magic ring. Without being anywhere near a neuro-
scientist's paintbrush or virtual reality goggles, my body had
become an empty space, and I had all but vanished.

Invisibility comes to me now in images: the light cloak; the
Icelandic stave; Tim Duncan in the checkout line at Old Navy;
the demilitarized zone with its military structures vanished;
Veruschka painted as a stone on a wintry beach; a transparent
fish in the deep, clear sea; the Icelandic woman in the blue dress.
I am especially enamored of the photographs of commuters
bicycling on the streets of Shanghai taken by the artist Zhao
Huasen. Although the riders' bicycles have been digitally
erased, their feet continue to pedal, their hands on the handle-
bars and their eyes on the road as they glide down the city
street, carried forward by something unknown. The child rid-
ing behind his father is still hugging his father; a woman re-
mains folded into her lover's back. With the shadows of the
bikes remaining on the pavement below, the images record the
kinetic partnership we all enter into with invisibility. The invis-
ible world animates our lives.

I once saw an exhibition about the geography of wonder.
The gallery notes referred to the space between knowing and
not knowing, but it seemed to me the liminality of visibility
and invisibility was at work here as well. The artist, Hope

Ginsburg, had filmed herself along with three other divers on a windy day under the stone-gray sky of the North Atlantic coast, sitting at the edge of the sea at the Bay of Fundy, where the range of tide varies between forty-seven and fifty-three feet. What she called her land dive team sat quietly with all their scuba tanks, flippers, and bright masks at the edge of the shore as the seawater came in, washing over the rockweed, sand, and stones. The video documented the way in which the tide rose around the divers, submerging their legs, then their torsos, and finally their shoulders and heads; in one close-up shot, with her bright red synthetic goggles and her head draped in seaweed, Ginsburg seems to have become a hybrid creature. In the end, all that remains visible is the tide rolling in, leaves floating on the gently rippling surface of the water, a few bubbles above that place in the ocean where the divers, with their tanks and respirators, continue to breathe.

The Irish poet, priest, and philosopher John O'Donohue said, "The more I've been thinking about this, the more it seems to me actually is that the visible world is the first shoreline of the invisible world. And the same way I believe with the body and the soul. That actually the soul—the body is in the soul, not the soul just in the body. And that in some way the poignance of being a human being is that you are the place where the invisible becomes visible and expressive in some way."

I'd go so far as to say we are all members of some similar land dive team, poised at that tide line where waves of the seen and the unseen meet and wash over us continually and inevitably.

ACKNOWLEDGMENTS

Researching invisibility has been a tenuous process drawing on all manner of human experience and perception. For their assorted research, knowledge, insights, memories, advice, instruction, suggestions, and speculations, I am grateful to David Anderegg, Dr. Armen Babigian, Carolyn Brooks, Michael Burkard, Alison Carper, Ron Cohen, Anna Crabtree, Sam DeVries, Carol Phillips Ewin, Tracy Gleason, Carin Goldberg, Logan Goodman, Scott Grafton, Kevin Harrington, Pam Hart, Dan Hofstadter, Ashley Hollister, Katherine Humpstone, Dr. Joshua Jaffe, Anne Kreamer, Francesca LaPasta, Heather Lee, Michael Lockwood, Michael Loening, Michael McTwigan, Margo Mensing, Emily Nachison, James Rohrbaugh, Noelle Rouxel-Cubberly, Bonnie Loopesko Shapiro, Betsy Sherman, Brooke Sippel, Alena Smith, David R. Smith, Doug Smith, Jane Smith, April Stein, the Reverend Astrid Storm, Christina Svane, Linnaea Tillett, and Mark Wunderlich.

The subject matter here was elusive from the start, and I am indebted most to my editor at Penguin Press, Ann Godoff, for seeing this book; for shepherding it to publication with tact, discernment, and an eye for distillation; and for remaining ever alert to ways in which the ephemeral can be addressed with

gritty pragmatism. I am also grateful to Casey Denis for her efficiency, unwavering patience, and ever gracious goodwill; to Will Heyward for his editorial insight and encouragement at opportune moments; to Angelina Krahn for her dedication to clarity and exactitude; to Gretchen Achilles and Darren Haggar for their grace and skill in finding the visual means to support the ideas here; to Gabriel Levinson for his precision and thoroughness; and to Juliana Kiyan and Caitlin O'Shaughnessy for their efforts to bring this book out into the world. Thanks go as well to my literary agent, Albert LaFarge, for the sage counsel, support, and enthusiasm he has long brought to our partnership; to the Civitella Ranieri Foundation in Umbertide, Italy, where the ideas for this book originated; and to Honor Jones, who found a place for these considerations in their seedling form. Finally, to Brian, Noel, and Luc—it is my great good fortune to be in your sight lines and to have you in mine.

NOTES

INTRODUCTION

19 **essential as conventional, material building supplies:** Avinash Rajagopal, "Three Forms of Invisible Architecture," *Metropolis*, November 2014.

21 **and then to sing a series of songs:** Ioannis Marathakis, "From the Ring of Gyges to the Black Cat Bone: A Historical Survey of the Invisibility Spells," Hermetics Resource Site, 2007, www.hermetics.org/Invisibilitas.html.

21 **a shirt, a sword, a mirror, an animal's heart:** Wendy Doniger, "Invisibility and Sexual Violence in Indo-European Mythology," in "Invisibility: The Power of an Idea," ed. Arien Mack, special issue, *Social Research: An International Quarterly* 83, no. 4 (winter 2016), 848.

CHAPTER ONE

27 **And then being found is confirmation:** David Anderegg, in conversation with the author, March 2, 2016.

29 **that allow the child's imagination to flourish:** Ronda Kaysen, "Secret Spaces," *New York Times*, October 16, 2016.

29 **We need to enter this space so we can reflect:** Alison Carper, "The Importance of Hide-and-Seek," Couch, *New York Times*, June 30, 2015, https://opinionator.blogs.nytimes.com/2015/06/30/the-importance-of-hide-and-seek/.

31 **future intimate relationships:** Alison Carper, email to the author, July 7, 2015.

32 **disappointment, sadness, and anger:** Tracy Gleason, "Dr. Tracy Gleason on Imaginary Friends," Glimpse Journal Blog, September 8, 2010, glimpsejournal.wordpress.com/2010/09/08/dr-tracy-gleason-on-imaginary-friends/.

34 **How do you manage that? she asks:** Tracy Gleason, in conversation with the author, March 31, 2017.

39 **real or not can be irrelevant:** Tracy Gleason, in conversation with the author, March 31, 2017.

39 **safely experiencing powerful emotions:** Tracy Gleason, "Murray: The Stuffed Bunny," *Evocative Objects: Things We Think With*, ed. Sherry Turkle (Cambridge, MA: MIT Press, 2007), 170–176.

40 **bare our souls to imaginary others:** Marjorie Taylor and Candice M. Mottweiler, "Imaginary Companions: Pretending They Are Real but Knowing They Are Not," *American Journal of Play* 1, no. 1 (summer 2008), 47, 50.

CHAPTER TWO

46 **beneficent and good like him:** Jean-Jacques Rousseau, *The Reveries of the Solitary Walker*, trans. Charles E. Butterworth (Indianapolis: Hackett Publishing Company, 1992), 81-2.

51 **And a single frequency cannot carry much information:** David R. Smith, "Invisibility: The Power of an Idea," 36th Social Research Conference, New School, New York City, session one, Research and Discovery, April 20, 2017.

52 **I think, is a ways off:** David R. Smith, email to the author, August 18, 2017.

53 **to look at something else:** John Howell, in conversation with the author, July 27, 2015, University of Rochester.

56 **the proposition that we can disappear:** Arvid Guterstam, Zakaryah Abdulkarim, H. Henrik Ehrsson, "Illusory Ownership of an Invisible Body Reduces Autonomic and Subjective Social Anxiety Responses," https://www.nature.com/articles/srep09831/.

56 **to bring it into material practice:** Philip Ball, *Invisible: The Dangerous Allure of the Unseen*, (Chicago: University of Chicago Press, 2015), 281.

CHAPTER THREE

65 **a picture of the environment on its body:** Kevin A. Murphy, *"Not Theories but Revelations": The Art and Science of Abbott Handerson Thayer* (Williamstown, MA: Williams College Museum of Art, 2016).

67 **conceal themselves out of necessity:** Kevin A. Murphy, *"Not Theories but Revelations"*.

68 **reduced to a mere inconspicuous line:** Hugh B. Cott, *Adaptive Coloration in Animals* (London: Methuen & Co Ltd., 1940).

77 **appeared foolish and out of place:** Helen Macdonald, "Hiding from Animals," *New York Times Magazine*, July 19, 2015, 16.

77 **against / a larger truth:** Katherine Larson, *Radial Symmetry* (New Haven, CT: Yale University Press, 2011), 12.

78 **landscape as one of its details:** Wendell Berry, "An Entrance to the Woods," in *The Art of the Personal Essay*, comp. Phillip Lopate (New York: Anchor Books, 1995), 673–677.

CHAPTER FOUR

83 **than verbal or emotional contact:** Diane Ackerman, *A Natural History of the Senses* (New York: Vintage Books, 1990), 77.

85 **differently minded because differently bodied:** Robert Macfarlane, *Landmarks* (New York: Penguin Books, 2015), 104.

86 **solid and liquid, evident and hidden:** Italo Calvino, *Invisible Cities* (New York: Harcourt, 1978), 88–89.

88 **predator species floating above them:** Kenneth Chang, "A World of Creatures That Hide in the Open," *New York Times*, August 19, 2014, https://www.nytimes.com/2014/08/19/science/a-world-of-creatures-that-hide-in-the-open.html.

89 **strategists studying submersive camouflage:** Molly Cummings, "Invisibility: The Power of an Idea," 36th Social Research Conference, New School, New York City, session one, Research and Discovery, April 20, 2017.

92 **and our involuntary reactions to stress:** Wallace J. Nichols, *Blue Mind* (New York: Little, Brown, 2014), 109.

92 **unconscious, and cognitive means:** Elizabeth R. Straughan, "Touched by Water: The Body in Scuba Diving," *Emotion, Space and Society* 5, no. 1 (February 2012), 19–26.

94 **emotional experience can be environmentally specific:** Deborah P. Dixon and Eliza-

beth R. Straughan, "Geographies of Touch/Touched by Geography," *Geography Compass* 4, no. 5 (May 2010), 449–459.

CHAPTER FIVE

103 **the whole text, intact and in order:** Mary Ruefle, "On Erasure" (lecture, Vermont College of Fine Arts, Montpelier, VT, January 2009).

103 **more of visibility than invisibility:** Mary Ruefle, in conversation with the author, May 25, 2016, Lake Paran, VT.

104 **forgotten so many phrases:** Jonathan Safran Foer, "Jonathan Safran Foer's Book as Art Object," interview by Steven Heller, *ArtsBeat* (blog), *New York Times*, November 24, 2010, https://artsbeat.blogs.nytimes.com/2010/11/24/jonathan-safran-foers-book-as-art-object/.

CHAPTER SIX

113 **cultural attitudes and behaviors:** Gender binary memo from Bennington College, September 4, 2014.

113 **of all adults were multiracial:** Bonnie Tsui, "Choose Your Own Identity," *New York Times Magazine*, December 14, 2015, https://www.nytimes.com/2015/12/14/magazine/choose-your-own-identity.html.

113 **director of social trends research at the center:** Richard Pérez-Peña, "Report Says Census Undercounts Mixed Race," *New York Times*, June 11, 2015, https://www.nytimes.com/2015/06/12/us/pew-survey-mixed-race-multiracial-america.html.

118 **with a singular amputated body:** Katy Diamond Hamer, "Ed Atkins, Performance Capture: The Kitchen," *Eyes Towards the Dove*, April 27, 2016, http://eyes-towards-the-dove.com/2016/04/ed-atkins-performance-capture-kitchen/.

CHAPTER SEVEN

126 **coincided with the emergence of industrial transportation:** Anthony Raynsford, "Swarm of the Metropolis: Passenger Circulation at Grand Central Terminal and the ideology of the Crowd Aesthetic," *Journal of Architectural Education* 50, no. 1 (September 1996), 11.

128 **and moving at a like pace:** Alexandra Horowitz, *On Looking: Eleven Walks with Expert Eyes* (New York: Scribner, 2013), 146.

128 **we have an inherent dependence:** Michael Lockwood, phone conversation with author, May 23, 2016.

129 **That's why people help each other:** Michael Lockwood, phone conversation with the author, May 23, 2016.

130 **that I'd like to continue to explore:** Elena Ferrante, "'Writing Has Always Been a Great Struggle for Me': Q. and A.: Elena Ferrante," interview by Rachel Donadio, *New York Times*, December 9, 2014.

136 **have come to celebrate theirs:** Susan Cheever, "Is it Time to Take the Anonymous out of AA?," *The Fix*, April 7, 2011, https://www.thefix.com/content/breaking-rule-anonymity-aa.

CHAPTER EIGHT

140 **only to reappear in a seat in the audience:** Philip Ball, *Invisible: The Dangerous Allure of the Unseen* (Chicago: University of Chicago Press, 2015), 195.

141 **makes her visible, most importantly to herself:** Manohla Dargis, "Review: 'Hello,

My Name Is Doris' about an Older Woman's Love for a Much Younger Man," *New York Times*, March 10, 2016.

143 **presence, authority, and voice:** Francine du Plessix Gray, "The Third Age," *The New Yorker*, February 26, 1996, 188.

144 **continue to objectify herself:** Alison Carper, in conversation with the author, April 1, 2016, New York City.

146 **with the emotional states of others:** Ana Guinote, Ioanna Cotzia, Sanpreet Sandhu, and Pramila Siwa, "Social Status Modulates Prosocial Behavior and Egalitarianism in Preschool Children and Adults," *PNAS* 112, no. 3 (January 20, 2015), 731–736.

149 **with which we come into contact:** Vera Lehndorff and Holger Trülzsch, *Veruschka: Trans-Figurations* (Boston: Little, Brown, 1986), 145.

CHAPTER NINE

155 **hand being stroked:** Anil Ananthaswamy, *The Man Who Wasn't There: Investigations into the Strange New Science of the Self* (New York: Dutton, 2015), 74.

156 **the perception of a visual double:** Anil Ananthaswamy, *The Man Who Wasn't There: Investigations into the Strange New Science of the Self* (New York: Dutton, 2015), 199.

157 **I feel invisible myself:** Dr. James Rohrbaugh, in conversation with the author, September 26, 2016.

161 **we would like to go to friendship:** Daniel Gilbert, "The Psychology of Your Future Self," recorded March 2014 at the TED2014 conference, TED video, 6:46, https://www.ted.com/talks/dan_gilbert_you_are_always_changing.

162 **sometimes vanishing entirely:** Mathew A. Harris, Caroline E. Brett, Wendy Johnson, and Ian J. Deary, ed. Ulrich Mayr, "Personality Stability from Age 14 to Age 77 Years," *Psychology and Aging* 31, no. 8 (December 2016), 862–874.

CHAPTER TEN

174 **supernatural beings of various kinds:** Terry Gunnell, "Legends and Landscapes in the Nordic Countries," *Cultural and Social History: The Journal of the Social History Society* 6, no. 3 (2009), 305–322.

178 **and scientists think around them:** Priyamvada Natarajan, "Invisibility: The Power of an Idea," 36th Social Research Conference, New School, New York City, session one, Research and Discovery, April 20, 2017.

179 **documents from the time reflect:** Gunnell, "Legends and Landscapes," 305–322.

180 **where the invisible and visible worlds coalesce:** Peter J. Gomes, *The Good Book* (New York: HarperCollins, 2002).

183 **learn about the environment:** Tiffanie Wen, "Can Virtual Reality Make You a Better Person?," BBC Future, October 1, 2014, www.bbc.com/future/story/20141001-the-goggles-that-make-you-nicer.

CHAPTER ELEVEN

188 **There is a reaction of wonder, excitement:** Mark Skwarek, in conversation with the author, May 9, 2016.

191 **to imagine our place in the universe:** Anna North, "What If We Lost the Sky?," *Op-Talk* (blog), *New York Times*, February 20, 2015, op-talk.blogs.nytimes.com/2015/02/20/what-if-we-lose-the-sky/.

192 **humanity people share with one another:** Paul K. Piff and Dacher Keltner, "Why Do We Experience Awe?," *New York Times*, May 24, 2015.

194 **sense of smallness of the self:** Paul K. Piff, Pia Dietze, Matthew Feinberg, Daniel M. Stancato, and Dacher Keltner, "Awe, the Small Self, and Prosocial Behavior," *Journal of Personality and Social Psychology* 108, no. 6, June 2015, 883–89.

194 **the first carrying cards we present to the world:** Alan Lightman, *The Accidental Universe* (New York: Vintage Books, 2014), 86.

195 **where freedom begins:** Jacob Needleman, *I Am Not I* (Berkeley, CA: North Atlantic Books, 2016), 53.

197 **And I'm fine with it:** Mark Strand, "Mark Strand: Not Quite Invisible," interview by Nathalie Handal, *Guernica*, April 15, 2012, https://www.guernicamag.com/not-quite-invisible/.

200 **continue to breathe:** Hope Ginsburg, *Land Dive Team: Bay of Fundy*, "Explode Every Day: An Inquiry into the Phenomena of Wonder," MASS MoCA, North Adams, MA, May 28, 2016–March 19, 2017.

200 **visible and expressive in some way:** John O'Donohue, "The Inner Landscape of Beauty," interview by Krista Tippett, *On Being*, August 31, 2017, https://onbeing.org/programs/john -odonohue-the-inner-landscape-of-beauty-aug2017/.